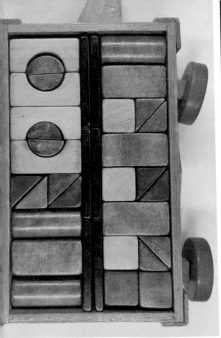

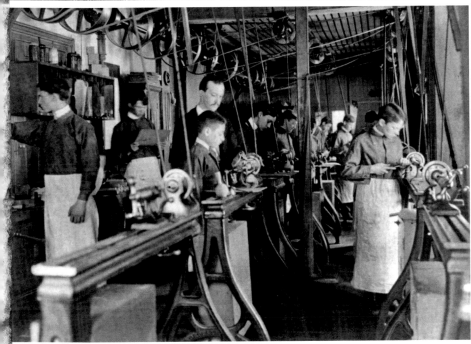

Texts by

PETER ALHEIT	RONALD JONES
JAROSLAV ANDĚL	MARKUS KAYSER
EVA BAKKESLETT	FLORIS KOOT
NANCY BUDWIG	EVA KOŤÁTKOVÁ
CATHY BURKE	GRAZIELA KUNSCH
LUIS CAMNITZER	PAM KUNTZ
TEDDY CRUZ	TYSON LEWIS
JIM DUIGNAN	SUGATA MITRA
TONY EAUDE	JAMES MOLLISON
BENTE ELKJAER	BASARAB NICOLESCU
PRISCILA FERNANDES	PETR NIKL
FONNA FORMAN	RENZO PIANO
LIANE GABORA	ANDREAS SCHLEICHER
HENRY GIROUX	CALVIN SEIBERT
ANN GOLDBERG	BÁRA ŠTĚPÁNOVÁ
KEN GOLDBERG	MARK TENNANT
MICHAEL JOAQUIN GREY	BRUCE E. WEXLER
ANE HJORT GUTTU	JUDY WILLIS
JESSICA HAMLIN	CONRAD WOLFRAM
KNUD ILLERIS	HAFTHOR YNGVASON
MANISH JAIN	PHILIP ZIMBARDO

BACK TO THE SANDBOX

ART AND RADICAL PEDAGOGY

JAROSLAV ANDĚL, EDITOR

Western Gallery, Western Washington University, Bellingham, WA

This publication was produced in conjunction with the exhibition *Back to the Sandbox: Art and Radical Pedagogy*, curated by Jaroslav Anděl for the Western Gallery, Western Washington University, January 9–March 16, 2018.

ISBN 978-1-5179-0752-5

Published by the Western Gallery
Western Washington University
516 High Street
Bellingham, WA 98225-9068
https://westerngallery.wwu.edu
Western is an equal opportunity institution

Distributed by the
University of Minnesota Press
111 Third Avenue South
Suite 290
Minneapolis, MN 55401
www.upress.umn.edu

Published with support from the Elizabeth Firestone Graham Foundation.

Editor: Jaroslav Anděl
Designer: Bedřich Vémola
Cover design: Bedřich Vémola
Front cover: *The Book of Aesthetic Education of the Modern School* by Priscila Fernandes, Installation at Espai 13, Fundació Joan Miró, 2014, photo by Edward Clydesdale Thomson
Copyediting: Lynn Rosen
Proofreading: Jemma Everyhope-Roser

Printed in Canada

CONTENTS

PREFACE AND ACKNOWLEDGEMENTS

Hafthor Yngvason

The *Back to the Sandbox* exhibition brings together an international group of artists who ask radical questions about the nature and significance of education. The aim is not only to draw attention to its vital role in contemporary society and to the challenges of reform but also to introduce new perspectives on learning and creativity with potential new educational models in mind.

I am pleased to bring this important project to the Western Gallery at Western Washington University. This is the third phase of the project. It was initiated in 2015 at the Reykjavik Art Museum, Iceland, during my tenure as the museum's director. It was next presented in a new form at Kunsthall Stavanger, Norway, in 2017. The Western Gallery exhibition took place from January 9 to March 16, 2018.

Unlike packaged traveling exhibitions, this project continues to evolve. It reaches beyond the gallery space and into the local communities through special art and education projects. At Western, the local component took the form of an eight-month-long program organized through an extensive collaboration between the Western Gallery and the university's Woodring College of Education. The program included: arts integration residencies in local schools by theater, dance, and storytelling artists who address critical issues in their work; a professional development workshop for teachers addressing the role of storytelling and art in education through the lens of Coast Salish native cultures; a radical theater project where Western students explored the power structure of higher education; and three assemblies—a summit on education and social justice, with special attention to racial equity; a summit on critical performance pedagogy; and a symposium on the future of education.

In Reykjavik, *Back to the Sandbox* was paired with the *Biophilia Educational Project*, which was originally developed by the Icelandic composer and singer Björk. And in Stavanger, the artist Eva Bakkeslett did a three-month-long participatory film project with students that reflected on education, school, learning and creativity. Called *Voicing*

7

Your Future, this ongoing project continues in the public schools in Western's home city, Bellingham.

It is no coincidence that the Western Gallery presents an exhibition on art and pedagogy. What is now Western Washington University first opened for classes in 1899 as Whatcom Normal School with a mission to train teachers for the small towns of Whatcom County. When Western officially became a four-year college in 1937, the name was changed to Western Washington College of Education. With a number of new degree programs added over the next decades and with growing emphasis on the liberal arts and sciences, Western gradually became a comprehensive university and changed its name in 1977 to Western Washington University. Throughout the changes, pedagogical explorations have maintained a strong presence on campus with the university's various colleges joining Woodring College in developing new approaches to education. This is particularly true of the College of Fine and Performing Arts faculty, including Deb Currier in theater, Pam Kuntz in dance and Chris Vargas in visual art, who have all employed radical pedagogical approaches in their art and teaching.

I'd like to thank Jaroslav Anděl for his vision and curatorial work. It has been a privilege to work with him twice on this exhibition, first in Reykjavik and now at Western. Thanks to the Elizabeth Firestone Graham Foundation for support for this publication, and to Doug Dreier and the Dreier Family College of Fine and Performing Arts Fund for supporting the educational programming. Thanks also to Professor Doug Banner and Karen Dade, Associate Dean for the Woodring College of Education, for their dedication to the experimental projects in the Bellingham public schools. I also want to thank the current director of the Reykjavik Art Museum Ólöf K. Sigurðardóttir and my former colleagues, Yean Fee Quay, Klara Þórhallsdóttir, and Heiðar Kári Rannversson for bringing the exhibition to fruition following my move to Western. Thanks to Hanne Mugaas and Maya Økland for bringing the exhibition to Stavanger. I owe special thanks to Kit Spicer, Dean of the College of Fine and Performing Arts, for his unwavering support of the *Back to the Sandbox* project and of the Western Gallery in general. Thanks also to Patricia Lundquist for her ever resourceful support. Last but not least, many thanks to all the artists in the exhibition and the many contributors to this book.

* **Hafthor Yngvason** is the Director of the Western Gallery and Sculpture Collection, Western Washington University.

BACK TO THE SANDBOX: ART AND RADICAL PEDAGOGY

Jaroslav Anděl

The educational paradox

Every generation and every historical period has its own educational issues. The neurological underpinnings to this difference are associated with neuroplasticity or brain plasticity. It is the brain's capacity to recreate synapses and change itself that makes learning possible. Neuroplasticity peaks during childhood and youth; this phenomenon constitutes a specific paradox of education. People learn most at a young age when they have little say about what and how to learn in school.[1] Older people make those decisions for them based on the past, which means that in school, learning is based primarily on the past and not the present.

This educational paradox becomes of primary concern in the times of great social and technological changes. We are now on the cusp of such dramatic changes and consequently, we witness more and more contentions about education.[2] There are numerous concerns but they all boil down to one underlying question: What education do we need? Behind this question is the feeling that the existing system of education no longer meets the present and future needs. The argument that schools don't provide relevant education is supported by statistics: Although 6.8 million unemployed Americans sought jobs, there were 6 million unfilled positions in the U.S. in June 2017. The proportion

1 Neuroplasticity can thus be seen as a neurobiological underpinning to the educational paradox as described by Immanuel Kant in his treatise *Über Pädagogik [On Education]* (1803). See note 43 below. For a discussion of neuroplasticity, see the essay "Radical Pedagogy for a Radical Brain" by Bruce E. Wexler in this publication. For a more detailed account, see Bruce E. Wexler, *Brain and Culture: Neurobiology, Ideology and Social Change* (Cambridge: MIT Press, 2008).

2 Some of the most frequent debates include topics such as charter schools versus public schools, knowledge versus thinking (content versus process), STEM versus STEAM, and the core curriculum versus the multicultural and/or transcultural curriculum.

in the European Union is comparable.[3] As reform-minded people often point out, the education system we have is the product of the Industrial Revolution while we are now living in a different society with different needs.[4]

The question "What education do we need?" sounds deceptively simple, but in fact it does bring out many complex issues. As the preceding two paragraphs hint, there are neurological, psychological, philosophical, political, social, technological, economic and historical underpinnings to such an inquiry. Though these underpinnings are interconnected we tend to address them separately. Hence, our discourse on education is quite fragmented. There are discussions on various aspects of education and their respective issues from neuroscience and cognitive sciences, digital technology and artificial intelligence, to creativity, social justice and politics, economy, historiography and futurology.[5] What is missing is a deeper understanding of how these particular issues and concerns relate to each other. Pedagogy, as a specialized discipline, doesn't do the job because it suffers *itself* from the limits of specialization.

Help in mapping out some of those connections is unexpectedly coming from artists. This does make sense, though, considering the unique cognitive capacity of art and the role it has played in the history of progressive education—and vice versa. More recently, there has been a growing interest in education among contemporary artists that inspired some critics and curators to coin the term "educational turn" along with other similar concepts.[6] This interest provides an opportunity to pose new questions while connecting ideas, people and disciplines. By asking radical questions, art becomes a kind of radical pedagogy that transcends institutional boundaries and inspires mind-changing narratives.

One of the objectives of *The Sandbox* is to recover traditions of progressive education and its vital cultural contribution. Many new ideas in education are reiterations of visions and concepts articulated by reform movements in pedagogy. In the past, they often emphasized the role of art and creativity in education, and thus it comes as no surprise that these ideas are today being rediscovered by contemporary artists.

The tradition that has recently received most attention is the kindergarten movement and the work of its founder, Friedrich Froebel. He introduced kindergarten (children's garden) in the late 1830s and early 1840s. It spread from Germany to the rest of Europe and other continents in the subsequent decades. Kindergarten is now synonymous with preschool education. Its inventions, including the sandbox and educational toys such as building blocks, became so commonplace that only specialists are aware of their origins.

3 Patrick Gillespie, "U.S. has record 6 million job openings, even as 6.8 million Americans are looking for jobs," *CNNMoney* (New York), first published June 6, 2017: 11:53 AM ET, http://money.cnn.com/2017/06/06/news/economy/us-job-openings-6-million/index.html.

4 British educator Ken Robinson is perhaps the best-known proponent of this argument. For instance, see https://www.ted.com/talks/ken_robinson_says_schools_kill_creativity?language=cs.

5 The five longer essays in this publication address the issues of social justice, creativity, transdisicplinarity, neuroplasticity, and the cognitive role of art, while the shorter texts that respond to the question "What education do we need?" also touch on a variety of other concerns, including the role of digital technology.

6 Paul O'Neill and Micky Wilson, eds., *Curating and the Educational Turn* (London: Open Editions / de Appel, 2010).

The sandbox

The sandbox is one of those ubiquitous objects of urban environment that we take for granted. However, it's a recent invention and we do know how it originated. The idea came from Hermann vom Arnswald, a former student and follower of Froebel. He wrote to his mentor on May 13, 1847: "Dear Fatherly Friend: Yesterday I was engaged in studying your Sunday paper when an idea struck me which I feel prompted to communicate to you. I thought, might not a plane of sand be made a useful and entertaining game? By a plane of sand I mean a low, shallow box of wood filled with pure sand. It would be a kindergarten in miniature. The children might play in it with their cubes and building blocks. I think it would give the child particular pleasure to have the forms and figures and sticks laid out in the sand before his eyes. Sand is a material adaptable to any use. A few drops of water mixed with it would enable the child to form mountains and valleys in it, and so on."[7]

Because of the initial association with the kindergarten, the sandbox was first called sand garden or sand table. A few decades later, the sandbox also found its way to public parks and led to the rise of children's playgrounds. This development first took place in Germany in big cities such as Berlin where sand piles placed in public parks became popular with children. The idea spread to the U.S. The first sand garden, a large pile of sand, appeared in a public park in Boston and inspired the playground movement.[8]

The reason why the sandbox has spread everywhere is that it provided a convenient and safe playing environment. Thanks to its pedagogical background, the word "sandbox" has become a metaphor of learning environment and carries pedagogical connotations in many different contexts: aesthetic, psychological, technological, economic, social and political. This fact testifies to the cultural power of the sandbox, also confirmed by artists' interest. Artists have explored various uses of the sandbox and playground in general, taking on a variety of connections. Each artist contextualizes it in different ways and brings out multiple associations and meanings that the sandbox might have in education and art, as well as in the contexts of technology, architecture and politics.

For instance, the short-lived Czech group, The Society for a Merrier Present, which organized political happenings that were critical of the regime before the fall of Communism, invited representatives of several dissident groups to play together in a sandbox. Václav Havel, who would become Czechoslovak president three months later, was among the participants. The title of the happening was *The Sandbox: Each in His Corner*, manifesting the intention of the organizers to foster a greater collaboration among the opponents of the regime.[9] In retrospect, one can read into this playful event a deeper meaning related to learning. This happening put on display the lesson that those participants, who became politicians, had to learn much later—notably, how to

7 Arnold H. Heinemann, ed., *Froebel's Letters* (Boston: Lee & Shepard Publishers, 1893), 61.

8 For a discussion of the beginnings of the playground movement in the U.S. and the first sand garden in Boston, see Clarence E. Rainwater, *The Play Movement in the United States. A Study of Community Recreation* (Chicago: University of Chicago, 1922), 22.

9 Petr Blažek, "Happeningem proti totalitě. Společnost za veselejší současnost v roce 1989," *Paměť a dějiny*, no. 3 (2014): 12–23. http://old.ustrcr.cz/data/pdf/pamet-dejiny/pad1403/012-023.pdf.

compete and collaborate in public life, one of the skills we all start to acquire early on in the sandbox.

As Froebel observed, the sandbox attracts children by providing an opportunity to do things—to dig, build, mold: "The little child employs itself for a long time merely by pouring water or sand one vessel into another… building and forming with sand and earth." [10] Children thus learn their first lessons to become a *Homo faber* (man the maker) by playing in the sandbox. A testimony coming from one of the most celebrated living architects, Renzo Piano, confirms that these first experiences of molding, shaping and building can turn children into future architects, sculptors, engineers and designers. "My career started when I was a child and I built my first sandcastle on the beach in Genoa, where I grew up. Making things has always been a pleasure for me—happy hands, happy mind—and making sandcastles was my training in fantasy." [11]

American artist Calvin Seibert, who is known for making elaborate sandcastles on beaches in the U.S. and elsewhere, makes a similar point about his artistic journey. He connects sandcastle-making directly to the kindergarten movement: "As with most artists, my life's work has been a process that began in play as a small child. There is hardly a line where (sic) the early activity can be distinguished from what came later. I have always felt a connection to the kindergarten movement, its aesthetic of primary color and basic shapes has informed the core of what I do. I always knew what I was about. I still make sandcastles." [12]

Piano finds in making sandcastles a pleasure together with learning lessons: "For an architect to make something so simple, so easy, so playful, like a sandcastle, it's still about learning. It's about physical law, it's about intuition, it's about forces of nature—it's about understanding, at the end of the day." According to Piano, the impermanence and uselessness of a sandcastle can teach architects something fundamental: "But making something so useless like a sandcastle teaches you a lot about the responsibility of making something that must remain for centuries… the old story of the relationship between manmade and nature." [13]

Piano here unwittingly identifies two core ideas behind Froebel's kindergarten: the essential connection between manmade and nature, and playing as the prime method to achieve a deeper understanding of that relationship. But while Piano seems to suggest that

10 Kate Douglas Smith Wiggin and Nora Archibald Smith, *The Republic of Childhood: Froebel's Occupation*, Boston and New York: Houghton, Mifflin and Company, 1900, 293.

11 Renzo Piano, "How to Build the Perfect Sandcastle," as told to Rosanna Greenstreet, *The Guardian*, July 14, 1015. https://www.theguardian.com/lifeandstyle/2015/jul/14/sandcastle-beach-renzo-piano-shard-architect-build.

12 See the artist's statement in this publication. The artist describes his practice elsewhere as follows: "Building 'sandcastles' is a bit of a test. Nature will always be against you and time is always running out. Having to think fast and to bring it all together in the end is what I like about it. I rarely start with a plan, just a vague notion of trying to do something different each time. Once I begin building and forms take shape I can start to see where things are going and either follow that road or attempt to contradict it with something unexpected. In my mind they are always mash-ups of influences and ideas. I see a castle, a fishing village, a modernist sculpture, a stage set for the Oscars all at once. When they are successful they don't feel contained or finished. They become organic machines that might grow and expand. I am always adding just one more bit and if time allowed I wouldn't stop." https://www.flickr.com/photos/45648531@N00/sets/72157594166672630/.

13 Piano 2015.

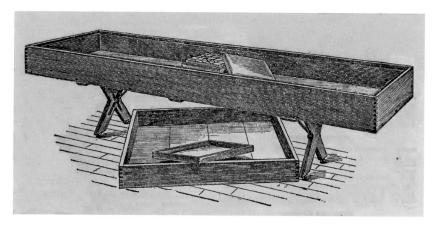

Sand table, *Steiger's Kindergarten Catalogue, Eighth Edition*, New York, 1900

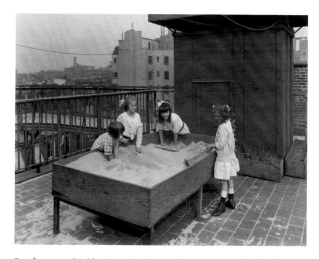

Rooftop sand table, New York Association for the Blind, 1917

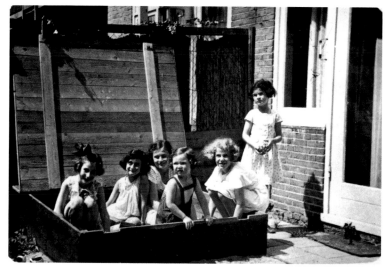

Anne Frank with Hannah Goslar and other friends, 1937

the builder competes with nature by presenting manmade and nature as opposites, Froebel's ideal was to be one with nature, to grasp and teach "unity in diversity, the correlation of forces, the interconnection of all living things, life in matter."[14]

Markus Kayser, Petr Nikl and Michael Joaquin Grey are other artists who use sand in their work, entering thus into a dialogue with the history of the sandbox and, to use Piano's phrase, with "the old story of the relationship between manmade and nature." The use of sand has been running throughout the human history, most frequently in construction and glass production, and also recently in the electronic industry, since silicon, a major component of sand, is a key ingredient in integrated circuits found in computers, mobile telephones and other electronic devices.

In his work *Solar Sinter*, Kayser brought together manmade and nature in a very specific and unexpected way. Working in the Sahara Desert, he created a new machine to connect the two main elements of the desert, sand and sun. He used the method known as sintering, i.e. transforming powder by heat into a solid form, which is called 3-D printing or SLS (selective laser sintering). By replacing a laser with the sun's rays and resin powder with sand, Kayser was able to produce glass objects. He calls a fully automated computer-driven version of the machine Solar Sinter. Kayser connected the ancient technology of glassmaking with a new technological process while using the natural resources of sun and sand. He thus created new technological and cultural loops by relating manmade and nature in order to engage today's concerns and challenges such as energy sustainability and climate change.

Petr Nikl's *Fata Morgana: Sand Object for Drawing* is a novel version of the sand table which consists of sand and a mirror. The object brings out multiple connections and associations. As its title informs, its purpose is not to use sand for molding and building but for drawing. "To draw a line in the sand" is an idiomatic expression that means to draw an arbitrary boundary whose crossing would entail consequences. Like building sandcastles, drawing in the sand is a favorite pastime on the beach. In some cultures, sand drawing is also an ancient ritualistic practice. By placing the sand on a mirror illuminated by a spotlight casting reflections on the wall, Nikl enriched the genre of sand drawing with additional virtual dimension. In order to foster play and imagination, he connected two ancient practices that use the impermanence of images: shadow plays and sand drawing.

The title of the project *7090 Kindergarten* (also *7090/Sandbox*) by American artist Michael Joaquin Grey includes a direct reference to the origins of the sandbox in the kindergarten movement. *7090 Kindergarten* is a sandbox installation of which one half occupies a sand sculpture of the IBM 7090 made in the full-scale 1:1; the other half serves the public for play and pedagogical exercise. One of the *7090 Kindergarten* proposals featured a permanent installation for Silicon Valley as *axis mundi*. This was a symbolic marker of a cultural milestone in the development of digital culture as the IBM 7090 was a first-generation silicon mainframe computer used for large-scale applications such as the NASA Gemini and Mercury flights and the U.S. Air Force Ballistic Missile Early Warning System. Grey's project is still waiting for its materialization. Together with other works, it's a part of a larger endeavor titled *Kindergarten 2.0*.

14 Ibid.

Born to build

Many people today use the term kindergarten as a generic term for preschool education without being aware of its origins and history, including the name and work of Friedrich Froebel. American artist and inventor Michael Joaquin Grey discovered the work of Friedrich Froebel in the first half of the 1990s when he was developing a modeling system called ZOOB. Grey first studied genetics. His interest in genetic algorithm and neural networks inspired him to question the arcane and linear nature of the language we use to describe spatial syntax and complex phenomena. This line of questioning led him to think about the significance of education and the need for new modeling tools. It was then when Herbert Kohl, an American educator and advocate of alternative education, brought the artist's attention to Froebel's educational toys called gifts and occupations.

Grey was surprised to find in the gifts and occupations and the kindergarten's philosophy not only similarities and parallels to ZOOB but also the evolutionary concept of recapitulation with which he identified. The concept itself has a long intellectual history and occupies the central position in Froebel's philosophy of education. Recapitulation was most frequently associated with an evolutionary theory advanced by German biologist Ernest Haeckel who claimed that ontogeny (individual development) recapitulates phylogeny (the evolution of species). Although Haeckel's theory is no longer accepted by biologists, the concept of recapitulation has still retained some popularity in the studies of cognitive development and in the theory of origins of languages.[15]

Grey believes that the concept of recapitulation is useful in understanding micro- and macrodevelopments in cultural evolution and in articulating a more holistic approach to education. He found evidence for his belief in the way the first generation of modernist artists who attended kindergarten recapitulated preschool learning in their mature work. There had been only a few scholars who explored this subject, primarily by writing on Bauhaus and Frank Lloyd Wright.[16] The connections of these artists to kindergarten aesthetics are to some extent self-evident thanks to their interest in pedagogy and personal acknowledgments.[17] It was only in 1997 when the book *Inventing Kindergarten* by Norman Brosterman (1997) made a more general claim regarding modern art movements' debt to

[15] For a discussion of the recapitulation theory in biology, see Stephen Jay Gould, *Ontogeny and Fylogeny* (Cambridge, Mass.: Belknap Press of the Harvard University Press, 1977).

[16] Frederick M. Logan, "Kindergarten and Bauhaus," *College Art Journal* 10, no. 1 (Autumn, 1950), 36–43.
Grant Manson, "Wright in the Nursery. The Influence of Froebel Education on the Work of Frank Lloyd Wright," *The Architectural Review*, no. 113 (June 1953), 349–351.
Richard C. MacCormac, "Froebel's Kindergarten Gifts and the Early Work of Frank Lloyd Wright," *Art Journal*, no. 1 (June 1, 1974), 29–50.
Jeanne S. Rubin, "The Froebel-Wright Kindergarten Connection: A New Perspective," *Journal of the Society of Architectural Historians* 48, no. 1 (March 1989), 24–37.
For a more comprehensive list of articles on Frank Lloyd Wright's relation to the Kindergarten, see Rubin 1989 and Jeanne S. Rubin, J.S. *Intimate Triangle: Architecture of Crystals, Frank Lloyd Wright, and the Froebel Kindergarten* (Huntsville, Ala.: Polycrystal Book Service, 2002).

[17] See, for instance, Frank Lloyd Wright, *A Testament* (New York: Bramhall House, 1957), 19–21, 63, 100, 206–207, 220, 300; *An Autobiography* (Spring Green, Wisc.: Taliesin Press, 1944), 14.

kindergarten. While mainstream academia's response to Brosterman's book has been skeptical, artists, designers and the general public have been more receptive.[18]

Grey, who earlier became acquainted with the kindergarten movement and its impact on modernist culture, addressed this topic in his own way. He appropriated the famous chart of modern art movements by Alfred Barr on the cover of the MoMA exhibition catalog *Cubism and Abstract Art* (1936) and extended its timeline to include two additional items—Froebel's kindergarten (1840) and Grey's *Kindergarten 2.0* (2013). He also replaced the cover's title with his own, *Kindergarten 2.0.* The point of this work goes further than Brosterman as it implies that the issue here is not just what art historians describe as "influence" but a more fundamental process of cultural reproduction characterized as recapitulation. *Kindergarten 2.0* also makes another point as it makes the case for a new kind of education: a call for the creation of a new education system, which would do for information society what the kindergarten accomplished for industrial society. In other words, by using Froebel's kindergarten as an historical frame of reference, Grey's work implies the question posed by this exhibition: What education do we need?

This is a quest Grey has pursued since the mid-1990s when he created a company called Primordial LLC. Its name, logo and mission "to create a classic collection of toys, tales and tools to help us understand who we are, where we come from, and where we are going" represent an explicit evolutionary statement.[19] The concept of *Kindergarten 2.0* makes the mission statement's implicit reference to Froebel's kindergarten *explicit*. It defines the conceptual framework of Grey's works and projects in different media over the last couple of decades.

Froebel's philosophy of kindergarten reflects the influence of naturphilosophie and German romanticism. He studied mathematics and botany in Jena from 1799 to 1802, i.e. in the final years of the first phase of German romanticism associated with that city. The romantic tradition is present in the origins of the word "kindergarten," which Froebel conceived as a metaphor: "Children are like tiny flowers; they are varied and need care, but each is beautiful alone and glorious when seen in the community of peers."[20] Froebel translated this metaphor into the kindergarten curriculum, which included the stewardship of the school garden.

All the kindergarten components—the sandbox, the garden and the gifts and occupations—served the same goal: to observe and learn about the universal principles that connect diverse phenomena in nature and society. According Froebel and many other theorists in the 19th and early 20th centuries, humankind has evolved through epochs of cultural history and each individual repeated, i.e. recapitulated, these epochs in his or her

18 Norman Brosterman, *Inventing the Kindergarten* (New York: Abrams Books, 1997).

19 For a discussion of ZOOB, see Alessandra Bianchi, "DNA-Like Toy Inspires Brand Creation," *Inc.com*, March 1, 1998, https://www.inc.com/magazine/19980301/876.html. http://www.sfgate.com/business/article/Zoob-Toys-Zooming-Consumers-snap-up-2794951.php.

20 http://www.froebelweb.org/web7001.html. For a description of the circumstances of Froebel's invention of the word "Kindergarten," see Johannes Barop, "Critical Moments in the Froebel Community," in *Autobiography of Friedrich Froebel*, trans. Emilie Michaelis (Syracuse, N.Y.: C. W. Bardeen, 1889), 137.

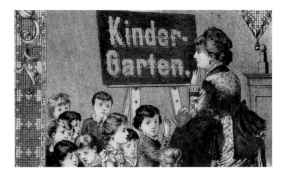

W. Schäfer, chromolithograph created to celebrate the 100th anniversary of the birth of Friedrich Froebel, *Anschauungsbilder für Kindergarten, Schule und Haus*. Berlin: Maurer-Greiner, 1882

Kindergarten tabletop, *Froebel's Kindergarten Occupations for the Family*, E. Steiger & Co., 1876

Illustration from *The Ninth Occupation, Peas and Cork Work, In Primary Schools* by J. H. Shults, New York: Kindergarten Magazine Co, 1901

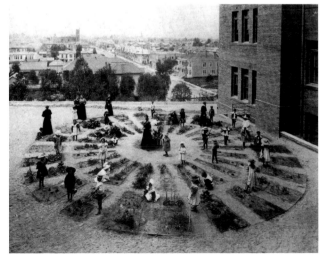

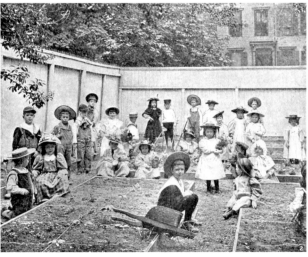

Children's garden, unidentified kindergarten, Los Angeles, ca. 1900

Children's garden, Pratt Institute Kindergarten, Brooklyn, New York, *New International Encyclopædia*, 1905

own personal development. Thus, learning should follow the same process of recapitulation and, in Froebel's view, play is instrumental in this process of learning.[21]

In *Kindergarten 2.0*, Grey has identified with this concept and sought to elaborate it further by using the main kindergarten components as reference, independently or together. For instance, the sandbox has appeared in the exhibition *Back to the Sandbox* at its first venue, the Reykjavik Art Museum, in 2016, linked to the theme of the garden in a site-specific installation. It included a small orange tree in a sand table standing in a sandbox and the computational drawings *One Thousand Citrus Trees @ Thingvellir, Iceland*, together with the computational animation *Northern Romantic Citrus*. The sand table's design evoked the inverted landscape of Thingvellir, the place associated with the origins of Icelandic identity. In these works, Grey projected the theme of the garden into the historical site while imbuing it with overtones of mythology and ecology. The pedagogical performance that was inspired by the installation followed the next day after the opening of the exhibition. Performed in the dark of winter with a busload of children, the artist and children brought an orange tree to Thingvellir and discussed, on the site, potential consequences of global warming and its implications for our understanding of who we are and where we live.

Inspired by the ground plan of the original garden designed by Froebel, Grey alluded to the debt of modern art movements to the kindergarten movement by inscribing artists' names (Piet Mondrian, Wassily Kandinsky, Mark Rothko, and Frank Stella among others) onto individual garden plots that children were assigned to care for. In this recursive gesture, Grey recapitulated a modernist cultural cycle and at the same time made a point about how much that is manmade is grounded in nature—in Froebel's language—and how much that the forms of nature, life, knowledge and beauty are interconnected.

Grey has further developed these notions of recursive process and recapitulation in his works that take up the themes of gifts and occupations. Froebel designed the gifts and occupations to manifest "forms of nature, life, knowledge, and beauty."[22] These designs were informed by Froebel's studies of mineralogy at the University of Berlin (1812–16) as minerals and their process of crystallization manifested to Froebel the principles of a universal law. There are 20 gifts and 20 corresponding occupations. The first gift consists of a wooden sphere, cube and cylinder. The second gift comprises a large cube divided into eight smaller cubes. The third, fourth, fifth, and sixth gifts divide the cube into blocks of different shapes.

Children can arrange blocks in many ways to create forms that relate to the real world, mathematics and aesthetics, i.e. nature and life, knowledge and beauty. In this way children learn to understand three different spheres—their environment, connections between human life and life in nature, and social connections, including those between children and adults.

21 For a discussion of recapitulation theory in the pedagogies of Froebel and other leading theorists, see, for example, Thomas D. Fallace, "Recapitulation Theory and the New Education: Race, Culture, Imperialism, and Pedagogy, 1894–1916," *Curriculum Inquiry* 42, no. 4 (September 2012), 510–533; and *Race and the Origins of Progressive Education, 1880–1929* (New York: Teachers College Press, 2015).

22 See, for instance, *Friedrich Froebel's Pedagogies of the Kindergarten or His Ideas Concerning the Play and Playthings of the Child,* trans. Josephine Jarvis (New York D. Appleton and Company, 1909), 106–107, 137–138.

Grey has been interested in children's building blocks and scientific modeling systems for a long time. His interest originated in the belief that we lack a language to read dynamic spatial communication and reproduction, dynamic and complex systems. He argues that we still rely on a linear linguistic pedagogy and ancient building strategies such as stacking and girders and beams, i.e. stereotomy and tectonics, in an increasingly complex world: "As the 20th century drew to a close, technology developed exponentially and extended the reach of the individual. We are examining the language of the body (DNA), as well as playing with the behavior of information and computation. We can explore the limits of knowledge with the internet, yet we are still dependent on the old pedagogy that limits our ability to solve problems and to parse the natural and technological world."[23]

Grey's response to this deficit is the Citroid and ZOOB systems. The Citroid system is a set of instructions to create spatial syntax and language that manifest the moving geometry of living systems. Based on the sphere structured with 61-fold symmetry, it captures the Archimedean and Platonic geometries found in nature, allowing for the articulation of anatomical and molecular structures. It thus represents "a new understanding of how we build and—how we are built" and "how our body empathy connects us to the history and evolution of making and building, from bones to branches, bricks, beams, bonds, and now big data."[24]

One of the Citroid applications is the ZOOB modeling system, which reverses mathematical structures into a hands-on mode based on body empathy. For instance, ZOOB (which stands for zoology, ontology, ontogeny, botany) has five units corresponding to the five fingers and the five joint connections. Each unit resembles a homunculus, a little human-like figure. Units can be connected in different ways, which creates an almost infinite number of permutations. This gives ZOOB unique properties manifested in the fact that ZOOB's users include children as young as three years old as well as a wide range of specialists from biologists and astrophysicists to programmers and engineers.

The Citroid and ZOOB systems are introducing a new fundamental pedagogy that updates the gifts and occupation philosophy for the information age. Unlike today's increasingly dominant tendency to let algorithms rule the world, the Citroid and ZOOB systems allow what Froebel successfully proposed in the gifts and occupations for industrial society: to create tools for understanding patterns and natural algorithms across three different realms: our body, man-made environment, and nature.

Discipline versus freedom

Jim Duignan's project, *A Plea for Playgrounds*, is an example of contemporary artists' effort to rediscover the contributions and lessons of progressive education.[25] The project sought

23 See the artist's statement for the exhibition *Child as Teacher: Art and Radical Pedagogy* at the Kunsthall Stavanger in Stavanger, Norway (January–March 2017).
24 Ibid. Also see the artist's statements in this publication.
25 Jim Duignan and Jennifer L. Gray, *A Plea for Playgrounds. An Appeal to the People of Chicago and Citizens Everywhere for Attention to Establish Playgrounds for Children*, issued by Special Park Commission, City of Chicago and Endorsed

to update the eponymous booklet published by the Chicago Park Commission in 1905. It also celebrated the playground movement and its leaders' contribution, Jane Addams's in particular, to social reform and progressive education of the progressive era of the early 20th century. Duignan collaborated on this project with architectural historian Jennifer Gray to reinterpret the original booklet in today's context of polarized political and economic interests "around either neoliberal privatization or centralized administration." The new booklet's objective was "to recapture the optimism in, and creative engagement with, the democratic process modeled by early playground activists."[26]

The artist has been interested in this concept: "memories of gathering, retreating, and realizing all marked a fundamental education in using the city as both a physical and social space."[27] Duignan grew up in Chicago in the 1960s and his childhood experience of the city led him to collaborate with a group of elders who shared with him their recollections and relationships with playgrounds. He has been exploring the topic by using the sculptural form of the playground equipment—for instance, a seesaw and a swing—associated with the history of playgrounds going back to the late 19th century.

In this history, Chicago occupies a memorable position thanks to one of the leaders of social reform in the U.S., Jane Addams, who was a pioneer of the American settlement movement, a social activist, public philosopher and key figure in women's voting rights and world peace. In 1889 she cofounded Hull House, a settlement that provided help for recently arrived immigrants and became a model for many other similar establishments all over the U.S. Hull House offered many programs for children and adults, and developed an alternative model of education and specific teaching methods. Hull House education was community-based, was open to everybody, and emphasized the importance of the arts. Together with John Dewey who often frequented Hull House, Addams recognized education as the foundation of democracy.

Addams was also one of the leaders of the playground movement in the U.S. who associated the need for playgrounds with the concepts of democracy and citizenship. These leaders expressed the belief in this connection in articles such as "Play and Democracy" or "Play as a School of The Citizen" or statements such as "The playground of today is the republic of tomorrow."[28] The movement originated in Boston in the summer of 1885 when Mrs. Kate Gannet Wells, chairman of the executive committee of the Massachusetts Emergency and Hygiene Association, received a report from Berlin about sand piles used by children for playing in public parks. The report inspired the first similar sand garden in Boston located in the yards of the Parmenter Street Chapel and the West End Nursery.

by His Honor, Mayor Edward F. Dunne, 1905 and Artist, Jim Duignan, Historian, Jennifer L. Gray, 2014 (Chicago: Stockyard Institute, 2014).

26 Ibid., 20. Both quotes are from the introductory text by Jennifer L. Gray.

27 Ibid., 23. The quote is from the text by Jim Duignan.

28 Luther Gulick, "Play and Democracy" in *Charities and the Commons* 18 (August 3, 1907), 481–486.
Joseph Lee, "Play As A School of the Citizen," *Charities and the Commons*, August 3, 1907.
The phrase "The playground of today is the republic of tomorrow" is from Lee F. Hamner, "Health and Playgrounds," in *Proceedings of the National Conference of Charities and Correction* (1910), 155–156.
For a discussion of this topic, see Linnea M. Anderson, "'The playground of today is the republic of tomorrow': Social reform and organized recreation in the USA, 1890–1930's," *the encyclopaedia of informal education* (2006), http://infed.org/mobi/social-reform-and-organized-recreation-in-the-usa/.

More sand gardens appeared in Boston in the subsequent years and other cities followed Boston's example, namely Philadelphia, New York, Providence, Brooklyn, Baltimore, Newark, Worcester, Chicago and Portland.[29]

The very name "sand garden" suggests that the sandbox, i.e. the "kindergarten in miniature," was the main inspiration for this initial stage in the playground movement. The fact that kindergarten teachers often supervised children in the first playgrounds also confirms this connection. In his authoritative history of the movement, Clarence E. Rainwater distinguished seven developmental stages of the playground between 1885–1918, describing the changing function and social context of playgrounds: "(1) the 'sand garden' stage, dominant during 1885–95; (2) the 'model playground' stage, about 1895–1900; (3) the 'small park' stage, about 1900–5; (4) the 'recreation center' stage, 1905–12; (5) the 'civic art and welfare' stage, 1912–15; (6) the 'neighborhood organization' stage, 1915–18; and (7) the 'community service' stage, since about 1918."[30]

As the history of the first sand gardens in Boston and Chicago illustrates, educated middle- and upper-class women who believed in the necessity of social reform were the main driving force of the playground movement. Hull House and its contribution to the playground movement is the case in point. It was a community of university-educated women who established it as a project of research-based social service and a tool for social reform. Its playground became a model for other similar initiatives and the term "model playground" originated there in 1894.[31]

In 1905 the Chicago Special Park Commission, which included "private citizens of public spirit," published a pamphlet titled *A Plea for Playgrounds*. To achieve its purpose, "an appeal to the people of Chicago for funds to establish playgrounds for children of the West Side," the booklet sought to explain: "Where playgrounds are needed; Why they are needed; Conditions which should touch the hearts and pocket books of all who have regards for the welfare of children."[32] The booklet ends quoting President Theodore Roosevelt's message to the Congress: "Public playgrounds are necessarily means for the development of wholesome citizenship in modern cities."

In 1906 the Playground Association of America was established in Washington D.C. One of its tenets was the belief that "play under proper conditions is essential to the health and the physical, social and moral wellbeing of the child, playgrounds are a necessity for all children as much as schools."[33] Jane Addams became the first Playground Association of America vice president and the following year spoke about "Public Recreation and Social Morality" at its first annual conference in Chicago.[34] She further elaborated on the subject

29 For a discussion of the beginnings of the playground movement in the U.S. and the first sand garden in Boston, see Clarence E. Rainwater, *The Play Movement in the United States. A Study of Community Recreation* (Chicago: University of Chicago, 1922), 13–44.

30 Ibid., 46.

31 For a discussion of the model playground, see Rainwater 1923, 55–69.

32 *A Plea for Playground*, issued by the Special Park Commission, (Chicago: W. J. Hartman Company, printers, 1905), 3, 5.

33 "Early Days," undated, National Recreation Association records, Social Welfare History Archives, University of Minnesota Libraries Historical material, Box 1, folder 1, quoted after Anderson 2006.

34 Jane Addams, "Public Recreation and Social Morality," *Charities and the Commons* 18 (August 3, 1907), 492–94. http://hullhouse.uic.edu/hull/urbanexp/main.cgi?file=viewer.ptt&mime=blank&doc=818&type=print.

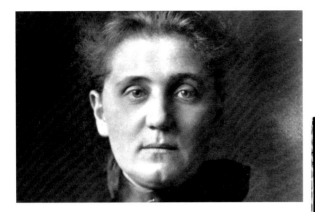

Jane Addams, 1880s. Courtesy of the Jane Addams
Hull-House Museum

Hull House, Chicago, IL, postcard, ca. 1910

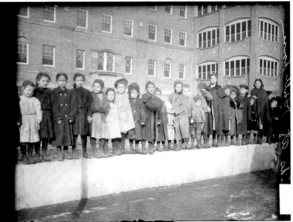

Children at Hull House, *Chicago Daily News*, 1908

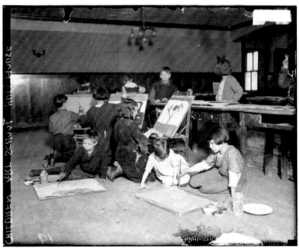

Art class at the Hull House, 1924. Courtesy of the Jane Addams
Hull-House Museum

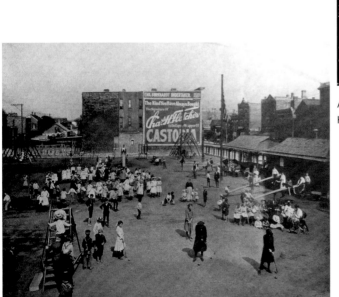

Lincoln Playground, West Chicago Avenue,
A Plea for Playgrounds, Chicago: Special Park Commission, 1905

in her book *The Spirit of Youth and the City Streets* (1909) in which she addressed challenges youth faced in big cities, such as overcrowding and unsanitary living conditions, monotonous industrial labor and the lack of educational opportunities.[35]
She saw solutions in reforms that would provide youth with public recreation, practical education and experiences in the arts, i.e. the approach Hull House had been practicing.

Jane Addams's work shows that the history of playground movement and progressive education are closely intertwined, driven by the same ideas of democracy and citizenship. This close association manifests itself in the spread of public playgrounds and playgrounds in public schools in which activists such as Jane Addams played a key role. While in the earlier period Germany was followed by other countries in primary education and the development of playgrounds, the U.S. became the leader in both fields thanks to rapid industrialization and urbanization, and the social reform movement in the late 19th and early 20th century. The U.S. set new standards in education, which the rest of the world gradually adopted as its own.

For instance, we find school playgrounds all over the world today as James Mollison's photographic project titled *Playground* documents. The photographer confessed that the project revived his childhood experience of school playgrounds as "a space of excitement, games, bullying, laughing, tears, teasing, fun, and fear."[36] Mollison's photographs reveal the vestiges of the original democratic ethos of the playground movement as well as the industrial tendency to standardize, control and discipline. This dichotomy runs through the whole history of modern education, reflecting the contradictory needs and trends of modernization. Their relations change from one historical period and country to another.

Not surprisingly, these contradictions and their reflection in the work of progressive thinkers and reformers were most pronounced in the centers of rapid urban growth and industrialization such as Chicago. Barcelona and the school movement *escuela moderna* founded by Francesc Ferrer i Guardia is another important example. In her installation and book, *The Book of Aesthetic Education of the Modern School*, Portuguese artist Priscila Fernandes makes the viewer aware of Ferrer's work by exploring the relation of escuela moderna to aesthetic education and modern art in general. She assembled writings by artists of the period in a publication titled *Book of Aesthetic Education*, suggesting that there was an affinity between progressive education and modernist aesthetic. She also connects the collection of writings to today's discussions on art and education in her installation by using modernist drawings of the early 20th century engraved into chairs that are installed in a gallery space and used for discussion about art education in public programs.

Escuela moderna had a wide international influence that reached as far as South America and the U.S., though the school in Barcelona lasted only from 1901 to 1906. The state and the church saw Ferrer's educational project as a subversive activity. The state closed the school and executed Ferrer on trumped-up charges for sedition in 1909. In his book on escuela moderna, Ferrer wrote perceptively on a number of key issues,

35 Jane Addams, *The Spirit of Youth and the City Streets* (New York: Macmillan, 1909). http://www.boondocksnet.com/editions/youth/ (July 6, 2001).

36 See the artist's statement in this publication.

including the reform of the school, a subject which is as much topical now as it was in Ferrer's time.[37] His main three points are still pertinent to today's debate.

The first point is that the reform of the school is necessary because of the new conditions of production and labor: "The progress of science and our repeated discoveries have revolutionized the conditions of labor and production. It is no longer possible for the people to remain ignorant; education is absolutely necessary for a nation to maintain itself and make headway against its economic competitors."[38]

The second point is that this recognition makes the authority, primarily the state, control learning under new conditions through its instrumentalization and organization: "Recognizing this, the rulers have sought to give a more and more complete organization to the school, not because they look to education to regenerate society, but because they need more competent workers to sustain industrial enterprises and enrich their cities. ...the children must learn to obey, to believe and to think according to the prevailing social dogmas."[39]

The third point is that the purpose of learning and education is more than just to serve the economy: "The whole value of education consists in respect for the physical, intellectual, and moral faculties of the child."[40]

Ferrer foregrounded the dichotomy of two contradictory strands running throughout the history of education: on one hand, learning and education as a means of empowerment, emancipation and liberation, on the other, education as an instrument of control and discipline. Ferrer was neither the first nor last who was pitting the two strands against each other. The tension between the two strands is intrinsic to our understanding of who we are as individuals, members of society and humankind, and is specific in each historical period and culture.

The current education system is a typical product of institutionalization grounded in the Enlightenment and carried out by emphasizing uniformity and conformity rather than creativity and diversity. This development is manifested in the rise of elementary education since the 19th century. It has been a process in which education has been gradually provided by the state and made compulsory for the reasons described by Ferrer in the quoted excerpt.

Rooted in the "Age of the Enlightenment" and the era of industrialization and urbanization, the present educational system bears the institutional heritage of these historical periods. Together with prisons, barracks and hospitals, schools are a typical example of the type of modern institution whose rise was so persuasively described by the French philosopher Michel Foucault in his book *Discipline and Punish*.[41] Czech artist Eva Koťátková is particularly interested in this specific feature of the school, focusing on its authoritarian nature. Characteristically, in her works she frequently revisits the themes of the school and the mental institution and their constraints on individual freedom.

37 Francisco Ferrer Y Guardia, *The Origin and Ideals of the Modern School* (London: Watts & Co., 1913), 42–54.

38 Ibid., 44.

39 Ibid., 44, 49.

40 Ibid., 50.

41 Michel Foucault, *Discipline and Punish: the Birth of the Prison* (New York: Random House, 1975).

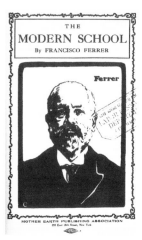

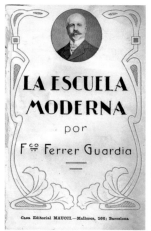

Francisco Ferrer Guardia,
The Modern School,
New York: Mother Earth
Pub. Association, 1910

Francesc Ferrer i Guardia,
*La Escuela Moderna:
póstuma explicación
y alcance de la enseñanza
racionalista*. Barcelona:
Maucci, ca. 1913

The front page of *Boletín
de la Escuela Moderna:
Enseñanza científica
y racional* [Bulletin of The
Modern School: Scientific
and Rational Teaching],
Barcelona, May 1908

Police photograph of Francesc Ferrer
i Guardia, 1909 (?)

Escuela moderna classroom, Barcelona (opened in 1901)

Norwegian artist Ane Hjort Guttu makes the tension between individual freedom and social discipline central to her work, *Freedom Requires Free People*, as its very title indicates. Featuring an eight-year-old boy attending a primary school in Oslo, the video shows how his feeling for freedom clashes with the school's rules and regulations. In her statement, the artist describes this conflict as an example of the "central pedagogical problem of power." She pointedly asks: "How can we learn to be free in systems and institutions where the methodology demands subordination?"[42] and buttresses her inquiry by quoting Immanuel Kant's essay *On Education* (1803): "One of the major problems in education is how subjection to lawful restrictions can be combined with the ability to make use of one's own freedom… How shall I cultivate freedom under conditions of compulsion?"[43]

In this context, the way the kindergarten and its emphasis on play was absorbed into the mainstream education system of the nation-state is typical. Though the kindergarten movement provided valuable lessons to primary education, its original cultural background (naturphilosophie and holistic traditions) was overshadowed or refuted by the political and economic needs of the nation-state, i.e. nation building by means of national ideology and the instrumentalization and specialization of education.

Guttu's earlier work, *How to Become a Non-Artist* (2007), is relevant to this broader context of institutionalization, though its subject is her own four-year-old son. The artist followed him in her home and documented the arrangements he made out of everyday objects such as coat hangers, glasses, shoes, etc. The artist's initial intention was to discover whether the impulse behind her son's actions was his interest in objects' meaning or in their composition. The work, however, evolved into a meditation on the meaning of both children's play and artistic practice and their similarity, which the artist identifies as "the concentrated and deeply earnest search for means to understanding and interpreting the world."[44]

The instrumentalization of children's play is the topic of Priscila Fernandes's videos, *For a Better World*; *To the Playground!* and *Product of Play*. The central message of all these three videos is summed up by the title *Product of Play* by bringing together two words in the way that makes one serve as an instrument of the other. The video shows two children separately, one playing with colorful building blocks, the other waiting nervously and then delivering a classical vocal performance. What links the two situations and isn't first evident is that both children are the subject of a test in which their performance is measured and quantified. The children's play is used for delivering a product.

42 See the artist's statement in this publication.

43 Immanuel Kant, *Über Pädagogik*. Königsberg: D. Friedrich Theodor Rink, (1803), 27. http://www.deutschestextarchiv. de/book/view/kant_paedagogik_1803?p=27.

Immanuel Kant, *Kant on Education*, trans. Annette Churton (Boston: D.C. Heath and Co., 1900), Chapter I: Introduction, paragraph 29, http://oll.libertyfund.org/titles/356>*Ueber Pädagogik*.

For a discussion of Kant's educational paradox, see, for instance, Birgit Schaffar, "Changing the Definition of Education. On Kant's Educational Paradox Between Freedom and Restraint," *Studies in Philosophy and Education* 33, no. 1 (2014), 5–21.

https://link.springer.com/article/10.1007%2Fs11217-013-9357-4.

44 See the artist's statement in this publication.

The two situations shown in the video are representative of a general trend we find on all levels of education from preschool to higher education. Driven by new technologies, financial incentives and competition, this trend has been growing and even reaching back to early childhood in recent years, raising questions about its value and sustainability. One can argue that this is partly the result of parents' tendencies to project their adult desires into their children's world and thus rob their kids of childhood. In the context of biological evolution, this trend is running counter to what has been *Homo sapiens's* evolutionary edge—a long childhood.

In the video *For a Better World*, the viewer visits a special children's playground run by corporate chains. It's conceived as a theme park representing a miniature city in which children play adult roles as customers and employees. One cannot find a better way to illustrate Ferrer's claim that education in which "the children must learn to obey, to believe and to think according to the prevailing social dogmas"[45] serves the authority to reproduce the system.

In her statement accompanying the video, the artist asks: "Who are the entities responsible for the design of play, and what are the motivations behind these decisions?"[46] Ferrer ponders the same question regarding the whole education system and gives a plausible answer: "I do not imagine that these systems have been put together with the deliberate aim of securing the desired results. That would be a work of genius. But things have happened just as if the actual scheme of education corresponded to some vast and deliberate conception: It could not have been done better. To attain it teachers have inspired themselves solely with the principles of discipline and authority, which always appeal to social organizers."[47]

The video *To the Playground* features a team-building expert coaching a group of adults in a play session designed to strengthen their team spirit and productivity. Adults here appropriate a children's playground and form of play, while in *For a Better World* children play adults. Both videos thus complement each other in showing the same effort to turn play and playgrounds into tools of production.

To have a voice

There is an intrinsic link between the modern education system and the nation-state.[48] The collective history and development show how much these two systems have been dependent upon each other. The roots of modern education are connected to the rise of nation-states going back to the 17th century. Comenius, who has been recognized as a founding father of the new science of pedagogy, was advising heads of states on reforming education. In his foundational text, *Didactica magna*, Comenius already outlined the education system divided into four levels according to four developmental stages: infancy,

45 Ferrer, 49.
46 See the artist's statement in this publication.
47 Ferrer, 49.
48 See Ernest Gellner, *Nations and Nationalism* (Ithaca: Cornell University Press, 1983).

27

childhood, adolescence and youth, corresponding to the current preschool, primary, secondary and tertiary education.[49]

Similar to the history of nation-states, the development of modern education has been a complicated and contentious affair full of conflicts and contradictions. The Catholic Church was reluctant to give up its centuries-long control of education, especially in Catholic countries. It's no coincidence that the two most influential thinkers on education in the 17th century, Comenius and John Locke, were Protestants.

Both philosophers, each in his own way, inspired the democratization of education driven by the rise of the merchant class. Though writing for his aristocratic class, Locke's ideas of the human mind as a *tabula rasa* at birth, i.e. a blank and receptive mind, and of the acquisition of knowledge through experience as well as the corresponding belief that people, "nine parts of ten are what they are, good or evil, useful or not, by their education,"[50] implied the idea of educational equality. Comenius was much more explicit in this regard by demanding universal education based on equal access regardless of social class or gender: "not the children of the rich or of the powerful only, but all alike, boys and girls, both noble and ignoble, rich and poor, in all cities and towns, villages and hamlets, should be sent to school."[51]

In the current times of rising inequality, this demand has a special urgency. Since the 17th century there was a slowly growing access to education, starting with primary education in the 18th and 19th centuries, followed by secondary education in the 20th century. The Prussian state was leading the way thanks to Frederick William I's edicts of 1717 and 1736, which paved the path to the creation of state-funded schools and compulsory attendance. Frederick the Great of Prussia further advanced this development by a decree in 1763, which laid down the Prussian education system emulated by other countries. Empress Maria Teresa of the Austro-Hungarian Empire was the first to follow suit by introducing compulsory education in 1774.

The 20th century brought technological and social changes, including assembly-line production, the rise of the automotive industry, consumer society and mass media. The U.S. was the leader of these developments together with advances in education manifested in the spread of free secondary schooling called the high school movement (1910–1940). In three decades the number of people enrolled in academic high schools in the U.S. grew from 19% in 1910 to 73% in 1940, which was a much higher rate than in Europe, where only 10–20% graduated from academic high schools by 1955.[52] There is a correlation between the population's education and its economic wealth. For instance, scholars argued that the high school movement contributed to U.S. prosperity after World War II.[53]

49 *The Great Didactic of John Amos Comenius*, Part II: Text, trans. M. W. Keatinge (New York: Russell & Russell, 1923), 255–58.
50 John Locke, *Some Thoughts Concerning Education and of the Conduct of the Understanding*, Ruth W. Grant and Nathan Tarcov, eds. (Indianapolis: Hackett Publishing Co., 1996), 10.
51 *The Great Didactic of John Amos Comenius*, Part II: Text, trans. M. W. Keatinge (New York: Russell & Russell, 1923), 66.
52 See Claudia Goldin, *The Race between Education and Technology* (Cambridge, MA: Harvard University, 2008), 195.
53 Claudia Goldin and Lawrence F. Katz, "Human Capital and Social Capital: The Rise of Secondary Schooling in America, 1910 to 1940," *Journal of Interdisciplinary History* 29 (Spring 1999), 683–723. http://www.nber.org/papers/w6439.

Title page (detail) of Comenius *Opera didactica omnia*, Amsterdam 1657. Designed by Crispijn de Passe, engraved by David Loggan

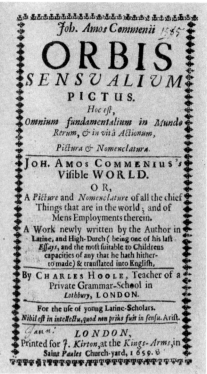

Title page of Comenius, *Orbis sensualium pictus*, London: Kirton, 1659

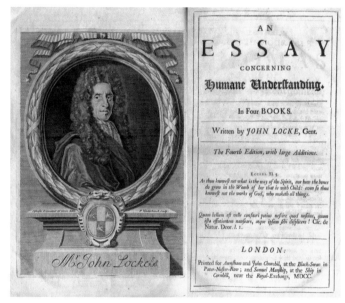

Title page and frontispiece of John Locke, *An Essay Concerning Human Understanding*, London: A. and J. Churchill and Samuel Mansbip, 1700

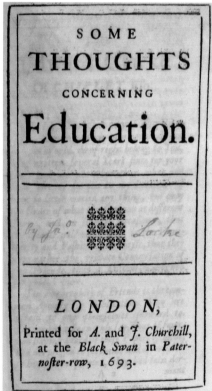

Title page of John Locke, *Some Thoughts Concerning Education*, London: A. and J. Churchill, 1693

The initial success of the high school movement contrasts with the decline of the American high school in the last 40 years. Thus, it is not surprising that there have recently been voices calling to look up to the high school movement as an inspiration. To duplicate it, however, would be difficult. America is now a different country, more polarized compared to the period called the progressive era a century ago. The high school movement was a primarily grassroots effort, creating public schools in small towns across America. While states helped to coordinate the spread of public secondary schooling then, today an influential part of the conservative political class promotes the privatization of education at the expense of public schools. Historically speaking, it was the position that "government is not the solution to our problem; government is the problem"[54] and the consequent disinvestment of the public sector that accelerated the public education decline in the U.S. since the early 1980s.

Low budgets for public schools have resulted in buildings in disrepair, overcrowding and a low morale manifested in teachers' discontent, high dropout rates and violence. Privatization further exacerbates the existing inequalities of the education system. With regards to educational inequality, some regions and cities in the U.S. resemble Latin American countries.

Chile is the case in point. This country promotes education for-profit based on vouchers while spending on education by 37% less than it's recommended by OECD for developed countries. The result is educational segregation allowing rich students to get an excellent education while about one million students are burdened with student loan debts and many languish in the underfunded schools. This situation led to a massive demonstration in 2006 called the Penguin Revolution. It consisted of an occupation of public schools by students that lasted about three months. Five years later demonstrations by university and high school students followed, known as the Chilean student protests and described by local media as the Chilean Education Conflict. The negotiations between the students' representative and the government didn't resolve the conflict. Students renewed their demonstrations in 2016 and 2017, demanding education reform.[55]

There have also been student demonstrations in Brazil. Inspired by the example of the Penguin Revolution, elementary, middle and high school students in São Paolo in 2015 occupied more than 200 state schools in protest against the state government's decision to close almost 100 public schools.[56] In her video *Escolas (Schools)*, Graziela Kunsch used photographs taken in occupied schools, some of them found on the Facebook pages of the

54 The phrase is from Ronald Reagan's inaugural address on Jan 21, 1981. http://www.presidency.ucsb.edu/ws/?pid=43130.

55 See, for instance, "The Fraught Politics of the Classroom," *The Economist*, Oct 29, 2011. http://www.economist.com/node/21534785; Max Radwin, "Students in Chile Are Demanding Free Tuition, and Protests Are Turning Violent," *Vice News*, June 2, 2016, https://news.vice.com/article/students-in-chile-are-demanding-free-tuition-and-protests-are-turning-violent.

56 Pablo Ortellado, "Brazil's Students Occupy Their Schools to Save Them," *The New York Times*, December 15, 2015, https://www.nytimes.com/2015/12/16/opinion/brazils-students-occupy-their-schools-to-save-them.html. Richard Romancini and Fernanda Castilho, "How to Occupy a School? I Search the Internet!: Participatory Politics in Public School Occupations in Brazil," *Intercom—RBCC São Paulo* 40, n. 2 (maio/ago. 2017), 93–109. http://www.scielo.br/pdf/interc/v40n2/en_1809-5844-interc-40-2-0093.pdf.

collective O Mal Educado. Photographs show not only school buildings in disrepair but also the way students reorganized classrooms into more democratic spaces. They feature students in charge of their schools engaged in various activities such as cooking, cleaning and fixing classrooms and other amenities, i.e. as active stakeholders, not passive subjects of a system founded on rewards and punishments. In a symbolic way, Kunsch is thus showing the students' occupation of schools not just as an act of protest but as one of taking ownership of their education.

Students want to have their voices heard and the education system most frequently doesn't provide any opportunity for that. Artists can create opportunities for children and teenagers to express their views, feelings and thoughts. American artist Pam Kuntz created *Airing... voices of our youth*, a dance/theater performance that "explored the pressures young people face in the formative years of middle and high school."[57] She worked with over 20 teenagers who shared their stories in collaboration with staff from the Bellingham and Mount Baker School Districts, The Whatcom Family and Community Network, and faculty at Western Washington University's Psychology Department. Performances took place at both performing art centers and Whatcom County middle and high schools, reflecting the artist's intention: "young people expressing *their* thoughts and *their* feelings in *their* words."[58]

Anxiety, peer pressure, bullying, suicide, depression, body image, sexual identity and relationships were the most frequent issues voiced by Whatcom County teenagers. They are typical for most American middle and high schools and for environments that prioritize discipline based on rewards and punishments, competition, hierarchy and authority. These are places with more frequent discrimination, physical and mental abuse, and with a deficit of compassion and collaboration. At the dawn of modern education, both Comenius and Locke criticized two characteristics that continue to reinforce and reproduce each other: the lack of respect for children as reasoning individuals and a disciplinary system based on rewards and punishments. In Locke's view "such a sort of *slavish discipline* makes a *slavish temper*."[59]

Discussions about discipline and the need for respect and freedom have run through the history of modern education and through generations. What makes today's debate different is the unprecedented speed of technological, economic, social, political and cultural changes. This demands new cognitive capacities and competences, which cannot be developed in a disciplinary system that prioritizes social reproduction of the status quo. We should remember the education paradox mentioned at the very beginning of this essay and listen more to voices of young people who will be living in the future world.

This might have been on Eva Bakkeslett's mind when she created the project *Voicing Your Future*. She developed a simple application that people can use to "reflect upon education, share their own experiences and voice their personal opinions about how

57 See the artist's statement in this publication.

58 Ibid.

59 John Locke, *Some Thoughts Concerning Education* (London: A. and J. Churchill at the Black Swan in Paternoster-row, 1693), 49, https://books.google.bg/books?id=OCUCAAAAQAAJ&hl=bg&pg=PP7#v=onepage&q&f=false.

31

schools and their curriculum content should change."[60] The project has its own website accessible to the public. Like Pam Kuntz's *Airings...*, it has been presented at both art venues and schools in the "hope that this collection of thoughts and ideas will inspire others to question, reflect and generate a gradual or radical change in our educational system."[61]

Democratize education!

The speed of technological changes has resulted in a growing demand for special competencies, which graduates of colleges and universities are often lacking. This gap has led many companies to develop internal training programs and some of them have created their own schools. The Apple University is perhaps the best known example.[62] A new field called learning design driven by new needs is related to these corporate educational programs and schools. There is almost an exponential growth of new learning terms and concepts that reflect these trends.[63]

Educational technologies provide opportunities to redesign education as we know it. But they also lead to further specialization and fragmentation of education, raising questions about its sustainability. They amplify the dichotomies of knowledge and thinking, learning content and learning to learn, rationality of means and rationality of values, which have run through the history of modern education. This explains the fragmented nature of the current educational discourse as well as contentious debates about educational reforms and programs in higher education such as STEM and STEAM. While the education system is now more than ever governed by instrumental rationality, there are a growing number of people with ideas to revive the issue of values.

Teddy Cruz and Fonna Forman (Estudio Teddy Cruz + Fonna Forman) who are working at the University of Southern California in San Diego belong to this category. Cruz is an architect and urban planner known for his innovative work in housing and urbanism who draws inspiration from slums in Latin America and addresses the divide between the global

60 See the artist's statement in this publication.

61 Ibid.

62 Sam Colt, "Here's what it's like to attend Apple's secret university," *Business Insider*, February 5, 2015. http://www.businessinsider.com/heres-what-its-like-to-attend-apples-secret-university-2015-.

63 Here are some learning terms associated just with e-learning: asynchronous learning, authoring tool, blended learning, cloud, cloud LMS (SAAS, on-demand LMS), content management system, competency-based learning, corporate training, e-learning (distance learning, online learning, computer-based learning, web-based learning), flipped learning, e-learning content chunking, e-learning personalization, game-based learning, gamification, ML5 (hypertext markup language), informal learning, installed LMS (on-premise LMS, deployed LMS, in-house LMS), instructional design, LCMS (learning content management system), learning path, learning snacks, LMS (learning management system), LTI (learning tools interoperability), micro-learning, m-learning, MOOC (massive open online courses), "One size fits all" e-learning model, problem-based storytelling, rapid learning, responsive design LMS, ROI (return on investments), scalable LMS, scenario-based learning, SCORM (sharable content object reference model), self-paced learning, social learning, student-centered approach to e-learning, synchronous learning, tin can (also called experience API or xAPI), virtual classroom, whiteboard. See, for instance, https://www.joomlalms.com/ knowledge-base/elearning-terms-glossary.html.

south and the global north. Fonna Forman is a political theorist and the founding Director of the UCSD Center on Global Justice. They have recently worked together on several projects, including *The Cross-Border Community Stations*, presented in this publication.[64] The project addresses several key issues—global and climate justice, social and economic inequality symbolized by the border between the global south and the global north, crises of knowledge and education—and proposes to deal with them by defining specific principles, strategies and tools for tertiary education.

In their research work, Cruz and Forman have focused on "successful models of participatory urban transformation across the world"[65] and learned important lessons in Bogotá and especially in another Colombian city, Medellín. This city has undergone an unbelievable transformation from the most dangerous place in the world into a center of urban experimentation and innovations admired and studied by architects, urban planners, scholars and city government representatives from all over the world. Cruz and Forman focused on the question usually overlooked by other urban planners and scholars—notably what were the social and political preconditions for such a miraculous turnaround.

They have found that its prerequisite was the process of "democratizing knowledge in cities, activating a more participatory citizenship culture and ultimately producing dramatic improvements in quality of life for the most marginalized populations" and that "partnerships between research universities, progressive municipalities, and community-based non-profits were essential."[66] In a project titled *The Medellín Diagram*, they created a visualization of the political and civic processes that made Medellin's urban transformation possible.

The research in Bogotá and Medellín has informed Cruz's and Forman's project of *The Cross-Border Community Stations* in the San Diego–Tijuana area. Arguing that public space is a pedagogical space, they founded "a network of field-based research and teaching hubs located in diverse immigrant neighborhoods across the border region, where experiential learning, research and teaching is conducted *collaboratively* with communities, advancing a new model of community-university partnership."[67] Cruz and Forman promote reciprocal knowledge production, "linking the specialized knowledge of UC San Diego with the community-based knowledge embedded in immigrant communities on both sides of the border."[68]

By making the value-oriented concepts of justice, reciprocity, compassion and cooperation central to their research and practice, Cruz and Forman are transforming the ethos of the tertiary education system governed by instrumental reason. Recent research into the biological underpinnings of empathy and moral concepts, such as equity and fairness, seems to justify the two educators' efforts. It has shown that moral feelings are to some extent hardwired and that cognition is value sensitive.

64 See the artists' statement in this publication,
65 Ibid.
66 Ibid.
67 Ibid.
68 Ibid.

Fragmented institutions fragment the city

Summon institutions to collaborate

Integrate their knowledges and resources

Redistribute to sites of poverty

Centralize and decentralize knowledges and resources simultaneously

Estudio Teddy Cruz + Fonna Forman in collaboration with Studio Matthias Görlich, *The Medellin Diagram*, 2013–2017, video, courtesy of the artists

34

For instance, recent experiments proved that some animals, such as chimpanzees and capuchin monkeys, show a sense of fairness and equity. In the famous cucumber grapes experiment, two capuchin monkeys are fed a cucumber each time they perform a task. After one of them is treated to a higher quality food—raisins—the other monkey doesn't accept a cucumber and stops performing.[69] The fact that the monkeys' perception of inequity interferes with their cognitive performance indicates a fundamental significance of moral feelings for learning.

Experiments with two-year-old infants provide evidence that children are naturally cooperative, i.e. their almost reflexive desire to help is not a learned behavior.[70] The discovery of the so-called mirror neurons as a neural basis of empathy and learning by imitation implies that empathy is a key component of education.[71] All these findings suggest that the education system dominated by instrumental reason might be limiting our cognitive potential.

Conclusion

The history of modern education since the dawn of nation-states in the 17th century reflects changing needs of the state and its political subjects. Consequently, one can describe it as a development driven by instrumental rationality and/or a gradual democratization. Its early stage responded to the need of emerging nation-states to establish a system that would educate, i.e. construct and foster their political subjects.[72] It also answered to the demands of the rising merchant class for a more empirical education compatible with the ascent of natural sciences, an effort manifested in the contributions of the two foundational figures of modern education, Comenius and Locke.

The second phase in the development of modern education responded to the Industrial Revolution. The need for basic literacy resulted in the invention of the monitorial system of schooling, the rise of kindergarten and the common school movement associated with the demand for state-funded schools and compulsory attendance through the 19th century.[73] The development of industrial society defined by rapid urbanization and mechanization,

69 Frans de Waal et al., *Primates and Philosophers. How Morality Evolved* (Princeton, N. J.: Princeton University Press, 2006).

70 Michael Tomasello, *Why We Cooperate* (Cambridge, Mass.: Boston Review and The MIT Press), 2009.

71 Giacomo Rizzolatti and Laila Craighero, «The mirror-neuron system,» *Annual Review of Neuroscience* 27 (2004): 169–192.
Lindsay L. Oberman and Vilayanur S. Ramachandran, "Reflections on the Mirror Neuron System: Their Evolutionary Functions Beyond Motor Representation," in Jaime A. Pineda, ed., *Mirror Neuron Systems: The Role of Mirroring Processes in Social Cognition* (Totowa, N. J.: Humana Press, 2009), 39–62.

72 (Gellner 1983).

73 Max Roser and Esteban Ortiz-Ospina, "Educational Mobility & Inequality," published online at *OurWorldInData.org*. (2017), https://ourworldindata.org/educational-mobility-inequality/.
For a discussion of monitorial schools, see John Churchill Rudd, *Monitorial Schools: The Origin, Progress and Advantages of the Monitorial System of Tuition...* (Elizabethtown, N. J.: Public School Association, 1826); Ronald Rayman, "Joseph Lancaster's Monitorial System of Instruction and American Indian Education, 1815–1838," *History of Education Quarterly* 21, no. 4 (Winter 1981), 395–409.

including agriculture, brought out the high school movement in the U.S. and the advent of consumer society in the first half of the 20th century. The postwar growth of consumer society introduced a democratization of higher education, starting with The Servicemen's Readjustment Act of 1944, also known as the G. I. Bill, and continuing with the baby boom generation. We are now entering a new period dominated by information society, i.e. robotization, digitization and artificial intelligence, which is again redefining the ends and means of education.

As the main driver of this civilizational change, digitization is advancing contradictory trends and impulses: surveillance versus privacy, control versus openness, proprietorship versus sharing, competition versus collaboration. There is a concentration of power on the one hand and economic and political decentralization on the other. Such contradictions relate directly to the underpinnings of democracy and demand our attention and civic engagement in which education plays a key role.[74]

In education, digitization also heightens traditional dichotomies between content and form, ends and means, and on a more general level, between value-oriented rationality and instrumental rationality. Of course, this has been the case of modernization, i.e. technology and its impact, for a long time.[75] In the early period, however, education was grounded in a traditional belief system provided by religion. With the development of science and technology and increasing specialization, this dichotomy has been growing. Kant's distinction between *Vernunft* and *Verstand* already indicates a differentiation between value-oriented and instrumental rationality.[76]

This process of differentiation was also recognized by other German philosophers who articulated a specific concept of education called *Bildung*. Though it appeared in writings by Herder, Hegel and Schiller, among other authors, it is most frequently associated with Wilhelm von Humboldt as he was in charge of reforming Prussian higher education. The purpose of Bildung is human development as self-fulfilling humanity, a process in which one achieves more freedom thanks to higher self-reflection.[77]

However, the needs of industry and the nation building, which accelerated after the unification of Germany, made the Prussian education system synonymous with discipline and rote learning rather than self-fulfilling humanity. The late 19th and early 20th centuries brought a pushback against instrumental rationality by the *Lebensreform* movement in Central Europe and Scandinavian countries.[78] This social movement reacted against the effects of the Industrial Revolution such as materialism, mechanization, fragmentation and alienation by promoting a different lifestyle and alternative education such as Rudolf Steiner's Waldorf schools or the Montessori schools of Maria Montessori. In the U.S., this

74 See, for example, Henry Giroux, "Toward A Pedagogy of Educated Hope in Dark Times" in this publication.

75 Max Weber, *Economy and Society*, vol. 1 (Berkeley, CA: University of California Press, 1978): 24–5.

76 For a discussion of Kant's concepts *Vernunft* and *Verstand* in this context, see Wolfgang Klafki, "The Significance of Classical Theories of Bildung for a Contemporary Concept of Allgemeinbildung," in Ian Westbury, Stefan Hopmann & Kurt Riquarts, eds., *Teaching as a Reflective Practice: The German Didaktik Tradition* (Mahwah, N. J.: L. Erlbaum Associates, 2000), 97–98.

77 For a discussion of Bildung, see, for instance, Klafki 2000, 85–108.

78 See Gerd-Bodo von Carlsburg and Irena Musteikiene, eds., *Lebensreform Educational Systems Development as Development of Human Being Bildungsreform ALS Lebensreform* (Frankfurt am Main: Peter Lang Publishing, 2005).

was the progressive era of social reform and the rise of progressive education that addressed similar issues.[79]

In order to counter the rote learning and stern discipline informed by the Prussian education system, reform movements sought to advance a more holistic education, for instance by emphasizing aesthetic education.[80] Though progressive education was more successful in impacting the education system than alternative schools, its influence has been limited. Today's growing discontent with education aims at its means and ends, both its instruments and values. However, instruments and values imply different temporalities. While the evolution of instruments is constantly accelerating, values are changing very slowly. This clash of temporalities creates tensions and conflicts, and produces a fragmented discourse.

Back to the Sandbox seeks to respond to this situation by inviting artists, scientists, educators, activists and local citizens to reach out across multiple fields. It employs various formats for this purpose, including exhibitions, publications and public events such as performances, workshops, discussions and conferences. One of them is a survey that has solicited answers to the question "What education do we need?" from artists, educators, scholars and activists all over the world. The first 20 responses, which are included in this publication, provide an illuminating cross-section of issues, approaches, ideas and views.

They focus primarily either on the means or on the ends of education. The majority have chosen the ends over the means, which suggests that the acceleration of means makes us think about the values that our education system fosters. The fact that in one generation many professions will disappear and unanticipated new professions will emerge should engage everybody in thinking about what education is for and what values it should advance. To provide a preliminary summary of concerns about the present state of education and offer some directions for such engagement, the conclusion presents a list of issues and ideas for action that resulted from this project. Together with other initiatives, these deliberations can be seen as a process of collective drafting of a future Education Bill of Rights.

1 Democracy and education

The present status: Democracy is on the retreat. Is democracy sustainable where discipline and control in education and parenting takes over caring and compassion?

The action we need: promote the values of caring and respect, and democratize the authoritarian nature of the education system on all levels.[81]

[79] Patricia A. Graham, *Progressive Education from Arcady to Academe: A History of the Progressive Education Association, 1919–1955* (New York: Teachers College Press, 1967).
William J. Reese, "The origins of progressive education," *History of Education Quarterly* 41, no. 1 (2001), 1–24.
Chara H. Bohan, "Early Vanguards of Progressive Education: The Committee of Ten, the Committee of Seven, and Social Education," *Journal of Curriculum & Supervision* 19, no. 1 (2003), 73.

[80] Tracie Costantino and Boyd White, eds., *Aesthetic Education. Essays on Aesthetic Education* for the 21st Century (Boston: Sense Publishers, 2010).

[81] This and the following eleven paragraphs quote my text from the video *Towards an Education Bill of Rights*, https://vimeo.com/267641432. For a discussion of the need to democratize the education system, see Yaacov Hecht, *Democratic Education: A Beginning of a Story* (S. I.: Innovation Culture, 2010); George Lakoff, *Moral Politics: How Liberals and Conservatives Think* (Chicago: University of Chicago Press, 2016).

37

2 Equal access to education

The present status: Education is increasingly commodified and the disparity in access to education between the north and the south, rich and poor regions and neighborhoods is growing despite the rhetoric and programs of inclusive education. Most countries are failing educational targets set by the United Nations as shown by the current lack of 69 million teachers to reach the UN sustainable development goal of universal education by 2030.

The action we need: to fight ubiquitous inequality in education and spread the message that exclusion in education impoverishes the human mind and diminishes humanity. To quote the father of modern education, Comenius, who pressed this point almost 400 years ago: "The children of the rich and the nobles, or those of holding public office, are not only to be born to such positions, and should not be able only to have access to schools, others being excluded as if they were nothing to be hoped from them. The spirit bloweth where and when it will."[82]

3 From fragmented to integrative knowledge

The present status: Learning and education are segmented into separate silos of many specialized fields, starting with the divide between the two cultures, natural sciences and the humanities. Adding social sciences, people now speak about the three cultures, splintered further into many expert cultures that are unable to deal with complex problems of the interconnected world.

The action we need: to support transdisciplinarity as well as multi- and cross-disciplinarity.[83] To recover traditions of holistic and integrative education, following the maxim expressed by Comenius: "...no one should be instructed in such a way as to become proficient in any one branch of knowledge without thoroughly understanding its relation to the rest."[84]

4 Collaboration and sharing over competition

The present status: The world is interconnected more than ever while we let competition rule over collaboration or rule it out.

The action we need: To be able to address today's major challenges, we have to collaborate much more than we are used to. Collaborative models and practices cultivate social intelligence and advance sharing over competition.[85]

5 The need for a problem-solving and experience-based education

The present status: Most knowledge acquisition takes place outside of school in nonformal education. Colleges and universities don't provide relevant education for the

82 Quoted by J. Piobetta in the Introduction to *La Grande Didactique* (Paris, Presses Universitaires de France, 1952), 26.

83 Paul Gibbs, *Transdisciplinary Higher Education: A Theoretical Basis Revealed in Practice* (Cham: Springer International Publishing, 2017).

84 *The Great Didactic of John Amos Comenius*, trans. M. W. Keatinge (London: Adam and Charles Black, 1896), 274.

85 See, for instance, Daniel Goleman, *Social Intelligence: The New Science of Human Relations* (New York, N.Y.: Bantam Books, 2007).

present and the future. According to a recent PricewaterhouseCoopers report, 38% of U.S. jobs will be replaced by robots by 2030.[86]

The action we need: to relate education on all levels to today's critical challenges, including climate change, sustainability, globalization, inequality, migration, social fragmentation and polarization.

6 Schola ludus: play, imagine and create

The present status: A large percentage of children don't enjoy going to school and the majority of people don't like what they do for living. Both phenomena have a negative impact on knowledge acquisition as well as on physical, mental and social wellbeing. While play, imagination and creativity fostered by the arts do the opposite, many countries and cities are now cutting school art programs instead of expanding them.

The action we need: to support and develop places for play, imagination and creation by harnessing the unique cognitive capacity of art.[87]

7 Learning to learn

The present status: Though children are born with a great capacity and desire to learn, most schools are using rewards and punishments for academic achievements. In other words, by using external motivation, schools undermine intrinsic motivation and destroy the desire to learn. Consequently, the current overemphasis on testing and quantification of academic achievement do more harm than good.

The action we need: Effective educators guide intrinsic motivation and thus help students to gain the power of competence, choice, connection and joy. The education system should replace the stimulus-response model of rewards and punishments grounded in 19th century psychology with the creation of environments in which intrinsic motivation thrives.[88]

8 Empathy, compassion and emotional intelligence

The present status: Schools and stern parents don't teach compassion. The lack of empathy and compassion may contribute to creating environments in which discrimination as well as physical and mental abuse increase.

The action we need: Caring parents and educators teach compassion by example and thus provide an antidote to the spread of physical and mental abuse such as bullying.

86 Richard Berriman and John Hawksworth, "Will robots steal our jobs? The potential impact of automation on the UK and other major economies," https://www.pwc.co.uk/economic-services/ukeo/pwcukeo-section-4-automation-march-2017-v2.pdf.

87 For a discussion of the cognitive nature of art and creativity, see essays by Luis Camnitzer and Liane Gabora in this publication. For additional reading, see, for instance, Mark Turner, ed., *The Artful Mind: Cognitive Science and the Riddle of Human Creativity* (Oxford: Oxford University Press, 2011); Shifra Schonmann, ed. *International Yearbook for Research in Arts Education: The Wisdom of the Many—Key Issues in Arts Education* (Münster – New York: Waxmann, 2015).

88 Edward L. Deci and Richard M. Ryan, *Intrinsic Motivation and Self-Determination in Human Behavior* (New York: Springer, 2014).

Empathy and compassion contribute to the creation of an environment beneficial for learning and overall physical and mental wellbeing.[89]

9 The need for transcultural competence in global society

The present status: The education system is still grounded in the monoculture of the past and ignores the transcultural dimension of today's reality. Mental maps thus lag behind global changes. We are witnessing strong anti-globalization sentiments as well as ethnic prejudice and hatred, often encouraged by political entrepreneurs and demagogues.

The action we need: Transcultural exchanges and collaborations or other ways to foster diversity in education, benefit cognitive development, and help to appreciate our own culture and understand today's world.[90]

10 Beyond the culture-nature divide

The present status: Our world view, exemplified by the division of nature and culture, is enabling the human destruction of biosphere that is manifested in climate change and the ongoing mass extinction of species. By separating the human actor from nature, this conceptual underpinning is present even in the environmental slogan "Save the Planet!"

The action we need: Environmental sustainability entails questioning and reimagining some of the most basic cultural codes and concepts we take for granted. We have to expand environmental education based on experience and problem-solving, while learning from other cultures that have been more successful in leading a sustainable way of life.[91]

11 The digital humanities and multiple intelligence against singularity

The present status: Digitization has amplified the gap between natural sciences and the humanities, resulting in the diminished status *of* and the lack of funding *for* the humanities. Algorithms are increasingly governing our life. More precisely, those who are in control of algorithms are ruling the world.

The action we need: Algorithms are powerful tools that can be both beneficial and harmful: As fire or science, they are a good servant but a bad master. Hence, we need more transparency and understanding of their intended and unintended consequences. The role of digital humanities might be critical in this regard.[92]

89 Mathew A. White and Gavin R. Slemp, *Future Directions in Well-Being: Education, Organizations and Policy* (Cham, Switzerland: Springer International Publishing AG, 2017);
Kimberly A. Schonert-Reichl and Robert W. Roeser, *Handbook of Mindfulness in Education: Integrating Theory and Research into…* (New York: Springer, 2016).

90 Emmanuel Jean Francois, ed., *Transcultural Blended Learning and Teaching in Postsecondary Education* (Hershey PA: Information Science Reference, 2013).

91 See, for example, Jane Roland Martin, *Education Reconfigured: Culture, Encounter, and Change* (New York: Routledge, 2011).

92 See, for instance, James Smithies, *The Digital Humanities and the Digital Modern* (London: Palgrave UK, 2017).

12 The instrumentalization of education is counterproductive

The present status: The current trends to commodify and privatize education amount to its massive instrumentalization, which diminishes its meaning by prioritizing extrinsic over intrinsic motivation.

The action we need: The significance of education is deeper and more fundamental than any particular agenda. We should constantly remind politicians and ourselves that education impacts everything else and makes us who we are as individuals, as a community and as humans. To quote Comenius again: "The school is the manufactory of humanity... an *emendatio rerum humanarum* (reeducation of society)" and "...the whole is not the whole if any part is lacking... whoever (sic) then does not wish to appear a half-wit or evil-minded, must wish good to all men, and not only to himself, or only to his own near ones, or only to his own nation."[93]

* **Jaroslav Anděl** is an artist, curator, consultant and educator. He has authored or coauthored more than 40 books and exhibition catalogs published in several languages and organized many exhibitions of modern and contemporary art in Europe, the U.S., and Japan. His recent exhibitions *The Art of Urban Interference*; *Modes of Democracy*; *Disabled by Normality*; *Cartographies of Hope: Change Narratives*; *The Lucifer Effect* have focused on the current crisis of liberal democracy. He has been a consultant to the Council of Europe on its exhibition program and its Platform Exchange *Smart Creativity, Smart Democracy*. He is a commissioning editor of the global online platform Artseverywhere.ca. He has been teaching at the Anglo-American University in Prague and initiating discussions on education worldwide, most recently at the UNESCO New York Office.

93 Johann Amos Comenius, *Pampaedia, or, Universal Education*, trans. A. M. O. Dobbie (Dover, Kent: Buckland Publications, 1986).

THE
SANDBOX

THE SANDBOX:
EACH IN HIS CORNER

Society for a Merrier Present
(Petr Payne, Luboš Rychvalský, Bára Štěpánová)

The Sandbox: Each in His Corner, October 12, 1989
Happening, participants in the photograph: Václav Havel, Jiří Gruntorád, Petr Placák, Stanislav Penc, Luboš Rychvalský, Lukáš Marvan, Hana Marvanová
Photographs: Miloš Fikejz
Video, 4:27
Courtesy of the artists

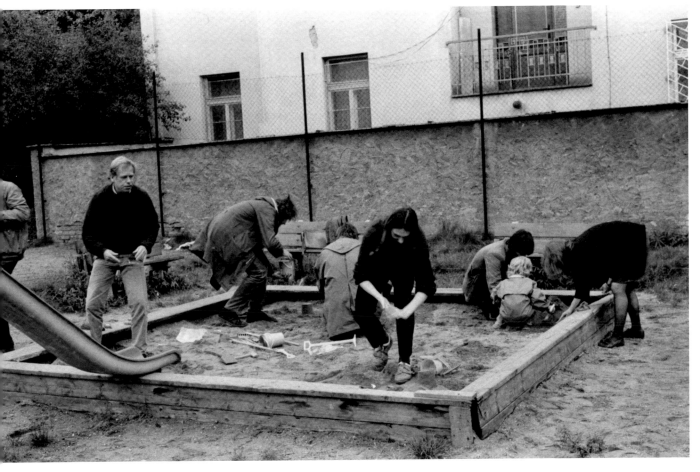

How and when did the Society for a Merrier Present originate? In 1986 I signed Charter 77, joined various demonstrations against the regime and made an acquaintance with Luboš Rychvalský and Petr Payne. We were arrested and taken to court several times. To support ourselves morally and psychologically, we visited each other's court proceedings and subsequently became friends. There were big demonstrations against the regime in 1988—August 21, October 28—and then in January 1989, the so-called Palach's Week. There were already numerous independent initiatives in that time—the Movement for Civil Liberties, the Peace Club of John Lennon, the Czech Children and many others. We were thinking about how to join this movement and what we could possibly do. I lived in the Libeň section of Prague then. We came up with an idea to invite representatives of several initiatives and to give them pails and shovels. This was our plan: Each of them would make a sand cake of his own, and when finished, a truck with the inscription "Society for a Merrier Present" would come and unload a full load of sand on top of their sand cakes. (Bára Štěpánová)

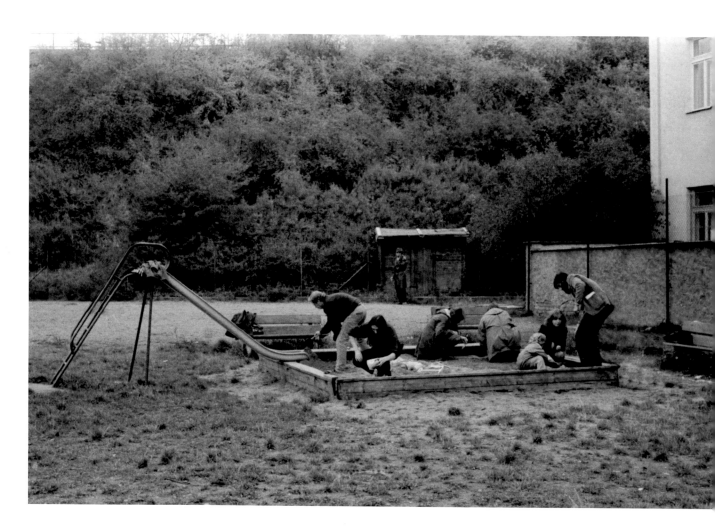

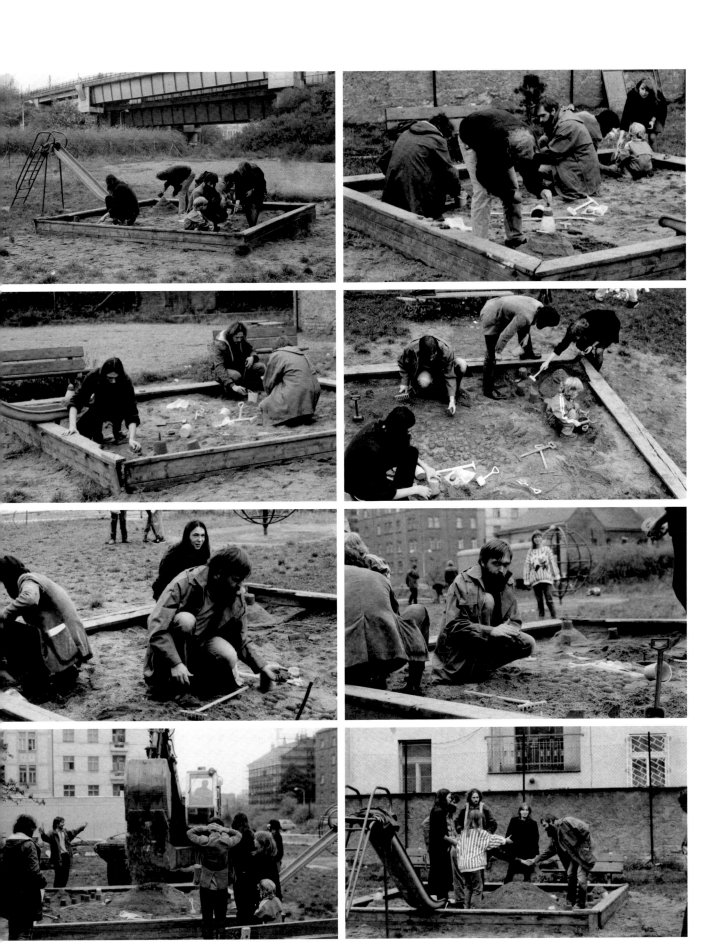

47

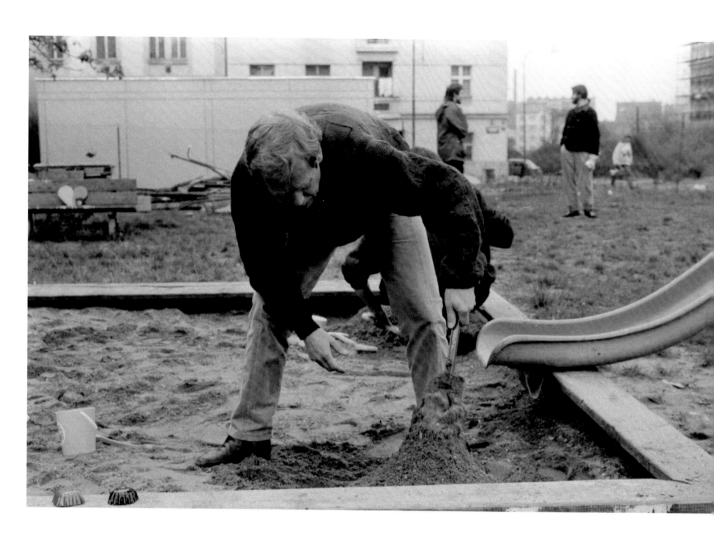

HOW TO BUILD
THE PERFECT SANDCASTLE

Renzo Piano

How to Build the Perfect Sandcastle, 2015
Wall text
Courtesy of the artist

Renzo Piano:

Hvordan bygge det perfekte sandslottet

Karrieren min begynte da jeg som barn bygget mitt første sandslott på stranden i Genoa, hvor jeg vokste opp. Å lage ting har alltid gitt meg stor glede – glade hender, glade tanker – og det å lage sandslott var min måte å trene fantasien på. Nå når jeg som arkitekt konstruerer bygninger som The Shard må jeg hele tiden tenke på det ferdige resultatet, men da jeg laget sandslott som barn trengte jeg ikke det, de var flyktige.

Jeg har fire barn; den eldste er 50 og den yngste 16, så jeg har laget sandslott i ganske lang tid. Det finnes ingen aldersgrense – du kan like å lage sandslott uansett hvor gammel du er, selv om det hjelper å tenke som et barn. Slik gjør du det:

1 Vær klar over det faktum at å bygge et sandslott er en totalt bortkastet handling. Ikke forvent for mye; det kommer til å forsvinne, hovedsakelig fordi det ikke er noe poeng i å lage slottet for langt borte fra havet. Et sandslotts relasjon til vann er viktigere enn hvordan det ser ut. Studer bølgene før du bestemmer deg for hvor du vil plassere slottet – er det for lavt på strandlinjen vil havet ødelegge det umiddelbart, er det for høyt så vil du ikke ha noen bølger å flørte med. Det høres komplisert ut, men det er enkelt og instinktivt.

2 Begynn med å lage en grøft der hvor bølgene har gjort sanden våt. Bruk hendene dine. Bygg opp sanden slik at du lager en masse for slottet, som egentlig er et lite fjell på ideelt 45°. Grøften trenger ikke være mer enn 30cm dyp og 45cm bred, og slottet bør være omtrent 60cm høyt.

3 Lag en inngang i grøften som sjøvannet kan renne gjennom. Det magiske øyeblikket er idet bølgene kommer og grøften blir til en vollgrav. Dersom slottet er godt plassert kan du se vannet renne ut og fylles opp i 10 til 15 minutter. Lukk øynene når vannet kommer inn slik at du lagrer bildet i hukommelsen.

4 Sett deretter et lite flagg eller noe annet du finner på sandslottet, for å gjøre det synlig for folk som løper på stranden. Gå hjem og se deg aldri tilbake.

Som fortalt til Rosanna Greenstreet.

How to Build the Perfect Sandcastle

My career started when I was a child and I built my first sandcastle on the beach in Genoa, where I grew up. Making things has always been a pleasure for me – happy hands, happy mind – and making sandcastles was my training in fantasy. Now, as an architect constructing buildings like the Shard, I have to think about the final result, but as a child making castles of sand I didn't, they were ephemeral. I have four children; the oldest is 50 and the youngest 16, so I have been making sandcastles for a long time. There is no age limit – you can enjoy making a sandcastle however old you are, although it helps to think like a child. Here's how to do it:

1 Be clear about the fact that building a sandcastle is a totally useless operation. Don't expect too much; it's going to disappear, mainly because there's no point making the castle too far away from the sea. A sandcastle's relationship to water is more important than its appearance. Study the waves, then decide where to position your castle – too low on the shoreline and the sea will immediately destroy it, too high and you have no waves to flirt with. It sounds complicated but it's simple and instinctive.

2 Start to dig a ditch where the waves have made the sand wet. Use your hands. Build the sand up to create the mass of the castle, which is really a little mountain with an incline of, ideally, 45°. You don't need the ditch to be more than 30cm deep and 45cm wide, and the castle should be about 60cm tall.

3 Make an entrance in the ditch for the sea to enter. The magic moment is when the waves come and the ditch becomes a moat. If the castle is in a good position, you can watch the water ebbing and flowing for 10 or 15 minutes. To capture the image in your memory quickly, close your eyes when the water comes in.

4 Then put a little flag or anything else you can find on the sandcastle, just to make it visible to people running on the beach. Go home and don't look back.

As told to Rosanna Greenstreet

■ Building sandcastles is a bit of a test. Nature will always be against you and time is always running out. Having to think fast and to bring it all together in the end is what I like about it.

I rarely start with a plan, just a vague notion of trying to do something different each time. Once I begin building and forms take shape, I can start to see where things are going and either follow that road or attempt to contradict it with something unexpected.

In my mind these forms are always mash-ups of influences and ideas. I see a castle, a fishing village, a modernist sculpture, a stage set for the Oscars all at once.

When they are successful they don't feel contained or finished. They become organic machines that might grow and expand. I am always adding just one more bit and if time allowed, I wouldn't stop.

MY SAND CASTLES

Calvin Seibert

My Sand Castles, 1980s-ongoing
Video/Slide show, 4:30
Courtesy of the artist

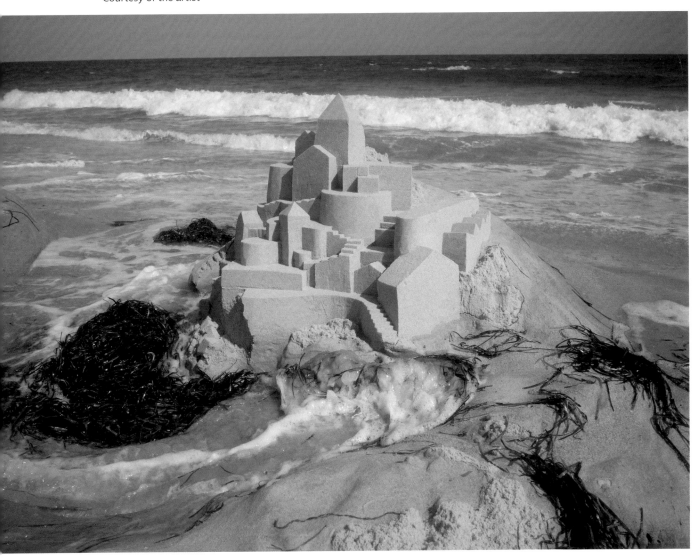

As with most artists, my life's work has been a process begun in play as a small child. There is hardly a line where the early activity can be distinguished from what came later. I have always felt a connection to the kindergarten movement. Its aesthetic of primary color and basic shapes has informed the core of what I do. I always knew what I was about. I still make sandcastles.

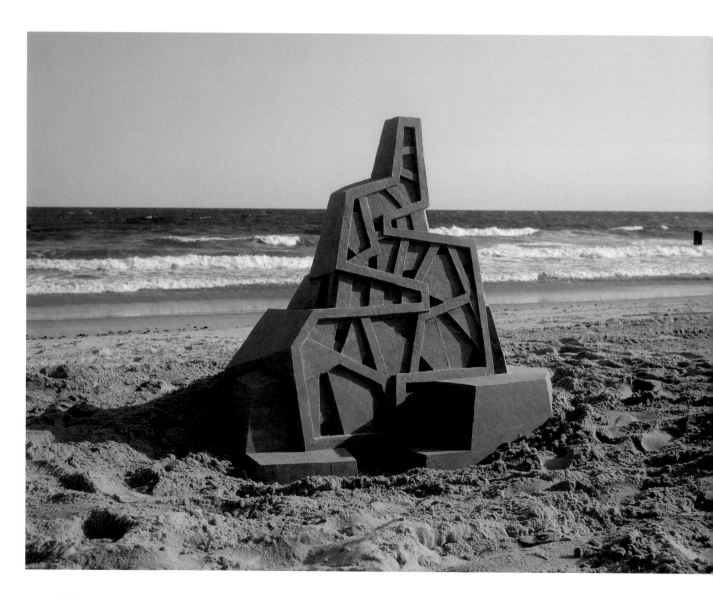

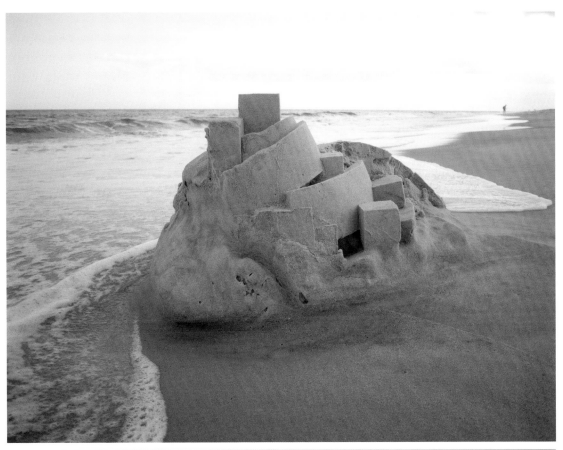

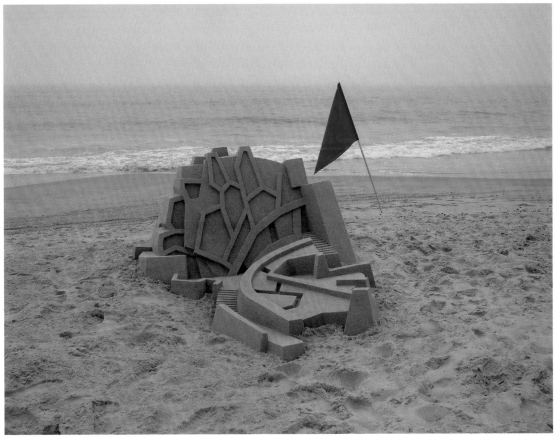

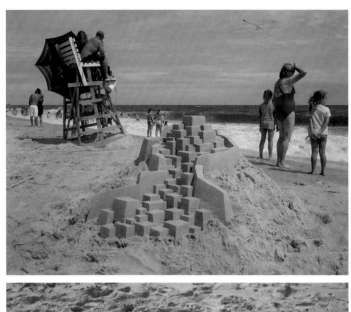
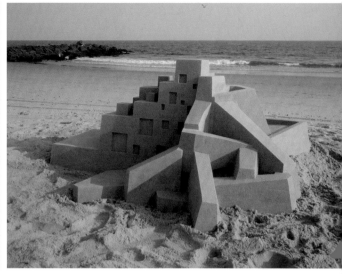
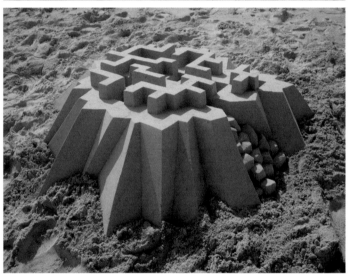
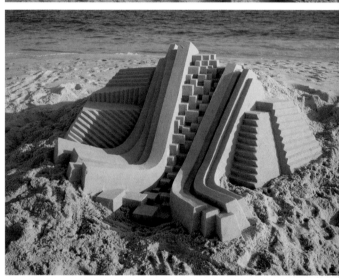
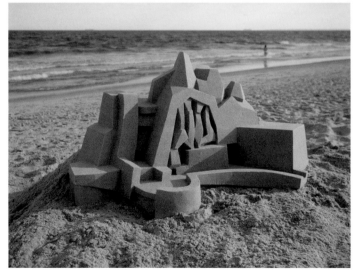
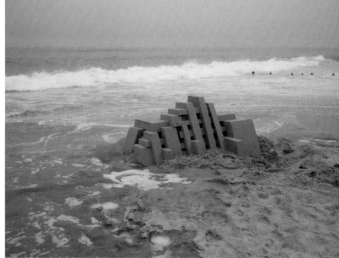

FATA MORGANA

Petr Nikl

Fata Morgana: A sand object for drawing by light, 2015–2016
Sand, mirror, wood, spotlight
Reykjavík Art Museum, 2016

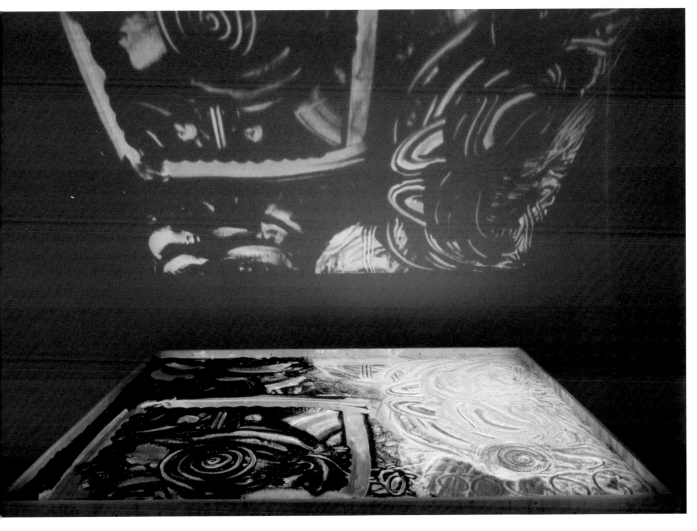

■ What is important is a process of the imaginative appearance and disappearance of drawings: to participate in the creation. Patterns in the sand are reflected by a strong spotlight on the wall or a canvas. Thus, continuously changing shadow traces appear upside down, made and animated by manual interventions of visitors. The object demonstrates spontaneous play as a principle of discovering unexpected relationships in patterns, messages and meanings.

Installation views: Reykjavík Art Museum, Reykjavík, Iceland, 2016
Kunsthall Stavanger, Stavanger, Norway, 2017

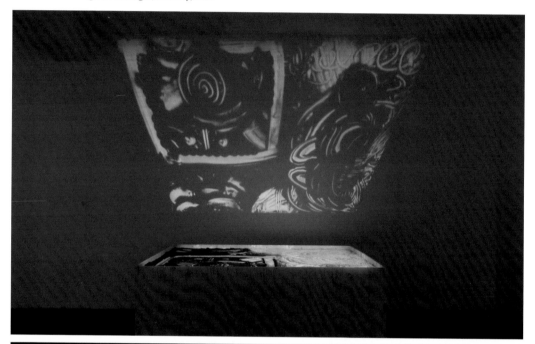

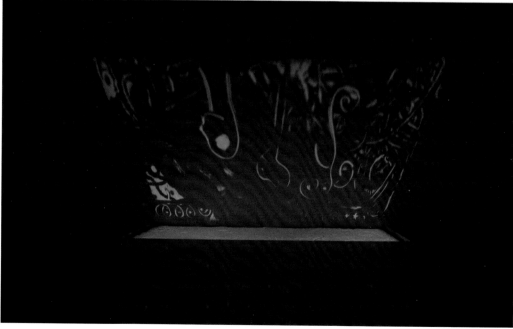

SOLAR SINTER

Markus Kayser

Solar Sinter, 2011
Video, 6:07
Courtesy of the artist

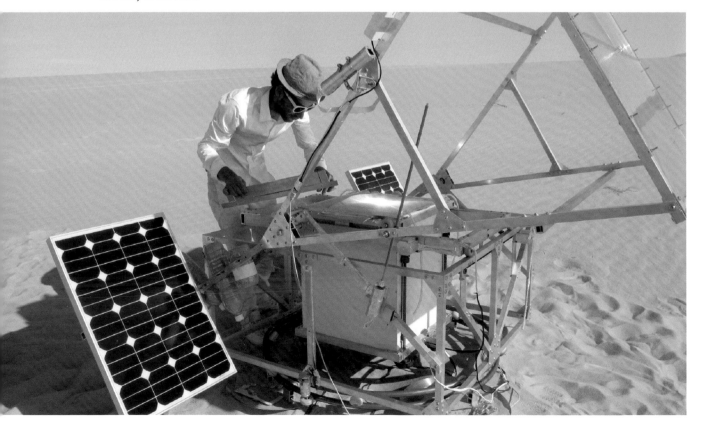

In August 2010, I took my first solar machine—the Sun-Cutter—to the Egyptian desert in a suitcase. This was a solar-powered, semi-automated low-tech laser cutter that used the power of the sun to drive it and directly harnessed its rays through a glass ball lens to "laser" cut 2-D components using a cam-guided system. The Sun-Cutter produced components in thin plywood with an aesthetic quality that was a curious hybrid of machine-made and "nature craft" due to the crudeness of its mechanism and cutting beam optics alongside variations in solar intensity due to weather fluctuations.

In the deserts of the world two elements dominate—sun and sand. The former offers a vast energy source of huge potential, the latter an almost unlimited supply of silica in the form of quartz. The experience of working in the desert with the Sun-Cutter led me directly to the idea of a new machine that could bring together these two elements. Silica sand, when heated to its melting point and allowed to cool, solidifies as glass. This process of converting a powdery substance via a heating process into a solid form is known as sintering and has, in recent years, become a central process in design prototyping known as 3-D printing or SLS (selective laser sintering). These 3-D printers use laser technology to create very precise 3-D objects from a variety of powdered plastics, resins and metals—the objects being the exact physical counterparts of the computer-drawn 3-D designs programed by the designer. By using the sun's rays instead of a laser and sand instead of resins, I had the basis of an entirely new solar-powered machine and a production process for making glass objects. This new process taps into the abundant supplies of sun and sand to be found in the deserts of the world.

My first manually operated solar-sintering machine was tested in February 2011 in the Moroccan desert with encouraging results that led to the development of the current larger and fully automated computer-driven version—the Solar-Sinter. The Solar-Sinter was completed in mid-May. Later that month I took this experimental machine to the Sahara desert near Siwa, Egypt, for a two-week testing period. The machine and the results of these first experiments presented here represent the initial significant steps towards what I envisage as a new solar-powered production tool of great potential.

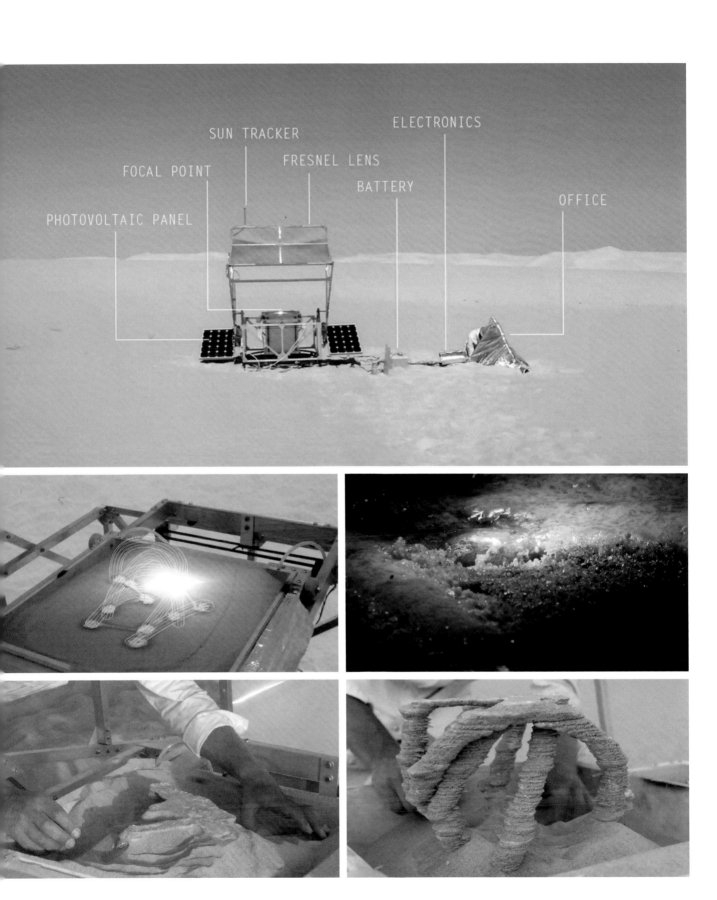

7090 KINDERGARTEN

Michael Joaquin Grey

7090 Kindergarten (Sandbox 7090), 2010
1:16 sand model, digital print
Courtesy of the artist

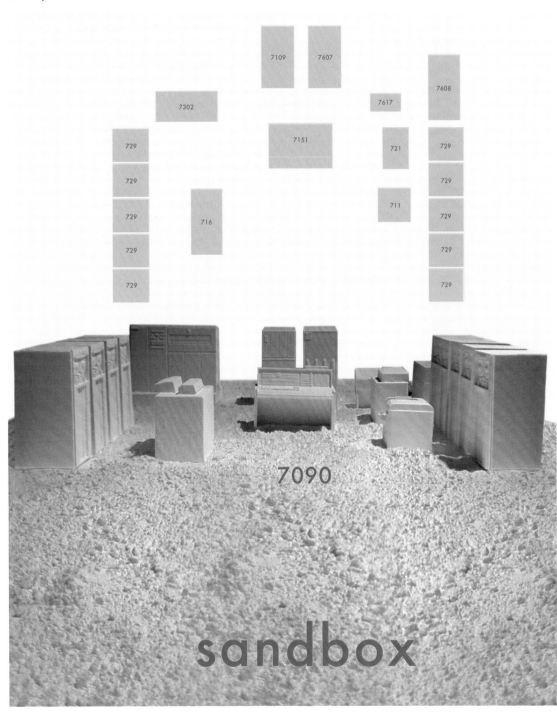

■ *7090 Kindergarten* is a large sandbox containing a sculpted IBM 7090 mainframe computer alongside an area dedicated to play and pedagogy.

The proportion of *7090 Kindergarten* (*Sandbox 7090*) is 2:1. Half of the sandbox is dedicated to a sand sculpture of the historical IBM 7090 computer. This early computer, an arrangement of large networked machines, was the first silicon-based transistorized computer. The other half of the sandbox is created for play, reminiscent of kindergarten sandboxes. The idea is to emphasize the elemental material (everything made of silica [SiO_2])—the visible elements being sand and glass as architectural support for the sandbox and sand sculpture.

The sculpture is created *in situ*. The play activity and creation/destruction cycle in the open area of the sandbox may be documented and displayed. Events and activity can be scheduled for the sandbox in collaboration with schools, universities, researchers, corporations, art, science and culture organizations, and individuals. The goal is to use the sandbox as a site, actual and metaphorical, to create a shared collection of ideas and object lessons that may develop recursively into the next generation of toys, tales and tools that will give deeper insight and perspective to our 21st century's individual and cultural development.

Each day the sand surface is raked back to its undifferentiated form and the creative process may cycle again. The aim is to encourage play and primary experience with the elemental material recapitulating modernism's origins in the kindergarten movement.

The kindergarten movement was an emergent technology; a bottom-up catalyst for some of our greatest achievements—both scientific and artistic. The collaborative play with *7090 Kindergarten* is intended to encourage a dialogue on the future of early play and pedagogy by reflecting and recapitulating the influences of kindergarten inventor and educator Friedrich Froebel over 150 years ago, an idea that still guides our educational system today. *Kindergarten 7090* is a catalyst to capture the changes of each generation's natural and cultural conditions in an iterative process for a new pedagogic model.

32'

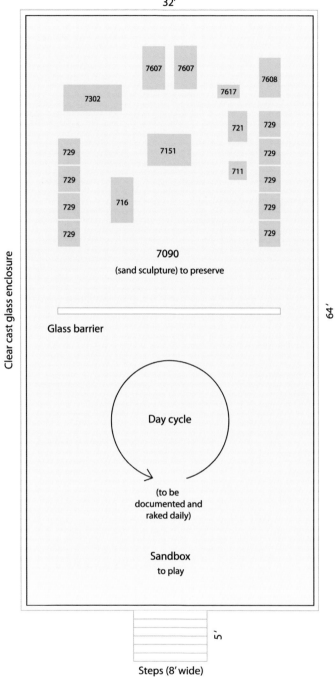

7607 7607

7608

7302

7617

721 729

729

7151 729

711

729

729

729

716 729

729 729

7090
(sand sculpture) to preserve

Glass barrier

Day cycle

(to be
documented and
raked daily)

Sandbox
to play

Clear cast glass enclosure

64'

5'

Steps (8' wide)

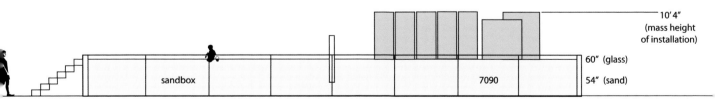

sandbox

7090

10' 4"
(mass height
of installation)

60" (glass)
54" (sand)

Jackson Pollock Sandbox One: 31, 2010
Digital painting
Courtesy of the artist

Recapitulating the work of famous modernists back to the sandbox

ESSAYS

TOWARD A PEDAGOGY OF EDUCATED HOPE IN DARK TIMES

Henry A. Giroux

Increasingly, neoliberal regimes across Europe and North America have waged a major assault on critical pedagogy and the public spheres in which it takes place. Public and higher education are being defunded, turned into accountability factories, and now largely serve as adjuncts of an instrumental logic that mimics the values of the market. But this is not true only for spaces in which formal schooling takes place; it is also true for those public spheres and cultural apparatuses actively engaged in producing knowledge, values, subjectivities and identities. This applies to a range of creative spaces including art galleries, museums, movie houses and various elements of mainstream media.[1] What the apostles of neoliberalism have learned is that this art and science of education can be dangerous and cannot only create critically engaged students, intellectuals and artists but can expand the capacity of the imagination to think otherwise in order to act otherwise, hold power accountable and imagine the unimaginable. Reclaiming pedagogy as a form of educated hope begins with the crucial recognition that education is not just about job training and product production, but also about matters of civic engagement, critical thinking, civic literacy, and the capacity for democratic agency, action, and change. It is also connected to the issues of power, inclusion and social responsibility.[2] If young people, artists and cultural workers are to develop a deep respect for others and a keen sense of social responsibility and civic engagement, pedagogy must be viewed as a cultural, political, and moral force. That collective force provides the knowledge, values and social relations that make such democratic practices possible in order to connect human agency to the idea of social responsibility and the politics of possibility. In this instance, pedagogy needs

1 Henry A. Giroux, *On Critical Pedagogy* (New York: Bloomsbury, 2011).

2 On this issue, see Henry A. Giroux, *Neoliberalism's War on Higher Education* (Chicago: Haymarket Press, 2014); Susan Searls Giroux, "On the Civic Function of Intellectuals Today," in Gary Olson and Lynn Worsham, eds. *Education as Civic Engagement: Toward a More Democratic Society* (Boulder: Paradigm Publishers, 2012), pp. ix–xvii.

to be rigorous, self-reflective and committed to the practice of freedom, to advancing the parameters of knowledge, addressing crucial social issues, and connecting private troubles and public issues. At stake here are pedagogical practices that create militant dreamers, people who are willing to struggle for a more just and democratic world. In this instance, pedagogy becomes central to politics and critical to the practice of art—a performance addressed to changing the way people think—one that awakens passion and energizes forms of identification that speak to the conditions in which people find themselves.

Critical pedagogy must be meaningful in order to be critical and transformative. It should be cosmopolitan, imaginative and demand a critical engaged interaction with the world we live in, mediated by a responsibility for challenging structures of domination and for alleviating human suffering. This is a pedagogy that addresses the needs of multiple publics. As an ethical and political practice, a public pedagogy of wakefulness rejects modes of education that are removed from political, social, historical and unjust concerns. This is a pedagogy that includes "lifting complex ideas into the public space," recognizes human injury inside and outside of the academy and uses theory as a form of criticism to change things.[3] This is a pedagogy in which educators and cultural workers are neither afraid of controversy nor the connections between private issues and the broader elements of society's problems that are otherwise hidden.

Critical pedagogy arises from the conviction that artists, educators and other cultural workers have a responsibility to unsettle power, trouble consensus and challenge common sense. This is a view of pedagogy that should disturb, inspire and energize a vast array of individuals and publics. Critical pedagogy comes with the responsibility to view intellectual work as public, raise political awareness, make connections to those elements of power and politics often hidden from public view and remind "the audience of the moral questions that may be hidden in the clamor and din of the public debate."[4]

Pedagogy is not a method but a moral and political practice, one that recognizes the relationship between knowledge and power. At the same time, it realizes that inside what is central to all pedagogical practices lies a struggle over agency, power, politics and the formative cultures that make a radical democracy possible. This view of pedagogy does not mold but inspires, directs and is capable of imagining a better world and the need to reimagine a democracy that is never finished. Critical pedagogy is a form of educated hope committed to producing young people capable and willing to expand and deepen their sense of themselves, to think of the "world" critically, "to imagine something other than their own well-being," to serve the public good, take risks and struggle for a substantive democracy.[5]

The moral implications of pedagogy suggest that our responsibility as cultural workers cannot be separated from the consequences of our knowledge, our social relations, and the ideologies and identities we offer up to students. Refusing to separate politics from

3 Edward Said, *Out of Place: A Memoir* (New York: Vintage, 2000) p. 7.

4 Edward Said, "On Defiance and Taking Positions," *Reflections On Exile and Other Essays* (Cambridge: Harvard University Press, 2001), p. 504.

5 See, especially, Christopher Newfield, *Unmaking the Public University: The Forty-Year Assault on the Middle Class* (Cambridge: Harvard University Press, 2008).

pedagogy means that teaching should not simply honor the experiences people bring to such sites but should also connect experiences to problems that come from everyday life. Pedagogy in this sense is not just about deconstructing texts but about politics in a broader sense. Such a project recognizes the political nature of pedagogy and calls for artists, intellectuals, and others to assume responsibility for their actions. As Susan Sontag once suggested, this summons these people to link their teaching to those moral principles that allow them to do something about human suffering.[6] Part of this task necessitates that cultural workers anchor their own work, however diverse, in a radical project that seriously engages the promise of an unrealized democracy against its radically incomplete forms. Of crucial importance to such a project is rejecting the assumption that theory can understand social problems without contesting their appearance in public life. Yet any viable cultural politics needs a socially committed notion of injustice if we are to take seriously what it means to fight for the idea of the good society. Zygmunt Bauman argues that "If there is no room for the idea of *wrong* society, there is hardly much chance for the idea of good society to be born, let alone make waves."[7]

A society must constantly nurture the possibilities for self-critique, collective agency and forms of citizenship in which people play a fundamental role in critically discussing, administrating and shaping the material relations of power and ideological forces that impact their everyday lives. At stake here is the task, as Jacques Derrida insists, of viewing the project of democracy as a promise, a possibility rooted in an ongoing struggle for economic, cultural and social justice.[8] Democracy in this instance is not a sutured or formalistic regime. It is the site of struggle itself. The struggle over creating an inclusive and just democracy can take many forms. That struggle offers no political guarantees but provides an important dimension to politics as an ongoing process of democratization that never ends. Such a project is based on the realization that a democracy open to exchange, question, and self-criticism never reaches the limits of justice.

Theorists such as Raymond Williams and Castoriadis recognized that the crisis of democracy was not only about the crisis of culture but also the crisis of pedagogy and education. Cultural workers would do well to take account of the profound transformations taking place in the public sphere and reclaim pedagogy as a central category of politics itself. Pierre Bourdieu was right when he stated that cultural workers have too often "underestimated the symbolic and pedagogical dimensions of struggle and have not always forged appropriate weapons to fight on this front."[9] He goes on to say in a later conversation with Gunter Grass that "left intellectuals must recognize that the most important forms of domination are not only economic but also intellectual and pedagogical, and lie on the side of belief and persuasion. It is important to recognize that intellectuals bear an enormous responsibility for challenging this form of domination."[10]

6 Susan Sontag, "Courage and Resistance," *The Nation* (May 5, 2003), pp. 11–14.
7 Zygmunt Bauman, *Society under Siege* (Malden, MA: Blackwell: 2002), p. 170.
8 Jacques Derrida, "Intellectual Courage: An Interview," trans. Peter Krapp, *Culture Machine*, Volume 2 (2000), pp. 1–15.
9 Pierre Bourdieu, *Acts of Resistance* (New York: Free Press, 1998), p. 11.
10 Pierre Bourdieu and Gunter Grass, "The 'Progressive' Restoration: A Franco-German Dialogue," *New Left Review* 14 (March–April, 2002), p. 2

These are important pedagogical interventions and imply rightly that critical pedagogy in the broadest sense is not just about understanding but also about assuming the responsibilities we have as citizens to expose human misery and to eliminate the conditions that produce it. Matters of responsibility, social action and political intervention do not simply develop out of social critique but also self-critique. The relationship between knowledge and power, on the one hand, and creativity and politics, on the other, should always be self-reflexive about its effects and how it relates to the larger world. In short, this project points to the need for cultural workers to address critical pedagogy not only as a mode of educated hope and a crucial element of an insurrectional educational project but also as a practice that addresses the possibility of interpretation as intervention in the world.

I want to end by insisting that democracy begins to fail and civic life becomes impoverished when pedagogy is no longer central to politics. The failure to recognize the educative nature of how agency is constructed, moral witnessing legitimated and the politics of social responsibility renewed empties democracy of any meaning. Democracy should be a way of thinking about education, one that thrives on connecting equity to excellence, learning to ethics, and agency to the imperatives of the public good.[11] The question regarding what role education and pedagogy should play in democracy becomes all the more urgent at a time when the dark forces of authoritarianism are on the march all over the globe. As public values, trust, solidarities and modes of education are under siege, the discourses of hate, racism, rabid self-interest and greed are exercising a poisonous influence in many Western societies, now most evident in the discourse of the right-wing extremists vying for the American presidency. Democracy is on life support, but rather than being a rationale for cynicism, it should create moral and political outrage, a new understanding of politics and the pedagogical projects needed to allow democracy to breathe once again.

As Ernst Bloch once insisted, "reason, justice, and change cannot blossom without hope because educated hope taps into our deepest experiences and longing for a life of dignity with others, a life in which it becomes possible to imagine a future that does not mimic the present. I am not referring to a romanticized and empty notion of hope, but to a notion of informed hope that faces the concrete obstacles and realities of domination yet continues the ongoing pedagogical and political task of "holding the present open and thus unfinished."[12]

* **Henry Giroux** is Professor for Scholarship in the Public Interest and The Paulo Freire Distinguished Scholar in Critical Pedagogy, McMaster University, Ontario, Canada. One of the founding theorists of critical pedagogy in the U.S., he is best known for his pioneering work in public pedagogy, cultural studies, youth studies, higher education, media studies and critical theory. In 2002 Routledge named Giroux as one of the top 50 educational thinkers of the modern period. In 2005, Giroux began serving as the Global TV Network Chair in English and Cultural Studies at McMaster University in Hamilton, Ontario. He has published more than 50 books and more than 300 academic articles, and is published widely throughout education and cultural studies literature.

11 Henry A. Giroux, *Dangerous Thinking in the Age of the New Authoritarianism* (New York: Routledge, 2015).
12 Andrew Benjamin, *Present Hope: Philosophy, Architecture, Judaism* (New York: Routledge, 1997), p. 10.

TRANSDISCIPLINARITY AS A RADICAL SHIFT IN EDUCATION

Basarab Nicolescu

Introduction

Why is transdisciplinarity today not only a realistic aim but also a necessary one?

The first argument is the big bang of the number of disciplines that increased from 7 (when first universities were founded in the 13th century) to more than 8,000 in 2017. A great expert in a given discipline is totally ignorant in more than 7,999 disciplines. The decisions that are taken in our troubled world are based on ignorance and this fact provokes inevitable crises, which will be deeper and deeper in the future.

Second argument: The rapid changes in our contemporary world cause more and more unemployment and therefore human beings must change their jobs several times during their active lives. But passing from one job to another is practically impossible in the context of an accelerated superspecialization.

Third argument: Recent discoveries in neurophysiology illustrated, for example, by the works of Antonio Damasio,[1] underline the unexpected fact that the analytic intelligence is too slow compared with the intelligence of feelings. Therefore, we have to find equilibrium in our educative system between the analytic intelligence and the interior being.

Fourth argument: Globalization induces an enormous migratory flux of people who belong to countries of a given culture, religion and spirituality towards countries of another culture, religion and spirituality. The new education has to establish the dialogue between cultures, religions and spiritualities.

Fifth argument: The rapid advance of means of communication implies an increased complexity in an interconnected world. The new education has to invent new methods of teaching, founded on new logics. The old classical binary logic, that of "yes" and "no," i. e. the logic of the excluded middle, is no longer valid in the context of complexity.

1 Damasio A. R., 2003. *Looking for Spinoza: Joy, Sorrow, and the Feeling Brain*. San Diego: Harcourt.

The sixth and final argument I would like to formulate is the following: Solving problems in the real world forces the university to interact with society, industry, banks and ecology. These problems clearly belong to the field of "trans:" Their resolution asks us to go beyond academic disciplines. Transdisciplinarity is therefore realistic and necessary for the survival of contemporary education.

Disciplinary education and transdisciplinary education

The transdisciplinary knowledge corresponds to an *in vivo* knowledge, concerned with the correspondence between the external world of the object and the internal world of the subject. By definition, the transdisciplinary knowledge includes a system of values—the humanistic values. It leads to a new type of education—the transdisciplinary education (TE), distinct from but complementary to our present disciplinary education (DE) (see Table 1).

It is important to realize that the disciplinary knowledge and the transdisciplinary knowledge are not antagonistic but complementary. Both their methodologies are founded on scientific attitude. *Building the transdisciplinary mind* is our main challenge today.

In order to explore the new transdisciplinary education, we have to apply the transdisciplinary methodology.[2] The methodology of transdisciplinarity is founded on three postulates:

1. The ontological postulate: *There are, in nature and in our knowledge of nature, different levels of reality of the object and different levels of reality of the subject.*
2. The logical postulate: *The passage from one level of reality to another is insured by the logic of the included middle.*

Table 1: Comparison between disciplinary education (DE) and transdisciplinary education (TE).

Disciplinary education (DE)	Transdisciplinary education (TE)
IN VITRO	*IN VIVO*
One level of Reality	Several levels of Reality
External world—Object	Correspondence between external world (Object) and internal world (Subject)
Accumulation of knowledge	Understanding
Analytic intelligence	New type of intelligence—harmony between mind, feelings and body
Binary logic (absolute truth)	Included middle logic (relative truth)
Oriented towards power and possession	Oriented towards astonishment and sharing
Exclusion of values	Inclusion of values

2 Nicolescu B., 2002. *Manifesto of Transdisciplinarity*. New York: State University of New York (SUNY) Press. Translation in English by Karen-Claire Voss.

3. The epistemological postulate: *The structure of the totality of levels of reality is a complex structure; every level is what it is because all the levels exist at the same time.*

The first two postulates received—in the 20th century—experimental evidence from quantum physics[3] while the last one has its source not only in quantum physics but also in a variety of other exact and human sciences.

The key concept of the transdisciplinary approach to nature and knowledge is the concept of *levels of reality*.[4]

Emergence of a transdisciplinary culture

The emergence of a transdisciplinary culture capable of contributing to the elimination of the tensions menacing life on our planet will be impossible without a new type of education that takes into account all the dimensions of the human being.

All the various tensions—economic, cultural and spiritual—are inevitably perpetuated and deepened by a system of education founded on the values of another century and by a rapidly accelerating imbalance between contemporary social structures and the changes that are currently taking place in the contemporary world. More or less embryonic wars between economies, cultures and civilizations never stop leading to actual wars. In fact, our entire individual and social life is structured by education. Education is at the center of our becoming. The future is shaped by the education that is delivered in the present, here and now.

In spite of the enormous diversity of the systems of education that can be found in various countries, the globalization of the challenges of our era involves the globalization of the problems of education. The different upheavals continually confronting education in one or another country are only symptoms of one and the same flaw: the disharmony which exists between the values and the realities of a planetary life in the process of change. Most certainly, while there is no miraculous recipe, there is nevertheless, a common center of questioning that it would behoove us not to avoid if we truly want to live in a more harmonious world.

Learning to know

Growing awareness of a system of education that does not keep pace with the modern world is demonstrated by numerous conferences, reports and studies. One detailed report was developed by the International Commission on Education for the Twenty-First Century chaired by Jacques Delors in cooperation with UNESCO.[5] The Delors Report strongly

3 Nicolescu B., 2012. *We, the Particle and the World / Nous, la particule et le monde.* Brussels: E. M. E. InterCommunications.

4 Nicolescu, B., 2009. *What is Reality? / Qu'est-ce que la Réalité?* Montréal: Liber.

5 Delors J., 1996. *Learning: The Treasure Within.* Report to UNESCO of the International Commission on Education for the Twenty-first Century. Paris: UNESCO Publishing.

emphasized four pillars of a new kind of education: learning to know, learning to do, learning to live together and learning to be.

Learning to know means, first of all, training in the methods that help us distinguish what is real from what is illusory and in the techniques which enable intelligent access to the fabulous knowledge of our age. In this context, the scientific spirit, one of the highest goals ever attained in the human adventure, is indispensible. Precocious initiation into science is beneficial because it provides access, from the very beginning of human life, to the inexhaustible richness of the scientific spirit. This spirit is based on questioning and on the refusal of all *a priori* answers and all certitude contradictory to the facts. However, "the scientific spirit" does not at all mean the thoughtless increase of teaching scientific matters or retreating to an interior world based on abstraction and formalization. Although such excess is, unfortunately, still current, it can lead only to the exact opposite of the scientific spirit: Previous readymade answers are replaced by other new, readymade answers (this time, having a kind of "scientific" brilliance); thus, in the final analysis, dogmatism is replaced by dogmatism. Nor is "the scientific spirit" the assimilation of an enormous quantity of scientific knowledge that gives access to this spirit but rather it is the quality of what is taught. And here "quality" means to lead the child, the adolescent, or the adult into the very heart of the scientific approach, which is the permanent questioning related to the resistance of facts, images, representations and formalizations.

Learning to know also means being capable of establishing bridges—between the different disciplines and between these disciplines and meanings and our interior capacities. This transdisciplinary approach will be an indispensable complement to the disciplinary approach because it will mean the emergence of continually connected beings who are able to adapt themselves to the changing exigencies of professional life and who are endowed with a permanent flexibility that is always oriented toward the actualization of their interior abilities.

Learning to do

Learning to do certainly means acquiring a profession or a craft and the theoretical and practical knowledge associated with it. The acquisition of a profession or craft necessarily passes through a phase of specialization. One cannot do open-heart surgery if one has not learned surgery; one cannot solve a third-degree equation if one has not learned mathematics; one cannot be a producer without knowing theatrical techniques.

However, in our tumultuous world, in which the tremendous changes induced by the information revolution are but the portent of other still more tremendous changes to come, any life that is frozen into one and the same occupation can be dangerous because it risks leading to unemployment, to exclusion, to a debilitating alienation. Excessive, precocious specialization should be outlawed in a world that is in rapid change. If one truly wants to reconcile the exigency of competition with the imperative of equal opportunity for all human beings, in the future, every profession and every craft should be an authentically woven occupation, an occupation that would bind together in the interior of human beings, the threads joining them to other occupations. Of course, it is not simply a

question of acquiring several competencies at the same time but of creating a flexible, interior core that could quickly provide access to another occupation, should that become necessary or desirable.

Here also, the transdisciplinary approach can be invaluable. In the last analysis, "learning to do" is an apprenticeship in *creativity*. "To make" also signifies discovering novelty, the process of creating and of bringing to light our creative potentialities. It is this aspect of "making" that is contrary to the boredom and sometimes even despair experienced by so many human beings obliged to work at an occupation that does not conform to their interior predispositions simply in order to underwrite their basic needs. "Equal opportunity" also means the opportunity for the actualization of the creative potentialities that vary from one person to the next. Competition could also mean the harmony of creative activities within a single community. Boredom and despair, the source of violence, conflict, and of moral and social resignation, can be replaced by the joy of personal realization, no matter what place this realization is effected, because a place can only be unique for each person at any given moment. Creating the conditions for the emergence of authentic persons also means insuring the conditions for the maximal actualization of their creative potentialities. The social hierarchy, so frequently arbitrary and artificial, could thus be replaced by the cooperation of levels structured in order to serve personal creativity. Rather than being levels imposed by a competition that does not take the interior being into account at all, these levels would in fact be levels of being. The transdisciplinarity approach is based on the equilibrium between the exterior person and the interior person. Without this equilibrium, "to make" means nothing other than "to submit."

Learning to live together

Of course, learning to live together first of all signifies respect for the norms that govern relationships between the beings comprising a collective. However, these norms must be truly understood and willingly internalized by each being, rather than obeyed out of submission to exterior constraints. "To live together" does not mean simply tolerating others' differences of opinion, skin color and beliefs; submission to the exigencies of power; negotiating between the ins and outs of innumerable conflicts; definitively separating interior from exterior life; and merely appearing to hear the other while remaining convinced of the absolute rightness of our own position. If this is what it means, "living together" is inevitably transformed into its opposite: fighting each other. The transcultural, transreligious, transpolitical and transnational attitude can be learned. To some extent, in each being there is a sacred, intangible core that is innate.

Yet, if this innate attitude remains merely a potential, it can forever stay nonactualized, absent in life and in action. In order for the norms of a collective to be respected, they must be validated by the interior experience of each being.

There is one fundamental characteristic of the transdisciplinary evolution of education: to recognize oneself in the face of the other. This is a question of permanent apprenticeship, which must begin in early childhood and continue throughout life. The

transcultural, transreligious, transpolitical and transnational attitude permits us to better understand our own culture, to better defend our national interests and to better respect our own religious or political convictions. Just as in all other areas of nature and knowledge, open unity and complex plurality are not antagonists.

Learning to be

Learning to be appears at first like an insoluble enigma. We know how to exist, but how can we learn to be? We can begin by learning what the word "exist" means, for us: discovering our conditioning, discovering the harmony or disharmony between our individual and social lives, testing the foundations of our convictions in order to discover that which is found underneath. In a building, the stage of excavation precedes that of foundation. In order to make a foundation for being, one must first proceed with the excavation of our certitudes, our beliefs and our conditioning. To question, to question always—here also, the scientific spirit is a precious gift for us. This must be learned by the teachers as well as the taught. "Learning to be" is also a permanent apprenticeship, in which teachers inform students as students inform teachers. The shaping of a person inevitably passes through a transpersonal dimension. The disrespect for this necessary process helps explain one of the fundamental tensions of our era—that between the material and the spiritual. The survival of our species largely depends on the elimination of this tension by means of reconciliation between these two apparently antagonistic contradictions, that takes place on another level of experience than that of everyday life. "Learning to be" also means learning to know and to respect the hidden third,[6] which joins the subject and object. The other remains an object for me if I do not make this apprenticeship, which teaches me that together we, the other and me, create the subject joined with the object.

The integral education of the human being

There are two very obvious interrelationships amongst the four pillars of the new system of education: how to learn to make while learning to know and how to learn to be while learning to live together.

In the transdisciplinary vision, there is also a trans relation that connects the four pillars of the new system of education and has its source in our own constitution as human beings. This trans relation is like the roof that rests on four pillars of a building. If any one of the pillars of the building collapses, the entire building collapses, the roof with it. And, if there is no roof, the building falls into ruin.

6 Nicolescu B., 2014. *From Modernity to Cosmodernity—Science, Culture, and Spirituality*. New York: State University of New York (SUNY) Press.

A viable education can only be an integral education of the human being, according to the apt formulation of the poet René Daumal:[7] an education that is addressed to the open totality of the human being, not to just one of the components.

At present, education privileges the intellect over the emotions or the body. This was certainly necessary in the previous era in order to permit the explosion of knowledge. But this privileging, if it continues, sweeps us away in the mad logic of efficacy for efficacy's sake, which can only lead to our self-destruction.

Of course it is not a question of limiting or increasing the number of hours provided for artistic or athletic activities. This would be like trying to obtain a living tree by juxtaposing roots, trunk, branches and leaves. This juxtaposition would only lead to a semblance of a living tree. Contemporary education concerns itself with only the leaves. But leaves do not make a whole tree.

The transdisciplinary approach is realistic and even necessary for the survival of contemporary education, placed in the chaotic context of globalization. One necessary condition is to understand what reality is today. We are part of the ordered movement of reality. Our freedom consists in entering into the movement or perturbing it. Reality depends on us. Reality is plastic. We can respond to the movement or impose our will of power and domination. Our responsibility is to build sustainable futures in agreement with the overall movement of reality.

The emergence of a new culture capable of contributing to the elimination of the tensions menacing life on our planet will be impossible without a new type of learning that takes into account all the dimensions of the human being.

Transdisciplinary education is founded on the inexhaustible richness of the scientific spirit that is based on questioning and of the refusal of all *a priori* answers and all certitude contradictory to the facts. At the same time, it revalues the role of the deeply rooted intuition, of the imaginary, of sensitivity and of the body in the transmission of knowledge. It is only in this way that the society of the 21st century can reconcile effectiveness and respect for the potentiality of every human being. The transdisciplinary approach will be an indispensable complement to the disciplinary approach because it will mean the emergence of *continually connected beings*, who are able to adapt themselves to the changing exigencies of professional life and who are endowed with a permanent flexibility that is always oriented towards the actualization of their interior potentialities.

A viable education can only be an integral education of the human being.

* **Basarab Nicolescu** is an honorary theoretical physicist at the Centre National de la Recherche Scientifique (CNRS), Laboratoire de Physique Nucléaire et de Hautes Énergies, Université Pierre et Marie Curie, Paris. Professor Nicolescu is the president and founder of the International Center for Transdisciplinary Research and Studies (CIRET), a nonprofit organization (163 members from 26 countries). In addition, he is the cofounder, with René Berger, of the Study Group on Transdisciplinarity at UNESCO (1992) and the founder and Director of the "Transdisciplinarity" Series, Rocher Editions, Monaco and of the "Romanians of Paris", Piktos/Oxus Editions, Paris. Nicolescu is the author of more than 130 articles in leading international scientific journals, has made numerous contributions to science anthologies and participated in several dozen French radio and multimedia documentaries on science.

7 Daumal R., 1972. *Essais et Notes, I,* p. 276. Paris: Gallimard.

RADICAL PEDAGOGY FOR A RADICAL BRAIN

Bruce E. Wexler

Humans have radical brains. We rightly marvel at our sense of self-awareness, time, death, aesthetics, morality, fairness, generosity, kindness, competitiveness and aggression. We also wonder at our cognitive skills, language ability, inventiveness and technological competence. We know that all these things somehow depend on the function of our brains. And while evidence of these behavioral capacities is found in more limited forms in some animals, the collective quantitative and qualitative differences are undeniable. How then did we come to have these qualities? If the behavioral functionalities somehow depend on the brain, what are the differences between our brains and those of other animals that make them possible?

Some evolutionary psychologists offer a solution that is bizarrely improbable and inconsistent with what we know about the brain. Referring to Darwinian processes, they suggest that each of our behavioral qualities has its own evolutionary history, each behavior and capacity began with a mutation that enabled or enhanced it, and each was progressively developed by selection based on its survival value. From altruism genes to religion, this theory requires that in some way, the trajectories of mutation and selection for the many different human qualities and capabilities fit together within the functional organization of the brain.

Evolutionary selection acts on the structure and function of brain cells. The great advance in evolution was not to laboriously create, through mutation and selection, the full array of individual human cognitive capacities or brain modules. Much more elegantly and parsimoniously, evolution adjusted a few fundamental parameters that increased the number of cells in the human brain and extended the period of postnatal neural plasticity to allow greater environmental shaping of functional neural circuits.

There are 100 billion neurons in the human brain, each directly connected to over 1,000 other neurons. Learning simple associations between stimuli leads to altered responses in millions of cells distributed across wide expanses of cortical territory (John et al. 1986).

When people perform simple cognitive operations, neuronal activity changes in multiple brain areas (e.g., D'Esposito 2007). When the same simple tasks are repeated within minutes or hours, there are different patterns of task-related regional activation changes associated with the tasks. As people get older, brain activation patterns associated with the same task change, indicating that the same tasks are done by different combinations of brain areas at different ages (e.g., Gaillard et al. 2000; Stebbins et al. 2002). If the same component cognitive operation is performed as part of different overall cognitive functions, the pattern of regional brain activation associated with that component operation is often different (e.g., Friston et al. 1996; Wexler 2004). The great Russian neuropsychologist A.R. Luria described such functional systems years before the new brain imaging data did what (Luria 1973; see also Vygotsky 1978). Luria concluded that while groups of cells in a specific anatomic location might collectively have some elementary tissue function, such functions do not correspond to mental functions like perception, memory or cognition. Such mental operations are instead properties of functional systems that perform the same function through different means or components in different circumstances or at different times. The functions are properties of the system, not of specific anatomic locations.

This modern view contrasts with 19th century concepts of phrenology and related 20th century concepts of modularity (see Wexler 2004, 2006). Phrenology and modularity posit that specific cognitive operations are performed at circumscribed, localized anatomic sites, and that the function of these brain locations is the specific cognitive operation. In contrast, the 21st century systems view is that ensembles of cells at different locations in the brain have different physiological characteristics, and that the ensembles are like different letters of an alphabet. Most human qualities emerge from combinations of different local units just as words emerge from combinations of letters. The same brain regions can contribute to different emergent functionalities based on how they are arranged, like the words TEA, EAT, ATE, TEAM and STEAM build different meanings based on the arrangements of the letters. Evolution increased the number of cells thus enabling more complex functional systems and allowing for the connections between cells that constitute the systems to be shaped by environmental input.

Sensory stimulation is literally a matter of life or death for cells in the nervous system, establishing the first level of necessity in the essential link between the mammalian brain and its environment. Information processing structures along pathways from peripheral sensory receptors to cortical processing centers atrophy without sensory input. Neurons at each stage of processing compete for connections with neurons at each subsequent stage, with neurons that fire more often gaining territory and follow the principle that "neurons that fire together wire together." Hubel and Wiesel received a Nobel Prize for showing the degree to which the structure and function of the mammalian brain are shaped after birth by stimulation from the environment (Hubel 1988). For example, some cells in the visual cortex respond selectively to moving objects, with each cell maximally sensitive to movement in a particular direction. Other cells respond selectively to lines (i.e., object edges), with each having maximum sensitivity to lines of a particular orientation. Kittens raised in strobe light that prevents appreciation of movement have decreased numbers of motion sensitive cells (Cynader et al. 1973; Cynader and Chernenko 1976). Kittens raised in

dark, except for exposure to stripes moving from left to right, have a marked increase in the proportion of cells selectively responsive to left/right rather than right/left movement (Tretter et al. 1975). Kittens exposed to vertical black and white stripes for a few hours each day, but otherwise reared in darkness, have only cortical cells with vertical line orientation preferences (Blakemore and Cooper 1970). In a particularly dramatic demonstration of plasticity, the optic nerve in one-day-old ferrets was rerouted to provide visual rather than auditory input to what is normally the auditory cortex. The auditory cortex developed a functional organization of ocular dominance columns highly similar to the normal visual cortex rather than its usual tonotopic structure and the ferrets saw with what would normally have been the auditory regions of the brain (Sharma et al. 2000). Mammalian brains (and minds) develop concrete perceptual structures, capabilities and sensitivities based on prominent features of the rearing environment, and then are more able and more likely to see those features in the world around them. Turning it around, mammals have limited ability to see even prominent features of a new environment if those features were absent from their rearing environment.

Adult caregivers vary in the ways they stimulate their infants and children. Naturally occurring differences in these parenting behaviors have lifelong and specific effects on the brains and behavior of their offspring. Changes in DNA structure that mediate these effects have been identified in studies of rats (Weaver et al. 2004a, 2004b). For example, mother rats differ in the amount of time they spend licking and grooming their pups. Michael Meaney and colleagues found that adult rats that had been licked more as pups had decreased behavioral and hormonal responses to stress, and greater spatial learning abilities—a capacity in which areas of the hippocampus play an important role (Weaver et al. 2004b). Examining the brains of the rats that had been licked more as pups, they found greater levels of two specific types of messenger RNA. One carries the information from the DNA to parts of the cells that synthesize the glucocorticoid receptors important in regulating stress responses. The other carries information necessary for building the

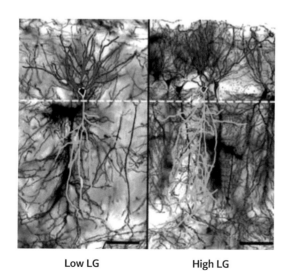

Low LG High LG Low LG High LG

Figure 1: There are more branches on neurons in the hippocampus in rats who had been licked and groomed more (on the right) than in rats who had been licked and groomed less. There are also fewer branching points along the axonal spine (left image) in the photograph to the right.

NMDA receptors important in promoting neuroplasticity. Anatomic examination of the hippocampus revealed that offspring of high-licking mothers had longer neurons with more of the branches and interconnections so important in brain function (Figure 1, Champagne et al. 2008). Moreover, examination of the DNA identified structural changes in the regions associated with stress response as a result of the degree of maternal licking. Shortly after birth, small chemical complexes called methyl groups cover much of the surface of DNA. The methyl groups limit access to the DNA and thereby limit activation or expression of genes. During the first weeks of life, sensory stimulation can lead to selective removal of methyl groups, making some genes more active.

Human rearing behaviors are more complex and varied than those of other mammals, and include massive social components and influences from extended families, communities and nation-states. Influences beyond the family include schools, mass media, arts, laws and customs. The human social and economic environments also affect the states of mind, time and energy of the parents, thus affecting their interactions with their offspring. And although beyond the scope of this essay, the role of language—spoken and written—in facilitating the influence of the human-made environment on the development of children is huge. Written language itself is a product of cultural evolution and it seems increasingly probable that language in general is in large part as well.

Some of the social input is actively shaped and provided by others but much is just absorbed through constant imitation. Infants will stick out their tongues and move their heads in imitation of an adult within just two days of birth (Meltzoff and Moore 1977, 1989). From infancy on, children learn how to do things simply by watching them done. They imitate the goals of action even by different means and imitate a parent's emotional response to new stimuli (Kaye 1982b; Klinnet et al. 1986). Mirror neurons fire when people (and monkeys) watch an act being done and are then active when the individual performs the action previously observed (Iacoboni et al. 1999; Rizzolatti et al. 1996; Umilta et al. 2001). Similarly, looking at someone else in pain activates the same regions of the brain as are active when the observer experiences pain him or herself (Gu and Han 2007; Jackson et al. 2005; Singer et al. 2004). The work of Hubel and Wiesel demonstrated that environmentally induced neuronal activity shaped the development of cerebral functional structures, following the principle that neurons that fire together wire together. In human development, parental and community interventions and nearly constant imitation of what is seen and heard produce intensive and repetitive firing of neuronal ensembles and circuits. This environment-induced neural activation shapes brain development to be consistent with the largely human-made rearing environment.

Psychologists were aware of the role of the social environment in shaping mental development well before neuroscience research added further support to their observations. Fenichel (p. 57) stated in 1926 that "changes in the ego, in which characteristics which were previously perceived in an object [usually an important person] are acquired by the perceiver of them, have long since been familiar to psychoanalysis." Freud (1933, p. 47) described identification as "the assimilation of one ego to another one, as a result of which the first ego behaves like the second in certain respects, imitates it and in a sense takes it up into itself." Greenson (1954, pp. 160–1) stated that "identification with an object means that… a transformation of the self has occurred whereby the self has

become similar to the external object... one can observe behavior, attitudes, feelings, posture, etc., which are now identical to those characteristics belonging to the external object", and that at early stages of development "perception implies transformation of the self." Reich (1954, p. 180) explained that "the child simply imitates whatever attracts his attention momentarily in the object... normally these passing identifications develop slowly into permanent ones, into real assimilation of the object's qualities." Writing from a different cultural and intellectual context, the Russian psychologist Lev Vygotsky described the process: "In the early stages of development the complex psychological function *was shared between two persons*: the adult *triggered* the psychological process by naming the object or by pointing to it; the child *responded* to this signal and picked out the named object either by fixing it with his eye or by holding it with his hand. In the subsequent stages of development...The function which hitherto was shared between two people now becomes a method of *internal organization of the psychological process*. From an external, socially organized attention develops the *child's voluntary attention*, which in this stage is an internal, self-regulating process" (Luria 1973, pp. 265–8).

Brain imaging studies clearly demonstrate the effects of childhood experience on brain structure and function. When children are blind from birth or very early age, the parts of the brain that usually process visual information become additional auditory processing areas instead (Figure 2, Weaver and Stevens 2007). This is probably one reason that blind people have better auditory memory than people who can see. Figure 3 shows the effects of practicing a string instrument for many hours as a child—clearly a culturally created and parent-facilitated activity. There is an increase in volume of the right somatosensory and motor areas associated with the rapid fine motor movements of the fingers of the left hand compared to the left somatosensory and motor areas associated with the relatively simple movements of the right hand that moves the bow (Schlaug 2001). Piano players who practice with both hands have volume increases on both sides (Bangert and Schlaug 2006).

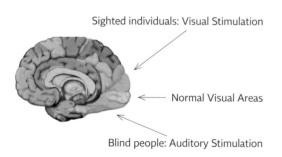

Sighted individuals: Visual Stimulation

Normal Visual Areas

Blind people: Auditory Stimulation

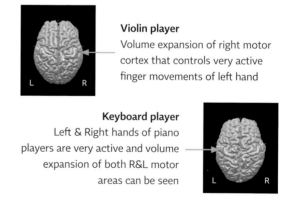

Violin player
Volume expansion of right motor cortex that controls very active finger movements of left hand

Keyboard player
Left & Right hands of piano players are very active and volume expansion of both R&L motor areas can be seen

Figure 2: In people who become blind when very young, parts of the brain that are normally associated with processing visual information process auditory information instead.

Figure 3: String players use their left hands for complex finger movements and their right hands for simpler bowing. The sensorimotor area on the right side of the brain that controls the left hand is larger in volume than on the left side that controls the right hand. Fingers on both hands are very active in piano players and the sensorimotor areas on both sides are expanded.

Over two million years ago the *homo* genus of hominids emerged in East Africa (*Homo habilis* and *Homo rudolfensis*) and distinguished themselves from the earlier bipedal hominids by a 40% increase in brain size and the manufacture of tools. These tools, known as Oldowan, are the earliest known items of material culture. These hominids created a rearing environment that included the objects themselves, the process of manufacture, and ways of hunting and eating that depended upon them. The use of specific types of stone depending on local availability suggests some flexibility in the process and abstract representation of the desired functionality. Abstraction, purpose and planning are equally apparent in instances where stone of better types for tool-making were carried from distant sites for manufacture. What is just as remarkable as the appearance of tools is the fact that there were so few in type and so constant in production. They remained fundamentally the same for over 700,000 years and at sites thousands of miles apart in Africa and Asia. Another tool set (Achulean) is associated with the appearance 1.8 million years ago of *Homo ergaster* and *Homo erectus*, the first hominids similar to modern humans (*Homo sapiens*) in body proportions and with a brain 50% larger than that of *H. habilis* but still only 60% of the size of *H. sapiens*. Tools were now shaped by systematically chipping the stone from both sides to create a symmetrical bifacial cutting edge. Here again, the tool set remained highly conserved for the next million years and across different communities extending into the Middle East, India and Europe. The eastern branch of *H. erectus* lived in Asia from 1.8 million years ago until only 27,000 years ago without ever changing their tool set from Oldowan to Achulean (Klein and Edgar 2002). What change in capacity and/or circumstance made advance in tool manufacture possible? Why did this or these changes not then lead to further change over such long ensuing periods?

H. neanderthalensis originated in Africa and populated Europe, East Asia and the Middle East 300,000 to 350,000 years ago until approximately 35,000 to 40,000 years ago. They introduced both new methods of tool production and a wider variety of those tools, cared for their sick, buried their dead, collected earth pigments, and left behind an abundance of hearths suggesting regular use of and control over fire. Tool production was differentiated to produce different types of blades. Individual blades from the same base were further refined and differentiated for specific uses. Tools included scrapers, most likely used to prepare animal skins to be worn as clothing. The wide tool set implied a general view that the environment can be altered. Also implied were the time and variety of ways in which individuals acted on the environment in a manner that would not have been possible without the tools they created. Greater variety itself in the available tools exhibited evidence of their concept of change and innovation. Better weapons turned prey into predators. Fire turned night into day, cold into warm and raw food into cooked. Caring for the sick changed the social landscape, and burial of the dead further differentiated sections of the physical environment. Earth pigments and clothes also changed the way individuals appeared to one another and may have contributed to a sense of self.

H. sapiens or anatomically modern humans appeared in Africa almost 200,000 years ago and expanded to Europe as early as 90,000 years ago. Archaeological discoveries in the last decade indicate the existence of multiple independent *H. sapiens* communities in which the sophistication of tool use moved beyond that of their hominid predecessors but varied

bidirectionally over time and location (McBrearty 2007). It is unlikely that such variation among communities of *H. sapiens* was related to genetic mutation and change in innate characteristics of brain or mind. In the Late Stone Age or Upper Paleolithic period, beginning approximately 50,000 years ago, change in technology and material culture more broadly accelerated. Upper Paleolithic sites reveal a greatly expanded tool set including bone, ivory and shell tools, fish hooks, and needles for tailoring clothes. Fire was used to alter the property of stones used for tools and to heat solidly constructed houses. Burial was ritualized and there was rich evidence of painting and sculpture. The Chauvet cave in France has 31,000-year-old wall paintings deemed beautiful and sophisticated by today's standards. An even earlier site in Germany yielded a 12-inch tall figure with a human body and lion's head sculpted from ivory. As 29,000-year-old site in Russia yielded 13,000 beads placed with the bodies of an adult and two children, with each bead estimated by modern simulations to have taken one to two hours to make. In contrast with previous periods and species, the material culture of *H. sapiens* quickly evolved into much more distinct subcultures in different parts of Europe, each with distinctive regional styles. Here then is a qualitatively as well as quantitatively different relationship between a hominid species and the environment.

But all these hominid alterations of the environment are small in comparison with the changes that took place with the rise of agriculture and animal husbandry approximately 10,000 years ago. Large and stable communities developed, changes in the built environment and material culture were greater than elsewhere, and "urban" spaces were built that regulated human interactions and themselves became the predominate features of the environment (Childe 1936, 2003). Writing and other powerful symbolic systems were developed that were external records of temporary and more lasting internal states and extended human memory. More generally, these systems broke down the barrier between internal and external, and allowed manipulations of internal states by manipulations of humanly created external manifestations of those states, both individually and collectively. Humans came to be raised in increasingly human-made environments. Not only is the human brain subject to environmental shaping for a much longer period of time than brains of other animals, we humans became the only animal to extensively shape the environments that shape our brains.

It is in this long view that we can consider, in the broadest and deepest sense, the nature of education and the work in this exhibit. It is our nature to be educated. Our brains demand environmental input to maintain structural integrity and develop functionality. The uniquely human dialectic between brain and culture has taken over from Darwinian biological evolution in creating the most fundamental and important aspects of human beings and human societies. Education is a much bigger enterprise than simply providing facts about national history and laws, mathematics and reading, and technical skills for employment. It fundamentally determines the ways we see and think about the world and other human beings. We are each the product of the human-made worlds that shaped us.

For most of the 200,000 year history of our species we lived in communities separated by mountains, rivers and oceans. Over the course of the last 20,000 years, these separated, human-made worlds became widely diverse in language, food, clothes, philosophies, religion, codes of conduct and language. For example, there are over 6,000 different

languages spoken on Earth, not counting dialects, each representing a society that lived in sufficient isolation of others for sufficient time to develop a distinct language. We are born into one of these cultural worlds with highly plastic minds and brains that develop internal structures consistent with all aspects of that culture. The fit or homology between internal and external is natural and comfortable. As adults we act in many ways to maintain that fit, by, for example, associating with like-minded people and ignoring, discrediting and forgetting sensory input that does not match our internal representations (Wexler, 2006). Indeed, numerous studies show that we feel uncomfortable, show physiological signs of stress and function more poorly when in an environment that does not match our internal structures.

It was only approximately 400 years ago that many distant cultures became aware of one another and that contact between them increased. The contact zones almost universally became ones of conflict and subordination of one culture, one belief system, one way of life, one worldview by the other. People fight so as not to live in someone else's symbolic or cultural space. The shaping of our brains by our human-made environments creates a neurobiological antagonism to cultural difference. We are like the dog who in the New Yorker cartoon by Gregory chases a cat up into a tree and says: "Okay, here's the deal—I'll stop chasing you if you agree to become a dog."

Problematic aspects of this meeting of cultures are increasingly apparent in our world today and perhaps most so with the large numbers of Muslim immigrants arriving in the long-stable Christian cities of Europe. The small French city of Dreux is an example (21). Its population grew by only 50 people per year from 1801 to 1900 and only 88 per year from 1900 to 1950, but by 1,000 per year from 1954 to 1968. By 1970, 11% of the population was recent immigrants, most of whom were Muslims from Algeria. Only a year later, 16% of the population was foreign-born. Ultra right-wing political candidates with fascist leanings made unprecedented gains in local elections, promising to do all in their power to close the newly opened mosque, distributing political pamphlets that referred to the "invasion of France by hordes of immigrants" and asserting that "the people of Dreux will defend their historical and cultural identity... the flow of immigration must be stopped" (Gaspard, 1995). In the 2017 Dutch national elections, a candidate echoed the earlier themes from Dreux with a campaign manifesto devoted to the "de-Islamisation of Holland" and pledged to close all mosques and Islamic schools and ban the Qur'an. His party garnered the second-most votes, as this liberal democratic society that had long prided itself on openness and tolerance now found itself in an identity struggle. Throughout Europe people grossly overestimate the proportion of their country's population that is Muslim, an expression of the size of their fear and discomfort. In France the average estimate of the size of the Muslim population was 31.5% when in fact it was 7.5%. In Holland where the actual figure is 6%, the average estimate was 19% (DutchNews.nl, December 14, 2016, http://www. dutchnews.nl/news/archives/2016/12/dutch-greatly-overestimate-size-of-muslim-population/).

Education has helped create the wonders of human life and culture. But it has also created what Margaret Mead called "cultural speciation." Professors Sami Adwan, Daniel Bar-Tal and I did a study of the ways Israeli textbooks portray Palestinians and Palestinian textbooks portray Israelis. I titled our report "Victims of Our Own Narratives" (http://

israelipalestinianschoolbooks.blogspot.com/). Our imaginations about the educations we provide for our children are constrained by the educations we have had. Can we possibly develop a truly radical pedagogy that transcends our own educations and enables us to look with calm at people and cultures different from ourselves? That enables us to see and feel foreigners to be equally worthy and human? Perhaps artists can help us see beyond the borders of our thoughts, gain perspectives outside of ourselves and the worlds we currently inhabit and enable us to imagine how things might be radically different.

* **Bruce E. Wexler**, M.D., is professor emeritus of psychiatry and senior research scientist at Yale School of Medicine and director of the Neurocognitive Research Laboratory at the Connecticut Mental Health Center. He is the founder and Chief Scientist of C8 Sciences, creator of C8 Kids, a brain-based content-independent pedagogy to directly improve thinking abilities in five- to nine-year-old children.

References

Bangert, M. and Schlaug, G. (2006). Specialization of the specialized in features of external human brain morphology. *European Journal of Neuroscience*, 24, 1832–4.

Benson, T. E., Ryugo, D. K., and Hinds, J. W. (1984). Effects of sensory deprivation on the developing mouse olfactory system: a light and electron microscopic, morphometric analysis. *Journal of Neuroscience*, 4, 638–53.

Blakemore, C. and Cooper, G. F. (1970). Development of the brain depends on visual experience. *Nature*, 228, 477–8.

Champagne, D. L., Bagot, R. C., van Hasselt, F., et al. (2008). Maternal care and hippocampal plasticity: evidence for experience-dependent structural plasticity, altered synaptic functioning, and differential responsiveness to glucocorticoids and stress. *Journal of Neuroscience*, 28, 6037–45.

Childe, G. V. (2003, first published 1936) *Man Makes Himself.* (Nottingham, Spokesman).

Cynader, M., Berman, N., and Hein, A. (1973). Cats reared in stroboscopic illumination: effects on receptive fields in visual cortex. *Proceedings of the National Academy of Sciences of the United States of America*, 70, 1353–4.

Cynader, M. and Chernenko, G. (1976). Abolition of direction selectivity in the visual cortex of the cat. *Science*, 193, 504–5.

D'Esposito, M. (2007). From cognitive to neural models of working memory. *Philosophical Transactions of the Royal Society of London—Series B: Biological Sciences*, 362, 761–72.

Fenichel, O. (1926). Identification, in G. Pollock (ed., 1993) *Pivotal Papers on Identification*, pp. 57–74, (Madison, CT: International Universities Press).

Freud, S. (1933). Excerpt from Lecture XXXI: The dissection of the psychical personality, in G. Pollock (ed., 1993) *Pivotal Papers on Identification*, pp. 47–52, (Madison, CT: International Universities Press).

Friston, K. J., Price, C. J., Fletcher, P., Moore, C., Frackowiak, R. S. J. and Dolan, R. J. (1996). The trouble with cognitive subtraction. *NeuroImage*, 4, 97–104.

Gaillard, W. D., Hertz-Pannier, L., Mott, S. H., Barnett, A. S., LeBihan, D. and Theodore, W. H. (2000). Functional anatomy of cognitive development: fMRI of verbal fluency in children and adults. *Neurology*, 54, 180.

Gaspard G. A Small City in France (translated by A. Goldhammer). Harvard University Press: Cambridge, 1995.

Greenson, R.R. (1954). The struggle against identification, in G. Pollock (ed., 1993) *Pivotal Papers on Identification*, pp. 159–75, (Madison, CT: International Universities Press).

Gu, X. and Han, S. (2007). Attention and reality constraints on the neural processes of empathy for pain. *NeuroImage*, 36, 256–67.

Hubel, D. H. (1988). Deprivation and development, in *Eye, Brain and Vision*, pp. 191–217, (New York: Scientific American Library).

Iacoboni, M., Woods, R. P., Brass, M., Bekkering, H., Mazziota, J. C., and Rizzolatti, G. (1999). Cortical mechanisms of human imitation. *Science*, 286, 2526–8.

Jackson, P. L., Meltzoff, A. N., and Decety, J. (2005). How do we perceive the pain of others? A window into the neural processes involved in empathy. *NeuroImage*, 24, 771–9.

Jans, J. E. and Woodside, B. (1987). Effects of litter age, litter size, and ambient temperature on the milk ejection reflex in lactating rats. *Developmental Psychobiology*, 20, 333–44.

John, E. R., Tang, Y., Brill, A. B., Young, R. and Ono, K. (1986). Double-labeled metabolic maps of memory. *Science*, 233, 1167–75.

Kaye, K. (1982a). Organism, apprentice, and person, in E. Tronick (ed.) *Social Interchange in Infancy: Affect, Cognition, and Communication*, pp.183–96, (Baltimore: University Park Press).

Kaye, K. (1982b). *The Mental and Social Life of Babies: How Parents Create Persons.* (Chicago: University of Chicago Press).

Klein, R. G. and Edward,I B. (2002) *The Dawn of Human Culture.* (New York: John Wiley and Sons, Inc).

Klinnet, M., Emde, R. N., Butterfield, P., and Campos, J. J. (1986). Social referencing: the infant's use of emotional signals from a friendly adult with mother present. *Developmental Psychology*, 22, 427–32.

Luria, A. R. (1973). *The Working Brain.* B. Haugh (trans.) (New York: Basic Books).

McBrearty, S. (2007) Down with the revolution, in P Mellars, K Boyle, O Bar-Yosef, C Stringer (eds) *Rethinking the Human Revolution.* (Cambridge, McDonald Institute for Archaeological Research).

Meltzoff, A. N. and Moore, M. K. (1989). Imitation in newborn infants: exploring the range of gestures imitated and the underlying mechanisms. *Developmental Psychology*, 25, 954–62.

Reich, A. (1954). Early identifications as archaic elements in the superego, in G. Pollock (ed., 1993) *Pivotal Papers on Identification*, pp. 177–95, (Madison, CT: International Universities Press).

Rizzolatti, G., Fadiga, L., Gallese, V., and Fogassi, L. (1996). Premotor cortex and the recognition of motor actions. *Cognitive Brain Research*, 3, 131–41.

Schlaug, G. (2001). The brain of musicians: a model for structural and functional adaptation. *Annals of the New York Academy of Sciences*, 930, 281–99.

Singer, T., Seymour, B., O'Doherty, J., Kaube, H., Dolan, R. J., and Frith, C. D. (2004). Empathy for pain involves the affective but not sensory components of pain. *Science*, 303, 1157–62.

Stebbins, G. T., Carrillo, M. C., Dorfman, J. et al. (2002) Aging effects on memory encoding in the frontal lobes. *Psychology and Aging*, 17, 44–55.

Tretter, F., Cynader, M., and Singer, W. (1975). Modification of direction selectivity of neurons in the visual cortex of kittens. *Brain Research*, 84, 143–9.

Umilta, M. A., Kohler, E., Gallese, V., et al. (2001). I know what you are doing: a neurophysiological study. *Neuron*, 31, 155–65.

Vygotsky, L. S. (1978). *Mind in Society: The Development of Higher Psychological Processes.* (Cambridge: Harvard University Press).

Weaver, I. C. G., Cervoni, N., Champagne, F. A., et al. (2004a). Epigenetic programming by maternal behavior. *Nature Neuroscience*, 7, 847–54.

Weaver, I. C. G., Diorio, J., Seckl, J. R., Szyf, M., and Meaney, M. J. (2004b). Early environmental regulation of hippocampal glucocorticiod receptor gene expression: characterization of intracellular mediators and potential genomic sites. *Annals of the New York Academy of Sciences*, 1024, 182–212.

Weaver, K.E. and Stevens, A. A. (2007). Attention and sensory interactions within the occipital cortex in the early blind: an fMRI study. *Journal of Cognitive Neuroscience*, 19, 315–30.

Wexler, B. E. (2004) Using fMRI to study the mind and brain, in R. Shulman and D. Rothman (ed.) *Brain Energetics and Neuronal Activity*, pp. 279–94 (West Sussex: John Wiley and Sons).

Wexler, B. E. (2006). *Brain and Culture: Neurobiology, Ideology and Social Change.* (Cambridge: MIT Press).

THE ARTS AS PORTHOLE TO ALTERNATE APPROACHES, SOLUTIONS, AND PERSPECTIVES

Liane Gabora

Introduction

I was honored to have been invited to write an essay for the *Back to the Sandbox: Art and Radical Pedagogy* project for this timely and provocative exhibition distills truths that are of vital importance to the continued wellbeing of human civilization. In this essay, I hope to explain some of the science behind why the arts "shake up" people's worldviews and why we are all at a tipping point in history when worldviews need shaking up.

Why do the arts "shake up" people's worldviews and why are we all at a tipping point in history when worldviews need shaking up? A scientific exploration of these questions has pedagogical implications. It can show how worldviews are transformed through the arts, and how the arts can, therefore, revitalize our educational system. It can also show why in a changing environment, cultivating creativity, diversity and uniqueness become more valuable than disseminating factual knowledge. But to understand the path to these conclusions, we must first consider the way in which we construct reality, how we share these constructions through generations, and how worldviews change through the absorption of cultural norms and attitudes, as well as through internal reflection and creative insight.

Worldviews and why they need shaking up

What is a worldview?

Although the concept of a worldview is related to the concept of a mind, the emphasis of a worldview is on a particular way of *seeing* the world and *being in* the world. Thus, while the term *mind* refers to the set of cognitive faculties, including perception, judgment, memory and consciousness, the term *worldview* refers to an individual's particular web of understandings and basic outlook. One can think of someone's worldview as having a

particular shape that reflects their own basic orientation in life, how they see things as being related to each other, how they interpret situations, what they tend to dwell upon or to avoid. Their understanding of the dynamics and complexity of the world also plays a factor. Thus, a worldview has a characteristic structure and the individual's behavior reflects the unique architecture of this web of understandings. Each idea or interpretation of a situation that each individual develops is a different expression of this underlying core network of understandings, beliefs and attitudes.

It can be necessary to categorize and compartmentalize information in order to accomplish particular tasks. But if any particular compartmentalization is taken too seriously—i.e., assumed to be a faithful representation of what really exists—this separation distorts how the world is seen, which in turn distorts how a person acts.

The development and evolution of worldviews

Our worldviews reflect the patterns and regularities we encounter in the world and help us fully live and feel good about our lives. The formation of worldviews is also highly influenced by the corresponding worldviews of influential people in our lives such as parents and teachers. We assimilate social norms and rules that help us know and do what is expected and help us behave in ways that are harmonious. Sometimes, in certain situations, these norms hold us back from responding appropriately. So, the structure of our worldviews both enables and constrains us, and inevitably is, in some ways, arbitrary. Since our world is constantly changing, our worldviews must also constantly change to keep up. Thus, our worldviews are constantly changing and evolving over lifetimes and over generations.

Cultural evolution, like any evolutionary process, must balance change and continuity (Gabora, 2013). If too much emphasis is placed on generating novelty, then proven effective solutions and approaches fall by the wayside, while effort is spent reinventing the wheel. On the other hand, if too much emphasis is placed on perpetuating existing approaches and attitudes, then our worldviews grow stagnant; we fall out of touch and lose the ability to respond effectively to unforeseen circumstances.

A useful way to investigate the interplay between novelty-generating and continuity perpetuating processes in culture is to us an agent-based model (ABM). An ABM is a computer program that simulates the actions and interactions of autonomous agents—both at the individual level and the collective level (e.g., organizations or social groups)—in order to assess their effects on the system as a whole (for a review of ABMs see Niazi & Hussain, 2011). Because ABMs enable us to manipulate variables and observe the effects in a more controlled manner than in real life, they are playing an important role in the development of a scientific framework for creative cultural change (e.g., Gabora, 2008; Guardiola, Diaz-Guilera, Perez, Arenas, & Llas, 2002; Spencer, 2012; Watts & Gilbert, 2014).

One such ABM is EVOC (for EVOlution of Culture), a computational model of cultural evolution developed by my students and I (Gabora, 1995, 2008). EVOC consists of an artificial society of agents with very simple (neural network) "brains" that both invent new actions and imitate actions performed by neighbors. Thus, their "culture" consists solely of ideas for actions of different kinds. These artificial agents learn generalizations concerning what kinds of actions are fit given the state of their world. Each agent can do one of two

things. They can either (1) *invent* a new action, using their acquired knowledge about their world to modify existing ideas, or they can (2) *imitate* the action of one of their neighbors. Through this interplay of inventing and imitating, the effectiveness of their actions increases cumulatively over time, as more effective actions come into existence.

EVOC enables change to various parameters of the model that affects the cultural evolution process. If the agents' ability to invent is turned off, then new actions never come into existence, there is nothing to imitate, and there is no cultural evolution. If the agents devoted a small amount of effort to inventing, not only would cultural evolution be possible, but eventually all agents would benefit.

The computer model makes clear something that historical analysis reveals: Both invention and imitation are crucial to the wellbeing of a society. While creative individuals generate the novelty that fuels cultural evolution, an excess of creative absorption impedes proven solutions, effectively rupturing the fabric of society. Thus, a society in which creative efforts are balanced by conforming efforts, new ideas emerge. If effective, they are not easily lost by society.

A quickly changing world calls for a quickly changing worldview

A particularly interesting finding to come out of the EVOC research is that when the artificial agents' external environment is not static but in a state of creative change, the society as a whole performed better (Gabora, Chia, & Firouzi, 2013). This makes sense. If the world changes, our worldviews must change to keep up. Bottom line: the faster the world changes, the greater the relative value of innovation versus imitation. Also, the faster the world changes, the greater the relative value of diversity. There are two reasons diversity becomes important. The first is: In changing times its harder to predict in advance what will be useful so it's a good idea to have available a variety of tools, techniques, attitudes and skill sets. Second: Culture tends to become more complex over time. So, if things are changing quickly, there are more "cultural niches" for different approaches and skill sets.

These lessons have important implications for the role of the arts in education. First, let's take a brief look at the process that fuels cultural innovation: creativity.

The creative process

According to the *honing theory of creativity*, culture evolves through the tinkering and transformation of worldviews, which are inherently self-mending and creative (Gabora, 2017). What generally drives creativity is an unexpected finding, a sense of fragmentation, curiosity, restlessness, disequilibrium, or what has sometimes been called "the gap". It can be due to something as trivial as the sense that a little scribble lacks a sense of completion or as profound as the need for creative solutions to complex problems such as poverty or climate change. A "gap" increases what Hirsh, Mar, and Peterson (2012) refer to as *psychological entropy*: arousal-generating uncertainty. This arousal can either be experienced negatively, as a source of anxiety, or it can be experienced positively, as a wellspring for creativity.

A gap challenges us to respond to it by spontaneously reorganizing our web of understandings so as to make sense of the unexpected or express something that needs to come out. We can channel arousal in creative directions because our worldviews are

self-organizing. We can reflect on their outputs, revise them, consider them from different perspectives, until psychological entropy reaches an acceptable level and we feel the piece is complete. Through play, exploration, imagination, fantasy, and "what if" type thinking, our worldview may achieve a more coherent state.

Why the arts "shake up" people's worldviews

Although it is tempting to focus on the external product that results from a creative task, the internal cognitive restructuring brought about by the creative process is also important, both for the creator and appreciators of the creative work. Honing an idea involves drawing associations, reorganizing understandings, and working through emotions. Not only does creativity lead to richer and more coherent understandings, but creating art can improve one's ability to manage intense feelings (Moon, 1999, 2009). Studies have shown that higher levels of creativity are correlated with positive affect (Hennessey & Amabile, 2010). In the extreme, the creative product can be seen as the "excrement" of this internal process of transformation.

An individual's artistic works and other creative outputs are like footprints in the snow; they suggest the "shape" of the underlying worldview (which we never see directly) and how it is transforming. These creative outputs, which are sometimes referred to as a "body of work," indicate that they are integrally related to one another, and often pave the way for one another (Gabora, 2010; Gabora, O'Connor, & Ranjan, 2012). They may also pave the way for transformative processes in others who interact with these creative outputs. In this way, the transformative process of said creator becomes externalized and assimilated, and contributes to the global process of the human cultural evolution as a whole.

The more experiences one has, the more ingredients one has to draw upon in one's creative process. Artistic expression can be seen as the manifestation of deeper hidden structures and as a means of accessing personal history that would not be available only through verbalization (Karkou & Sanderson, 2006). The creative arts thus provide a structured way for people to question beliefs and attitudes, restructure understandings, and reintegrate worldviews that are fractured or contain inconsistencies. The creative arts keep our worldviews flexible. They remind us that the way we carve up knowledge into academic disciplines is an artificial invention that we create for pragmatic purposes and does not reflect the nature of reality.

Pedagogical implications

Government policies and educational systems do not prioritize the cultivation of creativity, and in some ways, discourage it (Snyder, Gregerson, & Kaufman, 2012). Spontaneous deviations from school lesson plans tend not to be tolerated for fear that curricula would not be covered and scores on standardized tests would fall. As we saw earlier, the more quickly the world changes, the more quickly worldviews need to change in response. And right now, the world is changing at a rate that has never before been seen.

It made sense that when societies didn't change much from one generation to the next, the education system focused on the dissemination of knowledge. However, in this era when societies are vastly changing from one generation to the next, it is difficult to predict what kinds of situations, problems and opportunities future generations will face.

Opportunities are now needed to develop (1) competency deciphering complex situations, (2) confidence in the ability to find creative, harmonious approaches and solutions, and (3) skill sets that match interests and aptitudes.

Educational experiences prepare children to be contributing members of society. *"Crystalized" knowledge*—canned facts that provide a richer understanding of the world and how it functions, that prepare us for tasks and problems we all predictably face—is the standard educational format. However, a fast-changing world calls for educational systems that prepare youth by passing on *"fluid" knowledge*: the ability to find solutions to problems we can't predict. This knowledge should provide access to safe testing grounds to *explore ways of relating to the world* in situations where the outcome is inconsequential. To this end, programs such as *The Sandbox* project are unparalleled; they enable people to experiment with how actions lead to outcomes and gain a sense of self-efficacy. Exposure to art catalyzes new perspectives. For example, a recent study showed that readers feel as if the voices and perspectives of fictional characters stay with them for some time after they've finished the book (Alderson-Day, Bernini, & Fernyhough, 2017). Observing the planting of a citrus tree in Iceland challenges people to rethink their understanding of climactic zones and start to come to terms with the long-term effects of climate change.

To achieve a sustainable world, it is necessary to have a *sustainable worldview*: a way of seeing and being in the world that incorporates how different systems are interconnected and ecologically affect one another. Overcompartmentalization of knowledge may lead to an artificially compartmentalized view of reality. If knowledge is presented in compartmentalized chunks, then our youth may end up with a compartmentalized understanding of the world. If knowledge were presented more holistically, a more integrated kind of understanding might be possible. Exposure to a range of creative opportunities such as dance, painting, pottery, or creative writing allows for divergent thinking and the integration of experiences into a cohesive view.

An interesting aspect of *The Sandbox* project is that it fosters open ended, individualized exploration. Compare this to the experience of playing a computer game. Computer games are riveting and addictive; they're the gummy bear of leisure activities. Playing a computer game involves choosing amongst options, all of which were thought out in advance by the game designer. Thus, they do not provide opportunities to dream up a way of doing something that no one has thought of before, to "break out of the box". Moreover, kids everywhere are playing the same games, facing the same situations, and making the same choices. Thus, computer games cultivate generic worldviews, as opposed to worldviews that feature an individual's knowledge that capitalizes on that individual's unique mix of aptitudes and interests.

Conclusions

The *Back to the Sandbox* project is part of a family of allied programs such as *Learning Through the Arts*, in which students learn about food chains by painting murals or use theater and dance to learn about molecular forces and chemical bonds. Such ventures challenge our worldviews and invite new ways of understanding and relating. These activities can help forge the kind of integrated, innovative, resilient and deeply ecological worldviews that are needed to solve tomorrow's problems and create a bright future.

Acknowledgments

This work was supported by a grant (62R06523) from the Natural Sciences and Engineering Research Council of Canada.

* **Liane Gabora** is an Associate Professor of Psychology and creativity studies at the University of British Columbia. Her research, which employs both experimental studies with humans and computational models, has focused on creativity and how creative minds evolve over time as people adapt ideas to their own needs and tastes and put their own spin on them. Professor Gabora has over 150 scholarly publications in a diverse range of journals, as well as book chapters, conference proceedings papers, and encyclopedia articles. She has obtained over one million dollars in research grants and has given lectures worldwide.

References

Alderson-Day, B., Bernini, M., & Fernyhough, C., (2017). Uncharted features and dynamics of reading: Voices, characters, and crossing of experiences. *Consciousness and Cognition*, 49, 98–109.

Gabora, L. (1995). Meme and variations: A computer model of cultural evolution. In (L. Nadel & D. Stein, Eds.) *1993 Lectures in Complex Systems* (pp. 471–486). Boston: Addison Wessley.

Gabora, L. (2008). Modeling cultural dynamics. *Proceedings of the Association for the Advancement of Artificial Intelligence (AAAI) Fall Symposium 1: Adaptive Agents in a Cultural Context* (pp. 18–25). Menlo Park, CA: AAAI Press.

Gabora, L. (2010). Revenge of the 'neurds': Characterizing creative thought in terms of the structure and dynamics of human memory. *Creativity Research Journal*, 22, 1–13.

Gabora, L. (2013). An evolutionary framework for culture: Selectionism versus communal exchange. *Physics of Life Reviews*, 10(2), 117–145.

Gabora, L. (2017). Honing theory: A complex systems framework for creativity. *Nonlinear Dynamics, Psychology, and Life Sciences*, 21, 35–87.

Gabora, L., Chia, W. W., & Firouzi, H. (2013). A computational model of two cognitive transitions underlying cultural evolution. In M. Knauff, M. Pauen, N. Sebanz, & I. Wachsmuth (Eds.), *Proceedings of the 35th Annual Meeting of the Cognitive Science Society* (pp. 2344–2349). Austin TX: Cognitive Science Society.

Gabora, L., O'Connor, B., & Ranjan, A. (2012). The recognizability of individual creative styles within and across domains. *Psychology of Aesthetics, Creativity, and the Arts*, 351–360.

Guardiola, X., Diaz-Guilera, A., Perez, C., Arenas, A., & Llas, M. (2002). Modeling diffusion of innovations in a social network. *Physical Review E*, 66, 026121.

Hennessey, B. A. & Amabile, T. (2010). Creativity. *Annual Review of Psychology*, 61, 569–98. doi: 10.1146/annurev.psych.093008.100416.

Karkou, V. & Sanderson, P. (2006). *Arts therapies: A research based map of the field*. London: Elsevier Churchill Livingstone.

Moon, B. (1999). The tears make me paint: The role of responsive artmaking in adolescent art therapy. *Art Therapy: Journal of the American Art Therapy Association, 16*, 78–82. doi:10.1080/07421656.1999.10129671.

Moon, B. (2009). *Existential art therapy: The canvas mirror*. Springfield, IL: Charles C. Thomas Publisher, Ltd.

Niazi, M., & Hussain, A. (2011). Agent-based computing from multi-agent systems to agent-based models: A visual survey. *Scientometrics*, 89, 479–499.

Snyder, H., Gregerson, M., & Kaufman, J., Eds. (2012). *Teaching creatively*. New York: Springer.

Spencer, G. M. (2012). Creative economies of scale: An agent-based model of creativity and agglomeration. *Journal of Economic Geography*, 12, 247–271.

Watts, C., & Gilbert, N. (2014). *Simulating innovation: Computer-based tools for rethinking innovation*. Cheltenham UK: Edward Elgar Publishing.

HOLLOW STEMS

Luis Camnitzer

During the 1960s and '70s artists were pushing for integration of art and life. The idea was to permeate life with creativity and critical thinking, and to "liberate" art from commerce and life from the treadmill. Over time, integration did start to work, but in the wrong direction. Art integrated further into commerce and terms that once were typical for art creation became entrepreneurial buzzwords. Liberal arts and humanities, the areas where freethinking and open speculation had been preserved, lost funding and academic status. And even in science, applicability predominted over theory. Then, around 2006, STEM (science, technology, engineering and mathematics), became the educational curricular force that focused on applicability.

On its surface STEM seems to be a reasonable proposition. It addresses real life and, if government rhetoric is to be believed, equips students to be prepared for an increasingly technology-based future, enter an updated labor market, while it also helps countries to be more competitive. It was introduced with the explicit purpose of helping the U.S. secure markets against other countries and thus promote national prosperity. As one would expect, other countries also favor STEM and share the wish to be more competitive. Although not openly acknowledged, this promotion seems to be part of a very bellicose arrangement where each contending party tries to get ahead of all others, hoping that their competitors lose the battle. Donald Trump's slogan, "make America great again," is a *de facto* declaration of economic war against whatever other country would also like to be "great."

In 2011, the U.S. designed a next step for the future: ARPA-ED (Advanced Research Project Agency for Education). Although based on the model of DARPA, the Defense Advanced Research Project Agency that aggressively developed the internet, ARPA-ED hasn't yet taken off. But the arguments justifying it were revealing. ARPA-ED hoped to change education the way "Internet, GPS, and robotics have transformed commerce, travel, warfare, and the way we live our daily lives."[1] The goals were explained as follows:

1 https://www.ed.gov/sites/default/files/arpa-ed-background.pdf, accessed 03/20/2015.

"At the center of the President's strategy to win the future is the intersection of education, innovation and infrastructure. The growth industries of today and tomorrow require a workforce with unprecedented knowledge and skills and greatly improved adaptability. By aggressively pursuing new and better ways to educate and train our citizens, we can meet those requirements, leapfrog other nations, and reclaim global leadership in education. To achieve this, the United States must out-innovate the competition—competition that is already outperforming the United States and has clear national direction."[2]

There is no mention of either any welfare of the citizenship or the development of satisfied, mature and well-rounded individuals. The only time the document mentions the word "arts" is on page 14: "English language arts," referring to the effectiveness of the Common Core State Standards Initiative.

Now, in 2017, six years later, ARPA-ED is still on hold, seemingly since it would require the government to spend money on education. But the ideology behind it survives. It informs curricular design—mostly in private schools and charter schools—and is increasingly accepted around the world as "normal" thinking. Spanish Minister of Culture Ignacio Wert proclaimed in 2013 that art education distracts from other courses, and although at the time his remarks were ridiculed, two years later a Spanish government report, *Estrategia Universidad 2015* (Strategy University 2015), described the merging of academic and corporate thinking as something taken for granted:[3]

"The investment in education guarantees the future development of the country and always is a profitable investment. Education is one of the axles of the solution to the problems related to the competitiveness of a country. In a globalized world with an open labor market, it's necessary to best educate and enable university graduates for more enterprising culture with a greater social engagement."[4]

"Knowledge is a capital, but it's necessary to identify in it what in each moment really has value for the market, and that is what is transferrable."[5]

"The Ministry of Science and Innovation places great importance to the improvement of the transformation of the results of research in market value, in the betterment of entrepreneurial competitiveness and in the contribution for the change of Spain's economic model."[6]

2 Ibid.

3 *Estrategia Universidad 2015* Gobierno de España, Ministerio de Ciencia e Innovación, 2015.

4 "La inversión en educación es la garantía del desarrollo futuro de un país y es siempre una inversión rentable. La educación es uno de los ejes de la solución de los problemas relacionados con la competitividad de un país. En un mundo globalizado, con un Mercado laboral abierto, es necesario formar mejor y capacitar a los titulados universitarios para una cultura más emprendedora y con mayor compromiso social." Ibid. p. 25, 26.

5 "El conocimiento es un capital pero es necesario identificar en él lo que realmente tiene valor para el mercado en cada momento y eso es lo que es transferible." Ibid. p. 38.

6 "La Unión Europea, en la reciente recomendación de la Comisión C(2008)1329 de 10. 04. 2008 insiste en que la transferencia de conocimiento es una herramienta esencial en el desarrollo de la estrategia de Lisboa en tanto se

It is easy to attack governments for prioritizing national interests over individual welfare and wellbeing, and it's equally easy to attack STEM for its neglect or disregard of the humanities and the transformation of education into refined vocational training. On the other hand, the identification of STEM with prosperity, particularly national prosperity, helps overlook deeper and more dangerous implications. With the goal of forming a meritocracy, STEM will further increase social stratification by further separating menial from qualified activities. Although in developing economies STEM may give the needed help to improve survival problems, it also poses the danger of reviving the old colonial *comprador* elites and solidifying local oligarchies.

In reviewing the activities of two MIT graduates who returned to their countries (Nepal and Nigeria), an article in *MIT News* states:

> "[...] STEM education has proved successful in bridging economic gaps worldwide. Thousands of alumni have made education their life's mission, with some bypassing six-figure jobs in the United States to be catalysts of change in their native countries."[7]

While the sacrifice of the returning students is commendable, the article does not explain how the bridging of economic gaps will benefit the citizens or what infrastructure improvements will be provided. Ram Rijal, who started a school in Nepal, only comments: "There are people much more qualified than myself, but we need to find them."[8] And visiting Nigeria after one year at MIT, Obina Ukwuani "saw a huge discrepancy between his knowledge and abilities of his boarding school classmates." "I could tell that there was just no way they could accomplish what I may accomplish simply because they weren't equipped. I just thought, 'It's the educational system.'"[9]

Correctly applied, STEM may help solve many problems. Thus, to attack STEM might sound as regressive as denying technological progress. STEM therefore is not the problem. The real danger is in reductionist STEMism and the usurpation of the education it promotes. STEM only occupies a segment of knowledge, but its promoters try to have it represent the whole picture. With it, STEMism has also generated a form of social blackmail. Job opportunities in the U.S. increasingly demand STEM education with students forced to participate. Those who don't, mainly because they can't afford the expense of education, remain in both a jobless and luddite-like sphere, thus further increasing existing social disparities. Charter schools, better financed than normal public schools, are joining this trend. An article about one of them (LEAP University Academy

relaciona directamente con una mejora de la innovación y la productividad de las empresas. En ese contexto se sitúa la Estrategia Universidad 2015 Desde el.

MICINN se da gran importancia, a la mejora de la transformación de los resultados de la investigación en valor de mercado, en mejora de la competitividad empresarial y aportación de conocimiento para el cambio de modelo económico en España." Ibid. p. 36.

7 "Investing in Global Education," *MIT News*, March/April 2017, p. 25.

8 Ibid.

9 Ibid. p. 26.

Charter School) ends with: "Rags to riches—it is the American Way. It works in Camden; it can work elsewhere too."[10]

Over the years STEM proponents have become less dogmatic and have tried to include transdisciplinary thinking and creativity. STEAM (the addition of art) and STREAM (the addition of reading skills) are two of the reactions recognizing the initial weaknesses of the project. However, by making applicability and technology the primary goal, the STEM curriculum still focuses on the quantitative aspect of knowledge and the predictability of results. Creativity in this context is not only redefined but also seriously amputated.

For a long time corporate thinking has been integrating art tools for commercial development. "Blue-sky thinking," "thinking outside the box," "disruptive thinking," "broadband thinking," and many other terms are "in-corporated" into entrepreneurial profit-making. A good entrepreneur is innovative, an innovator is ingenious, and—ergo—ingenuity is creativity.

The marketing company Persado created software that tries to approximate art creation at the service of advertising to what we may call "the state of the arts." It "deconstructs advertisement into five components, including emotion, words, characteristics of the product, the 'call to action' and even the position of text and the images accompanying it."[11] Persado borrowed methodologies usually employed to form artists and applied them to marketing. Lawrence Whittle, head of sales, believes that "A creative person is good but random. We've taken the randomness out by building an ontology of language."[12] The process erased the borderline between art and non-art professions by removing it from the exploration of knowledge and reducing it to a set of recipes.

By using STEM as a closed environment, words taken from art creation become false synonyms that mostly refer to ingenuity but not to art. While art is a tool for totally open exploration, ingenuity only works with combinations of available resources under conditions of scarcity. Ingenuity therefore works by reshuffling what's available to increase resonance and possible effects that maximize productivity in the realms of the practical. Ingenuity does not make new meanings. It keeps speculation limited to the solving of issues pertaining to the ignorance of the predictable. Results deserve admiration and gratitude, but the ability to wonder is, if not absent, seriously diminished.

It is therefore indisputable that to function at its best, STEM needs the development of ingenuity. And it's also logical that a STEM-oriented society needs to pursue the development of a meritocracy, filter out those that may contribute to technological progress and lower the status of those that may not. Because the humanities often deal

10 Gloria Bonilla-Santiago, "STEM and Urban Schools: Opportunities to Escape Poverty's Cycle," *U.S. & World Report News*, 12/19/2011, https://www.usnews.com/news/blogs/stem-education/2011/12/19/stem-and-urban-schools-opportunities-to-escape-povertys-cycle-, accessed 03/26/2017.

11 Cristopher Mims, "Artificial Intelligence Comes to Your Inbox," *The Wall Street Journal*, p. B1-B2, 08/25/2014.

12 Ibid. The webpage of Persado shows a chart with the following steps: "Database of semantically organized marketing language; We produce & model all the possible variations (up to 16 million); We create the most representative sample from space variants; We optimize the sample size that will allow us to determine the relationship between ad copies elements & user responses; We dramatically improve conversion rates. 30%–100%. Systematically. Across online channels; We deliver powerful insights on the emotions & features that make your product sell." http://www.persado.com/how-it-works/marketing-language-engineering, accessed 08/26/2014.

with imponderables, this discipline is more lax in that filtering process. A STEM-guided education eliminates this laxity and improves accountability. It allows a globalized curriculum with transferrable knowledge perfectly measurable with credits and grades, satisfies a U.S. profit-oriented education industry and complies with the dreams of the Bologna Accords.

One of the big questions then is what happens to the local concerns as opposed to the global? The financial flow, unification of markets, English as the new Latin, and art not addressing the immediate geographic public all erode the notion of locality. Art has already been downgraded to produce marketable objects classed as useless. Guided by meritocratic criteria as well, only a chosen few are able to raise art to be a productive moneymaking profession and they cater to a scattered few. The growth of museum visitors is based on tourists, not on people from the local neighborhood. Meanwhile, with the humanities diminished or excluded, communal issues are confined to the solution of practical survival problems while culture and identity issues are slowly excluded from the educational process.

This problem is not ignored by artists, just not well addressed. Art as social practice is an activist response that tries to counter these issues. However, when not used to extol individual authorship, most of artistic social practice is not much more than improved social service. As such, it becomes one more functionalist tool and plays into STEMism's hands. Art as social practice attempts to normalize progressive behavior instead of opening perspectives. Art should, instead, be a way of thinking within both the predictable and the unpredictable spheres of knowledge. Unfortunately it's questionable if STEM will allow this big A-art to prosper and if its exclusionary policy is at all reversible. Schools are putting art among extracurricular activities. University studies are cutting down the humanities and, more specifically, the study of art. Emory University closed its art school in 2012, invoking reallocation of funds needed to create leaders for the country. In 2015, 26 of 60 Japanese public universities complied with the request of Hakubun Shimomura, the Minister of Education, and cut their humanities and social studies programs. According to *Time Magazine,* this followed Prime Minister Shinzo Abe's wish to "reassert Japan's economic and political stature."[13] Singapore is laying out its own view of the school of the future. Children as early as three years old are introduced to "computational thinking." Using programmable toys, by age six they are able to use MIT's program Scratch. A teacher describes it: "The toys teach them that programming is a game and not a form of punishment." According to the government, "there is a difference between a country that consumes technology and a country that creates technology." Adrian Lim, a former Minister of Education presently in charge of the project sums it up with: "Technology is a tool to help their creativity. We want them to develop new ideas. We need to construct intelligent citizens."[14] Intelligence, however, is being defined by national usefulness, and while believing they prepare students to work with artificial intelligence, they may be

13 Nash Jenkins, " Alarm Over Huge Cuts to Humanities and Social Sciences at Japanese Universities," Time Magazine, 09/15/2015 http://time.com/4035819/japan-university-liberal-arts-humanities-social-sciences-cuts/, accessed 03/26/2017.

14 Beatriz Guillén, "La escuela del future ya existe en Singapur," El País, Madrid, 06/10/2016, p. 28.

implanting artificial intelligence in the students instead. Again, on the surface this project too seems commendable and pedagogically progressive.

One of the characteristics of a good work of art is that during its life there is always an unexplainable residue. Exhaustive explanation erases the need for the work, the same as a punch line given in advance eliminates the joke and makes it fall by the wayside. It is this residue that separates the known from the unknown. For lack of a better word, we may call this residue the "poetic" aspect. STEM's push to occupy the territory of education obliterates the perception of the poetic. Or, if some is left, it's reserved for an increasingly rarified wealthy segment of the population.

Artists are presently divided into those who pursue the making of art objects/situations and those who seek an activist role in society. It's still the old polemic between autonomous art and nonautonomous art, art on its own or art merged with life. Few artists are fighting for art as a third and more important possibility: as a nonspecialized form of knowledge acquisition. Thus, we are facing a wrong menu of choices: to work as specialists in our trade in isolation of political/educational reality, or to become creative political activists. The problem is that autonomous art, in its efforts to escape conventionality and equip us to critically defy normality, is increasingly led to abandon society and real life. Political activism, on the other hand, in its effort to serve and improve society, works with predictable knowledge and tries to normalize its achievements. The questions then are how to integrate the poetic aspect into political resistance, how to integrate normalization with creativity, how to have normalization constantly de-normalize and re-normalize, and how to seek the poetic in all our activities, STEM included.

Unexpectedly, and not with education in mind, but strategizing the destruction of Iraq, Donald Rumsfeld summed up the problem:

> *"There are known knowns; there are things we know we know. We also know there are known unknowns; that is to say we know there are some things we do not know. But there are also unknown unknowns—the ones we don't know we don't know."*[15]

STEM only focus on the known knowns and the unknown knowns. Good art tries to address the unknown unknowns. If Rumsfeld had made the connection with art rather than with fictional weapons of mass destruction, we might have faced a better future.

* **Luis Camnitzer** is a Uruguayan artist and educator based in New York and Professor Emeritus of the State University of New York, College at Old Westbury. He represented Uruguay in the 1988 Venice Biennial and, among many other exhibitions, participated in Documenta XI and the Whitney Biennial 2000. His work is in the collection of over forty international museums and is represented by Alexander Gray Associates, NY, and Galería Parra y Romero, Madrid. He is author of several books, among them *New Art of Cuba, Conceptualism in Latin America: Didactics of Liberation* and *On Art, Artists, Latin America and Other Utopias*, all by University of Texas Press.

15 Donald Rumsfeld in a 02/12/2002 briefing to the U.S. Department of Defense.

BORN
TO BUILD

BORN TO BUILD

Michael Joaquin Grey

What Is Not Built?, 1988–2018
Pedagogical illustration

The ontogeny of building. Beginning and ending with body knowledge.
A dynamic recursive pedagogical cycle.

WHAT IS NOT BUILT?

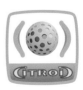

Citroid System Logo, 1996

■ *Kindergarten 2.0* is the creation of a new pedagogic cycle beginning with a refection on one of the more under recognized influences on modernism—kindergarten.

Kindergarten 2.0 is a social sculpture that begins a narrative of development—connecting the elemental to early pedagogy. The movement's intention is to reveal the deep connection between the prolific innovation and cultural production of early modernism as a recapitulation of the "serious play" from Froebel's kindergarten. From the realization of the importance of early pedagogy we have worked to evolve and create a new set of toys, tales and tools that offer a holistic pedagogical cycle relevant to each successive generation.

The goal is a collection of playthings and object lessons that recapitulate both our history and increase our knowledge of the needs of the present culture and ecosystem. These playthings, or as Froebel called them, "gifts and occupations" allow for the growth of empathy and holistic awareness. As the lessons are passed from one generation to another, adaptations should evolve to reflect important changes in society and the environment.

The new pedagogy of kindergarten developed in the romantic era greatly expanded the consciousness of the modern era. Kindergarten was invented by the crystallographer Fredrick Froebel in Germany during the mid-19th century and had a profound yet largely unrecognized influence on early modernism. Kindergarten spread around the world very rapidly and could be considered among the earliest transcending cross-cultural movements. The original kindergarten gave birth to a new perspective on early child development and creativity. It was radical for the shift in focus toward children's formation and learning through play and empathy with nature. Several of the innovations of kindergarten, which are often taken for granted today, are the creation of the sandbox, the planting and stewardship of a garden (derived from the root of the word itself: kindergarten), and the use of the gifts and occupations: a set of play materials and toys (the first product of the toy company Milton Bradley), which were the basis of curriculum for the original kindergarteners.

Most of the early modernists were the first few generations of kindergarteners. The Bauhaus was in many ways based on a very similar pedagogic model. Many of the professors at the Bauhaus were some of the original generation of kindergarteners or worked as kindergarten teachers. It is striking how much of their mature artistic work remains almost untransformed from the early pedagogic play and exercises of Froebel's gifts and occupations.

Kindergarten 2.0, 2009
A modification of Alfred Barr's *Cubism and Abstract Art*, 1936
Digital print, 45 × 36 inches / 114.3 × 91.4 cm
Courtesy of the artist

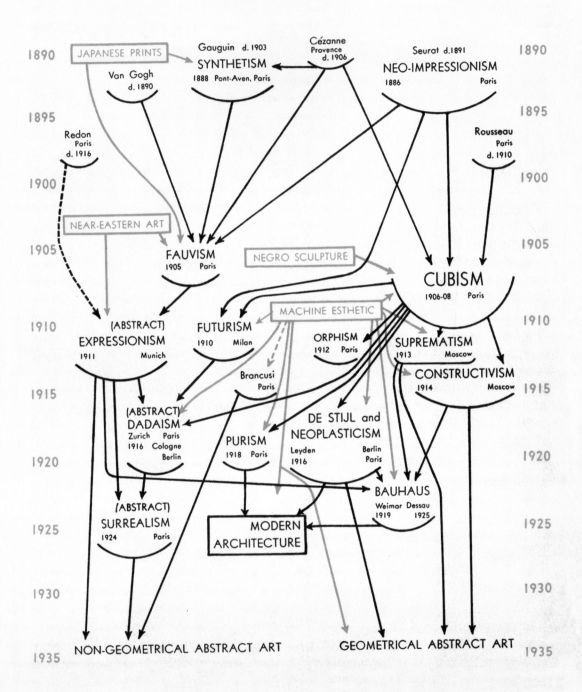

1830

JAPANESE PRINTS

Gauguin d. 1903
SYNTHETISM
1888 Pont-Aven, Paris

Cézanne
Provence
d. 1906

Seurat d.1891
NEO-IMPRESSIONISM
1886 Paris

1890

Van Gogh
d. 1890

1895

Redon
Paris
d. 1916

Rousseau
Paris
d. 1910

1900

NEAR-EASTERN ART

1905

FAUVISM
1905 Paris

NEGRO SCULPTURE

CUBISM
1906-08 Paris

1910

(ABSTRACT)
EXPRESSIONISM
1911 Munich

FUTURISM
1910 Milan

MACHINE ESTHETIC

ORPHISM
1912 Paris

SUPREMATISM
1913 Moscow

CONSTRUCTIVISM
1914 Moscow

1915

Brancusi
Paris

(ABSTRACT)
DADAISM
Zurich Paris
1916 Cologne
 Berlin

PURISM
1918 Paris

DE STIJL and
NEOPLASTICISM
Leyden Berlin
1916 Paris

1920

(ABSTRACT)
SURREALISM
1924 Paris

MODERN
ARCHITECTURE

BAUHAUS
Weimar Dessau
1919 1925

1925

1930

NON-GEOMETRICAL ABSTRACT ART

GEOMETRICAL ABSTRACT ART

1935

The fundamental kindergarten experience deeply influenced the mature work, not only of the original modernists, but also impacted later generations of artists and scientists. Focusing on art, pointillism, cubism, constructivism, de Stijl, dadaism, surrealism, abstract expressionism, Bauhaus, pop art, minimalism, conceptual, and process art movements through to contemporary art practice today are deeply indebted to this early model of "serious play."

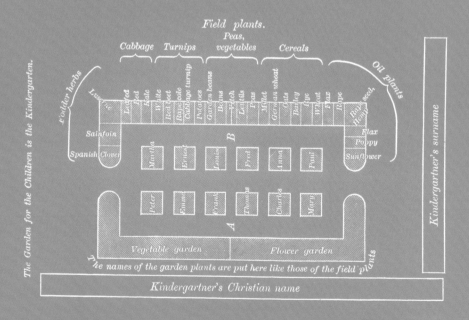

The Original Kindergarten, 19th Century

The Original Kindergarten, 19th Century—The Modernist Kindergarten, 20th Century, 2018
Pedagogical illustration

The Modernist Kindergarten, 20th Century

The garden for the grandchildren and adults of early kindergarten.

Peas, Kohlrabi

Beets
Chard (Swiss)
Beans (Lima)
Carrots, Radishes
Squash

cezanne duchamp matisse picasso kandinsky mondrian

klee malevich rothko stella johns warhol

Lettuce, Cabbage

Pesticide, herbicide, synthetic fertilizer

Tomatoes

Corn

Victory Gardens of WW I & WW II

Northern Romantic Citrus, 2006
Animation of Caspar David Friedrich's *Village Landscape in Morning Light (Lonely Tree)*
Computational drawing, silent screen display, computer
Courtesy of the artist

Around the turn of the 20th century, my grandfather traveled by horse from Mexico through the desert to university in California. Early on, California was depicted as a utopic agrarian destination, often represented by the orange and citrus fruit. By the time I graduated from university, California was a fully developed industrial center rivaling all but a few nation-states. My family moved to New York in my teens and I became aware of cultural differences in places where citrus could not grow. Later, as I traveled to Northern Europe as an artist from the south, I experienced difference in a new way. *Northern Romantic Citrus* is a slow computation meditation on the accumulation of oranges and southerners on the archetypical oak tree and the northern romantic landscape. The appropriation and dynamic juxtaposition slowly reveal a narrative with metaphorical cultural and ecological implications.

One Thousand Citrus Trees @ Thingvellir, Iceland

Begin caring for 1000 citrus trees in preparation
for a time approaching when oranges may become
common to Iceland and the North.

To envision this idea, we start with an act of radical pedagogy:
We take one citrus tree to Thingvellir in the winter with a class of
children and talk about the possibility that what is native to Iceland
may change dramatically enough so that citrus could someday
grow here.

The action reflects displacement during a time of climate change and cultural
diaspora in which plants, animals and people are forced to adapt or migrate to
survive. The reality and challenges of welcoming others into one's homeland may
become central to our world.

Michael Joaquin Grey 2015 - 2016

Invitation to a *Pedagogical Performance @ Thingvellir, Iceland*, January 15, 2016

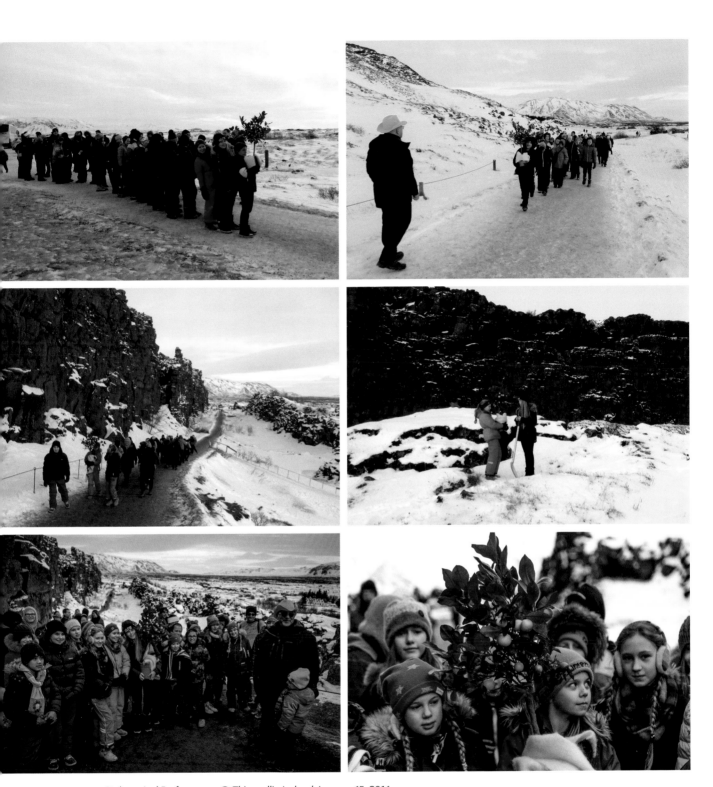

Pedagogical Performance @ Thingvellir, Iceland, January 15, 2016

Children's building blocks and scientific modeling systems always caught my interest. Playing with them I could see the finite strategies for how we have built our language and the world around us. For over 30 years I have tried to get back to playing with the primitives of matter and media.

Repeatedly I have come around to a question asked in my first class in graduate school: What is not built?

My observation reflected on the limitations of how we teach and play with our spatial and linguistic syntax. Having studied genetics I felt there was a level of communication between tiny complex sculptures, such as macro molecules, that demonstrated a deep intelligence of spatial relations and self-organization. This appeared to me as a huge clue to understanding the complex behavior of information, inanimate and animate. I saw this as an opportunity to develop and introduce new ways of "reading" language and living systems for pedagogy and play. I sensed it was a bit late for the adults in my world to fully comprehend; however, I saw hope and opportunity with children who are extremely receptive to new patterns, language and learning through play.

It can be said that what we play with as children directly influences how we form language and greatly defines our perception as adults. For centuries, understanding the connection between play and development made alphabet blocks a standard of childhood. Alphabet blocks appeared before 1693, when philosopher John Locke pointed out their potential for pedagogy: "...dice and play-things, with the letters on them to teach children the alphabet by playing".

Almost a century and a half later, Friedrich Froebel, who created kindergarten in 1837, introduced geometric solids carved from wood in his "gifts and occupations". Since then, reproductive media such as photography and film prompted an explosion of new content and form. Television, video and ultimately the digital platform perpetuated this disruptive

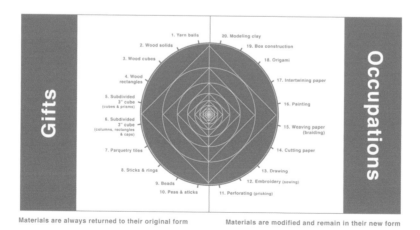

Froebel's Kindergarten

Gifts

Occupations

1. Yarn balls
2. Wood solids
3. Wood cubes
4. Wood rectangles
5. Subdivided 3" cube (cubes & prisms)
6. Subdivided 3" cube (columns, rectangles & caps)
7. Parquetry tiles
8. Sticks & rings
9. Beads
10. Peas & sticks

20. Modeling clay
19. Box construction
18. Origami
17. Intertwining paper
16. Painting
15. Weaving paper (braiding)
14. Cutting paper
13. Drawing
12. Embroidery (sewing)
11. Perforating (pricking)

Materials are always returned to their original form

Materials are modified and remain in their new form

Play Materials for Object Lessons

Gifts and Occupations Mandala, 2017
Pedagogical illustration

114

effect, expanding a field of emerging media and commercial forms. This paradigm shift, however, amazingly did not fundamentally alter much of our early play and pedagogy established in the first kindergarten over 150 years ago.

In 1990 I started a project, R.ED RE.D (Re:education Re:design) to develop a new processes of making. Looking at the limited ways of creating in the tradition of building and sculpture there were few variations on casting and carving available. I started to play with a new process, now known as 3-D printing, using a UV laser to draw to create solid forms inside a cube filled with a UV-sensitive liquid resin. This process could make a form in a new way, like a tissue, organ or cell, by creating by drawing in 3-D. This method allowed creating from the inside of a form to the outside. The process was later called stereolithography. The series of works were interlocking organic building blocks called "gametes" after our sex cells. They were one-inch connected cubes and inside were 23 internal cubes and spheres when joined (similar to a miniature 3-D mandala). Inspired by Charles and Ray Eames seminal film "Powers of 10", a film I saw early on in kindergarten at the Museum of Science and Industry in Los Angeles. The film is a reminder that we had only just begun creating on the infinite orders of scale and magnitude.

Gametes, 1990
3-D printing, stereolithography, laser cured resin
Courtesy of the artist

Schematic illustrations for *Gametes*

The Drip and *C Drop Experiment* are meditations on learning to read development by sensing change over time: geological, biological and cultural.

The Drip was an early work to capture the event of going from an undifferentiated state to a differentiated state—an event of conception. The work was a metaphor for the evolution of the building block brick into a biological unit of growth and decay.

C Drop Experiment, 2012
Pewter, anthracite coal
Courtesy of the artist

The Drip, 1988
Hydrocal, marble dust
Courtesy of the artist

Seven Scale Body (drip replica), 2011
Mixed media
Courtesy of the artist

In 1988 I created a set of building blocks named the *Erosion Blocks: Units of Growth and Decay*. They were an object lesson for the "decisive moment", a single drop of water captured in a brick form.

I imagined the block starting in a sealed box and as each side was taken off over time the form would erode or grow into different morphologies based on a set of rules for complexity. I saw the first six sides removed as creating the six senses, and the 20 total as the number of amino acids, the building blocks of living systems. Later I discovered the similarities in Froebel's work as a crystallographer and the wooden and porcelain models that were the object lessons for the early natural philosophers and scientists of the time.

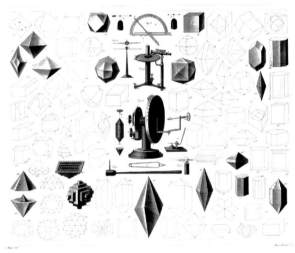

Illustration from *Iconographic Encyclopedia of Science, Literature and Art* by J. G. Heck
Published by Rudolph Garrigue, New York, 1851

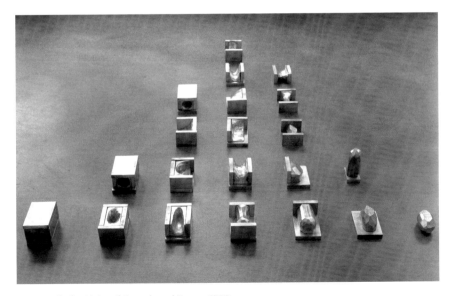

Erosion Blocks: Units of Growth and Decay, 1990
Pewter, cast from plasticine, 76 elements, 20 blocks
Courtesy of the artist

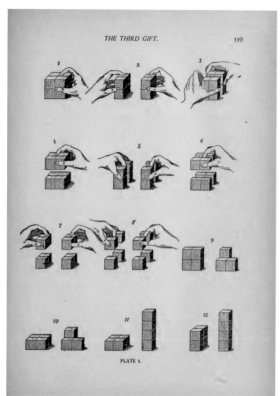

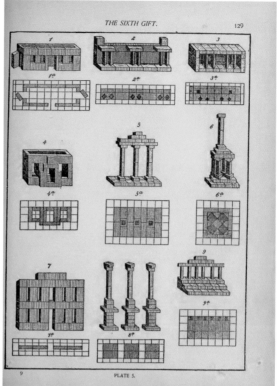

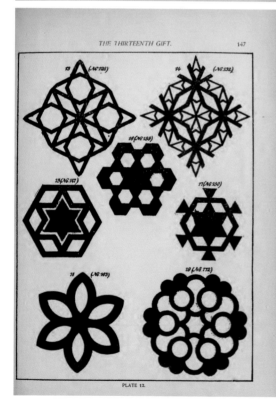

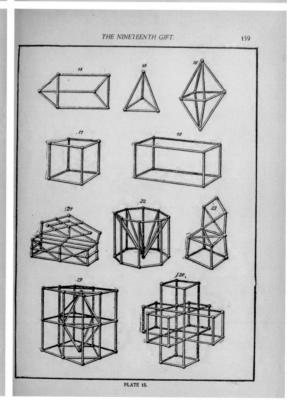

Plates of Froebel's gifts and occupations, *The Kindergarten* by Lida Brooks Miller,
Philidelphia and Stockton, Chicago, 1891.

Object as Preposition: Relational Evolution, 1988
Four scalable wall drawings
Courtesy of the artist

This was an object lesson in the evolution of the identity of an object starting as a noun, later becoming a verb (as in art history with the action verbs of process art, i.e. Richard Serra's *Verb List Compilation: Actions to Relate to Oneself*) and ultimately developing into the relationships of objects as prepositions.

1968

The 'Jelly Lovers' were an alternative radially symmetrical body to help consider empathy for an alternate body form. The medusas were generated with my own proprietary Artificial Life software neural networks and genetic algorithms, developed in 1990.

Jelly Lovers Game Spinner, 2017
Playground graphics
Courtesy of the artist

2018

The "non-binary *TWISTER*" is a concept for a playground or home game to feature 32 gender identities discovered at the time of the piece's conception. When I developed the work "Object as Preposition" in 1988, I only considered 2 identities and their possible relations to each other.

Non-Binary Twister, 2017
Playground graphics
Courtesy of the artist

I started Primordial, LLC in San Francisco (1996) as an artist realizing the limits of the current pedagogy and increasing problems with specialization and overtly didactic contemporary art. The art world became more focused on connoisseurship over experimentation and I experienced this as deeply limiting for the development of an individual's creative practice and awareness.

Primordial's mission was to create a classic collection of toys, tales and tools to help us understand who we are, where we come from and where we are going. The concept was for a new social sculpture, a new set of playthings and object lessons updating the "gifts and occupations" of the first kindergarten and recognizing its profound influence on the work of generations of modernists. As we moved more into the biotechnology and information age the world had radically changed and our education was not keeping pace. The first product of Primordial was the ZOOB play system: a modeling system to integrate our expanding awareness and relationships with the micro, macro, body and information spaces.

Primordial Landscape, 1997
Digital graphic
Courtesy of the artist

Orange Navel Mirror, 2008
Archival inkjet print on paper, aluminum mount, 10.75 × 54 inches / 27.3 × 137.2 cm
Courtesy of the artist

My artwork was based on a cosmology and creation story which over time took on an epic children's narrative of the rise and fall of the Citroid Sovereignty, an agrarian culture trying to cope with the displacement and acceleration of modernity (a metaphorical California). Out of the Primordial ZOOP in the Primordial Garden came a set of cosmic books and playthings including a new modeling system called ZOOB (an acronym for zoology, ontology, ontogeny, botany) based on building with (living, complex and dynamic systems) bones, braids, branches, bees, bricks, beams bonds, and big data etc. I conceived of a developmental process from our history of making. It was a new way to understand how we are made and how to understand building in the micro, macro, body and information spaces.

When I started Primordial I looked for a new synthesis in the way we model and build the language of the world around us. Just as Froebel had the "gifts and occupations" I was looking for a new set of object lessons and playthings that would help the next generation understand complexity and dynamic systems. I was looking for a way to read beyond the limits of linguistic syntax. ZOOB and the Citroid System were an attempt to look at the history of how we have built as an extension of our body knowledge. I wanted to create a simple prosthetic object, an extension of us, that was as intrinsic as our bones. The goal was to develop a building system based on our evolving relationship to dynamic living, complex and self-organizing systems.

M IS FOR MONOLITH

JOHN LOCKE'S
ALPHABET BLOCK
1693

INDUSTRIAL
REVOLUTION

FROEBEL'S
KINDERGARTEN

PAST
PRIMITIVES

EVOLUTIONARY
THEORY

BIRTH OF
PHOTOGRAPHY

NATURAL
PHILOSOPHY

9 : 4 : 1
MONOLITH

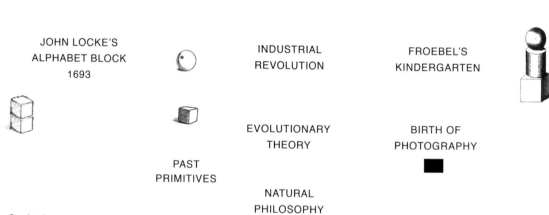

3^2

1^2

2^2

EARLY FRAMES (PORTRAIT, LANDSCAPE, MARINE)

STANDARD SIZES FOR PAINTING

Evolving Primitives, 2017
Pedagogical illustration

EVOLVING PRIMITIVES

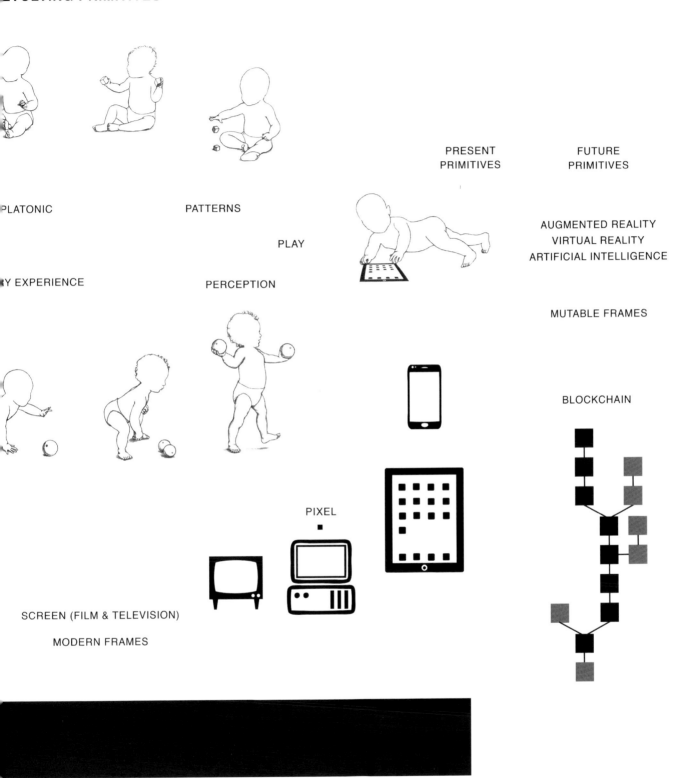

PLATONIC

PATTERNS

PLAY

Y EXPERIENCE

PERCEPTION

PRESENT
PRIMITIVES

FUTURE
PRIMITIVES

AUGMENTED REALITY
VIRTUAL REALITY
ARTIFICIAL INTELLIGENCE

MUTABLE FRAMES

BLOCKCHAIN

PIXEL

SCREEN (FILM & TELEVISION)

MODERN FRAMES

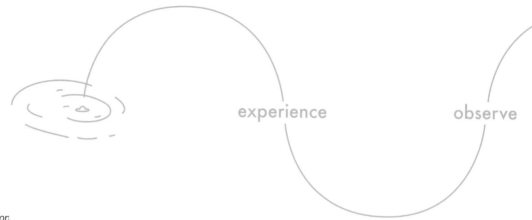

Ontogeny of Information
Pedagogic illustrations (3)

1. Thinking as an artist or scientist or child, I was concerned about our collective drift away from the "art of observation" and the value of primary experience in contemporary culture. There is often more of an emphasis on explaining and exploiting information than direct experience. Classically we followed an event with observation and description. The first wave map shows the ontogeny of information in extreme Western culture as an irreversible one-way process with an emphasis on explaining and exploiting information rather than a focus on primary experience.

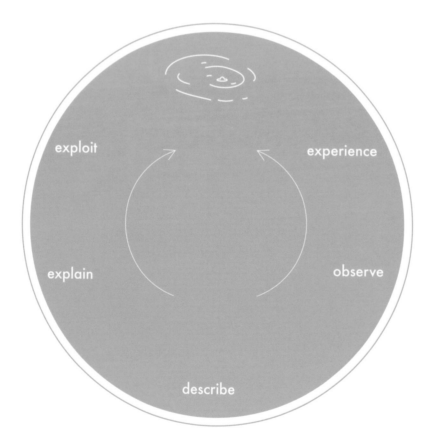

2. Our common cultural environment is often clouded with an accelerated pace, overstimulation and goal-oriented manipulation of our media sources and information as products. The circular map of the ontogeny of information shows a more idealized potential of cycling back to an event or phenomenon with the emphasis on primary experience.

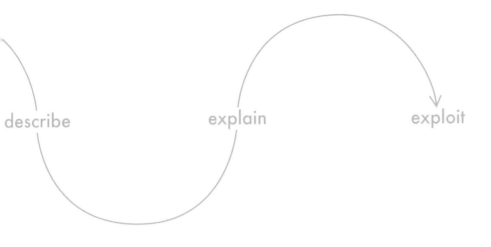

describe explain exploit

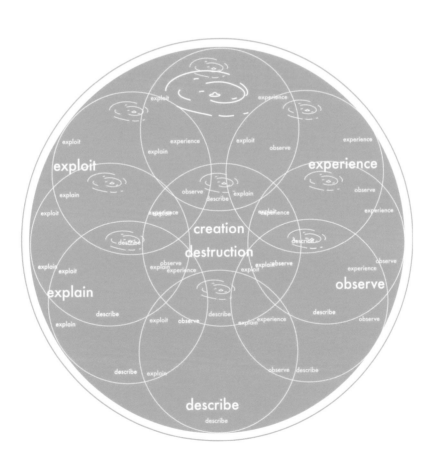

3. The third dynamic circular map of the ontogeny of information is a complex relational exchange schematically mapping an event similar to children at play. We experience multiple cycles at once with repeated creation and destruction cycles, which promote rapid growth and learning. This is a contemporary version of what Friedrich Froebel referred to as: "serious play".

19th century illustration of Froebel's
Gift No. 2 (Froebel's Monument)

The red ZOOB unit (RA). A simple homunculus, material
synecdoche, a mini everyone, every finger or bone. A small free
standing prosthetic to orient and relate to how we are built and
our relationship to ourselves and other things. *In vivo* to *in vitro*.

The ZOOB Play System is a pedagogical toy based on the Citroid Operating System. ZOOB is an acronym for: zoology, ontology, ontogeny and botany.

Prior to the Citroid System there were two major modes of manipulative modeling. The first was stereotonic modeling, or stacking. Stacking was common from the beginning of civilization: stone, wood, masonry (i.e. LEGO building block). Secondly, tectonic modeling was based on framing and mechanical engineering as with the Industrial Revolution (ie. Erector or Meccano). With tectonic modeling we have beams, bridges, skyscrapers.

Living and dynamic systems are geometry in motion. Having studied genetics I was initially interested in modeling the dynamics of the double helix of DNA. The Citroid System uses an articulated sphere to capture the flux between possible positions and energy states we find in natural and complex forms. The Citroid System makes use of all the symmetrical solids, the Platonic and Archimedean geometries, to model and animate complex anatomical, biological, molecular and mechanical behavior.

ZOOB is a prosthetic, an extension of how we are built. The first five joints mimic and animate the five basic anatomical joints in the skeletal body. The Citroid System tessellates to map folding surfaces and topologies. The system was intended to demonstrate complex symmetries. With ZOOB you can create subassemblies and simple mechanical and biomechanical functions (joints, axles, hinges, springs, switches, pistons, weaving patterns etc.). The Citroid System has the depth to model the dynamics of complex biological behavior such as macro molecules and complex protein folding. ZOOB and the Citroid

System can be as simple or as complicated as you want it to be. You can create anything from DNA to play dinosaurs.

The five basic units are intended to follow the rules of complexity (i.e. similar to DNA). The gestalt of the system is unified with simple body empathy to emulate our five fingers, five vowels, five anatomical joints, five senses, five base pairs, five platonic geometries with five basic colors. ZOOB connects in 40 ways and has 61 fold symmetry. The system engages play and proprioception. The Citroid System models the realms of micro, macro, information space and the body (biological).

Living and complex systems are animations of geometry or spatial language over time. This can also be said of child's play. Shared play with "building blocks" quickly moves from formal relationship to social complexity. Eventually our play develops beyond formal behavior to take on cultural consequences challenging our relationships, awareness and sense of responsibility.

I developed ZOOB to model complexity, dynamic and natural systems so it could be used by almost everyone. It has had broad pedagogic applications from kindergarten to cutting edge research. The Citroid System and the ZOOB play system are considered in a tradition of social sculpture reaching far beyond the toy and art worlds.

5 FINGERS
5 VOWELS
5 JOINTS
5 BASE PAIRS
5 PLATONIC SOLIDS

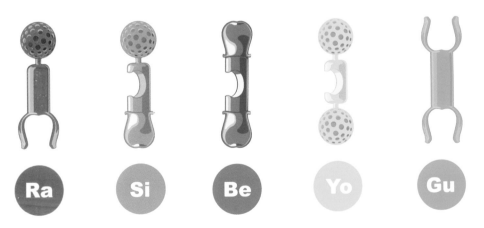

Five basic ZOOB units connect to each other in 40 different ways.

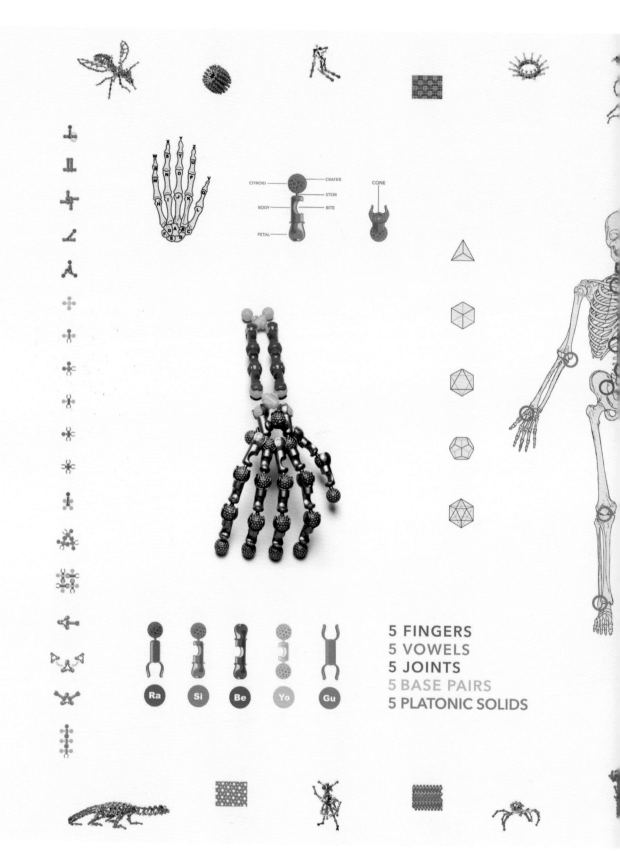

ZOOB Map, 2015
Digital print, 129.5 × 184.5 inches / 329 × 469 cm
Courtesy of the artist

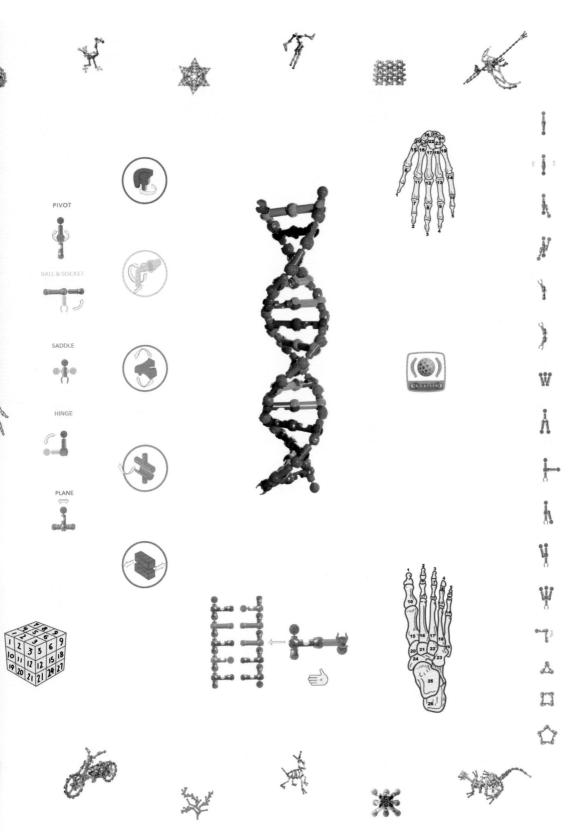

The ZOOB map is a large roll-up map in the tradition of pedagogical charts. It was created for large installations and play days. This ZOOB map's focus is on body empathy. It shares the joints of our body, the double helix of DNA, and the anatomy of a hand.

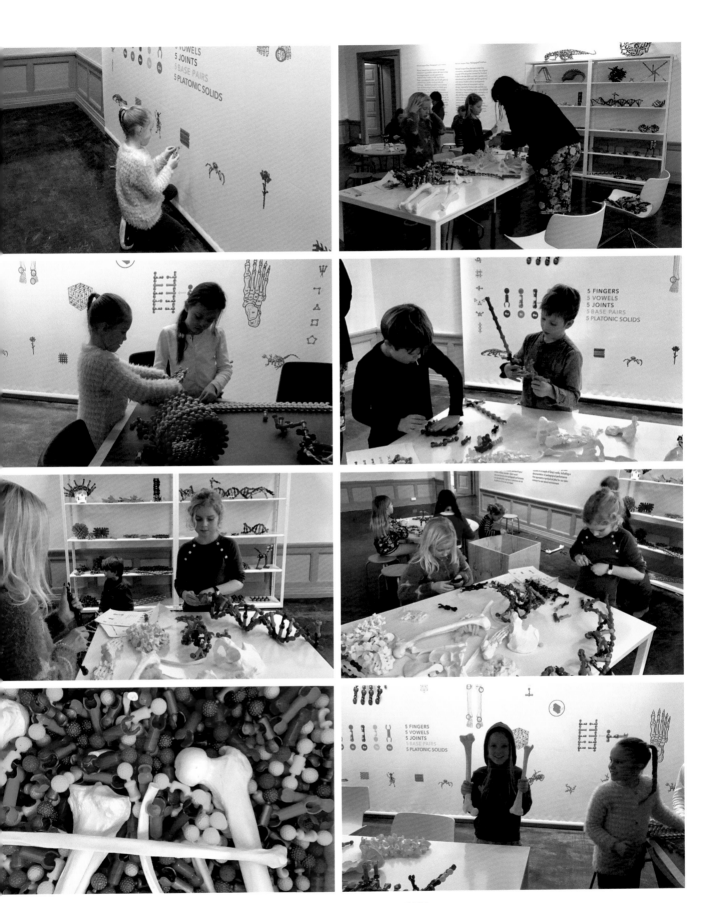

ZOOB workshops, Kunsthall Stavanger, Stavanger, Norway, January 2017

DISCIPLINE VS FREEDOM

SIT UP STRAIGHT!

Eva Koťátková

Sit Up Straight!, 2008
4 videos
Courtesy Hunt Kastner Gallery, Prague

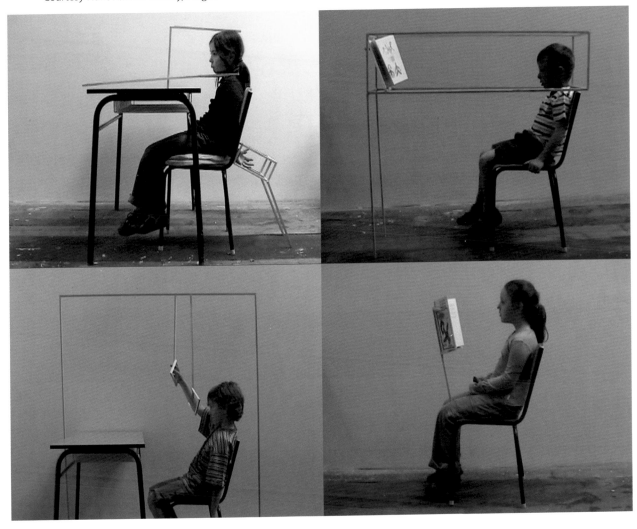

School is understood not only as a specific space where children are collectively taught by adults, accepting and following their rules, communication patterns, etc. It is often the first structured community that (after family) crucially influences their future integration and functioning in other social structures. Education can be and (previously in several countries, including the Czech Republic) was misused as a powerful tool of social control, manipulation and dissemination of unifying thoughts and propagandistic ideas. History can easily be played with and modified, facts drastically changed, parts of school books erased when not in compliance with the official version declared by the regime. Even though education methods in my country developed for the better during the last 22 years, both in the less authoritarian approach to the children as well as in the uncensored content and different structure of the study programs, school (with a few exceptions) still remains an isolated complex filled with blackboards, benches, inner rules and restrictions, rather than an institution that fulfills the role of an open structure based on a nonhierarchical dialogue. In the past I focused on the destructive aspect of education, which restricts, traps and manipulates the individual instead of providing support for individuality against collectively accepted mental schemes. From the study of my nearest surroundings and the focus on very personal themes that question memory and construct one's biography, I moved to bigger-scale projects. These projects entail constructing and visualizing social schemes together with integrated active participation of various groups of people.

In my work I often question such subjects as social control and manipulation and the position of the individual with certain social structure and his/her failing in the attempt to fit into that structure. I base my projects on a detailed study of concrete social situations or phenomena and through observations as well as active collaboration with participants, I try to develop a fresh view on the explored theme.

Installation view: Reykjavik Art Museum, 2016

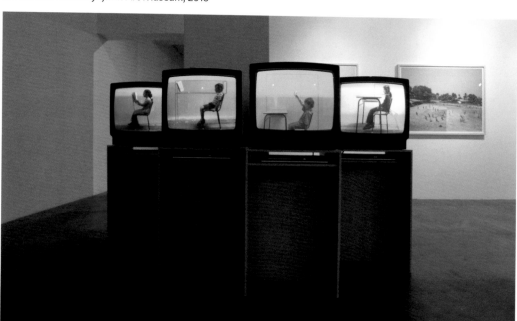

FRIHET FORUTSETTER AT NOEN ER FRI / FREEDOM REQUIRES FREE PEOPLE

Ane Hjort Guttu

Frihet forutsetter at noen er fri / Freedom Requires Free People, 2011
HD video, 33 min
Cast and crew
Director/producer: Ane Hjort Guttu
Cinematography/sound: Marte Vold
Edit: Bodil Furu, Ane Hjort Guttu
Sound, postproduction: Bodil Furu
Music: Byen vågner/Den døde by Thomas Koppel/The Savage Rose: Dødens triumf, Polydor 1972
Produced with the support of Norwegian Artistic Research Programme and KHIO

■ *Frihet forutsetter at noen er fri / Freedom Requires Free People* presents an eight-year-old boy at a primary school in Oslo. The film follows him through interviews and during school hours and looks at the conflict between his strong desire for freedom and participation, and the framework that is put forward by the school. *Freedom Requires Free People* questions the conditions of critical thinking within educational institutions and, in a broader sense, within society.

FOR A BETTER FUTURE

Priscila Fernandes

For a Better World, 2012
HD-video, 8:30
Courtesy of the artist

In a miniature city, several corporate chains get together to stage, for children, the role of adult consumer and employee. The video follows a group of children role-playing as adults in a modern city. Children are asked to find jobs in a supermarket, work as doctors or spend leisure time in the disco. The police are there to protect, firemen are there to help, but in this seemingly smoothly run environment, chaos starts to erupt. Will the children conform to the given tasks or will they rebel?

My interest in this specific location is to reveal and question how (and what) didactic methods are being employed to prepare children for the economies of the 21st century: Who are the entities responsible for the design of play and what are the motivations behind these decisions?

143

THE BOOK OF AESTHETIC EDUCATION OF THE MODERN SCHOOL

Priscila Fernandes

The Book of Aesthetic Education of the Modern School, 2014–2017
Installation: books, tables, carved chairs and archival material, dimensions variable
Courtesy of the artist
Commissioned by Espai 13, Fundació Joan Miró in Barcelona, Spain and with the support of Mondriaan Fonds
and CBK Rotterdam, The Netherlands
Photograph by Edward Clydesdale Thomson

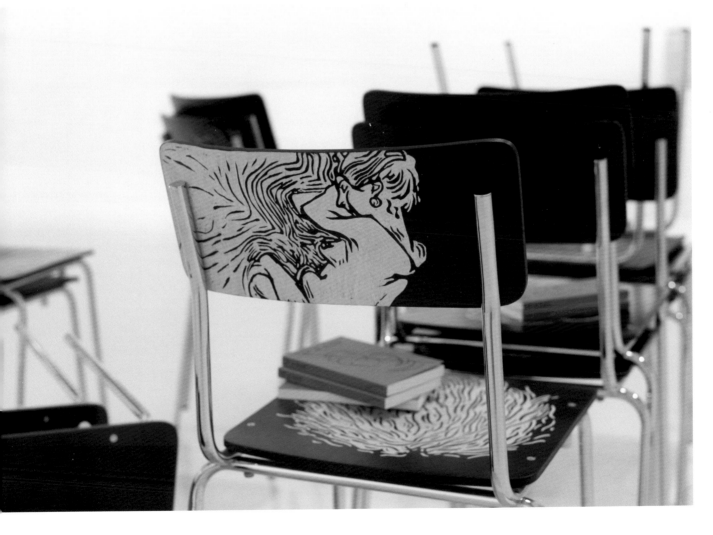

Even though aesthetic education was not material covered in the Modern School (La Escuela Moderna, Barcelona, 1901–1906), there were several published articles in its monthly newsletter that pointed to the role of the artist in society and the advantages of including artistic activities in the learning process.

More than a century after the death, in 1909, of Francesc Ferrer i Guàrdia, its founder, we can only wonder why his approach to art was not included in the program and imagine what would have been if it were.

To address this and other issues, my project turned an exhibition space into a classroom with reproductions of artworks and posters, furniture, and all necessary equipment to conduct a learning activity, as well as a recently published book *The Book of Aesthetic Education of the Modern School.*

All these objects and resources create a display that has a double function: It serves as the base onto which the installation of the show stands as well as hosting the activities related to the project, such as a teacher training course.

The Modern School offered a free, rational, secular, egalitarian and noncoercive education for children and parents. Francesc Ferrers' clear comment on the inequality of the classes a comment cannot struggle to overcome the obstinate dogmatisms of his era. His school intended a radical social change where the goal was not to adapt the student to fit into a pre-existing society but to prepare them to have a critical vision of their surroundings.

The school was forced to close its doors in 1906 and Francesc Ferrer became the victim of theological hate, dominant classes and conservative government, which ultimately led to his execution in 1909. The model of this revolutionary school continued to influence many other schools after its closure.

In my research I found very curious that amongst the diverse literature published by the school there was no manual for aesthetic education.

The Book of Aesthetic Education of the Modern School is a book and exhibition where I devise what would have been the art education in such an environment.

But this gesture immediately poses many questions. What was the school orientation towards art? What were their considerations about the role of the artist in the shaping of a new society? How could art be included in such a rational and scientific school program? And what was the context of art in Europe at the emergence of modernity? And finally, how can I, living in the 21st century, enter a history so distant from me?

Textbooks published by the Escuela Moderna in the 1900s

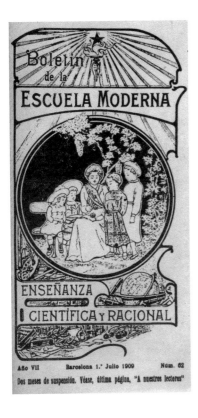

Boletín de la Escuela Moderna: Enseñanza científica y racional [Bulletin of The Modern School: Scientific and Rational Teaching], vol. 7, no. 62, Barcelona, July 1909

Cover of *¿Y El Arte? The Book of Aesthetic Education of the Modern School*, Priscila Fernandes (ed.), Rotterdam: Priscila Fernandes, 2014

¿Y el Arte? A book, an exhibition display, a classroom

In the last newsletter, *Boletín de la Escuela Moderna* (published by *La Escuela Moderna*), which appeared just before the execution of Ferrer, I found an article entitled *¿Y el Arte?* (What about Art?), a question that resonated with my own at the start of my research. The article consisted of an excerpt of Peter Kropotkin's *The Conquest of Bread—The Need of Luxury* (1892), asserting that literature, science and art must be cultivated by free man in order to become emancipated from the repression of state and capital.

These ideas are also shared by the Spanish libertarians of Ferrer's time, who sought to destroy the status of art as an exclusive enjoyment of the wealthy classes and as an exclusive product, giving it the right to be enjoyed and created by every individual. Had the school not been closed so abruptly, this last article could lead us to think that the emphasis of the Modern School would be to follow an artistic praxis of social and political art, giving art the mission of cultivating morals and constructing a fair society, revealing the ills of capitalism while still giving an optimistic glimpse of the great human future.

Even though aesthetic education was not material covered in the Modern School, there were several published articles in its monthly newsletter that pointed to the role of the artist in society and the advantages of including artistic activities in the learning process. We can't be certain art activities were indeed part of the program, even though there are clues Ferrer i Guàrdia was in correspondence with Czech artist František Kupka and commissioning illustrations to the books of the Modern School. But we are still left to wonder why Ferrer's ideological approach to art was not included or more visible in the program guidelines.

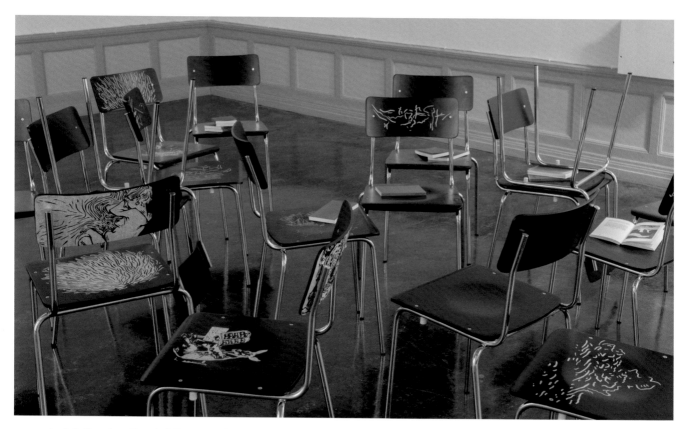

Installation view: Kunsthall Stavanger, Stavanger, Norway, 2017, photo by Kunsthall Stavanger

To address these issues I published the book *¿Y el Arte? The Book of Aesthetic Education of the Modern School*. In its pages a series of texts written until 1909 by critics, philosophers, and artists establish a dialogue with reproductions of works of art from the same period. This compilation intended to shed light onto the different debates that were held at the time and that could have formed part of Ferrer's pedagogical doctrine in relation to art. In an exhibition context, several copies of this small pocket-size red book are placed in different parts of the space and are available for reading, together with archival material and other original books by the Modern School.

The exhibition space was turned into a classroom. The surface of chairs were carved and engraved with abstractions, recalling the student drawings left on desks during the class. Others resembled artworks or styles from early 20th century, a reproduction of a woodcut by Matisse, sketches by Picasso, and so on. Tables piled up or stood upright in the space, supported by red books. One table in particular displayed a rainbow made of chewing gum on its back.

All these objects and resources in the exhibition space created a display that had a double function: It serves as the base onto which the installation of the show stands as well as hosting activities related to the project, such as teacher training courses, debates and presentations. The installation was first produced and displayed at Espai 13, Fundació Joan Miró, Barcelona, with the kind support of Mondriaan Fonds and CBK Rotterdam. Since then it has been exhibited at TENT. Rotterdam, The Netherlands; Reykjavik Art Museum, Iceland, and Kunsthall Stavanger, Norway.

A PLEA FOR PLAYGROUNDS

Jim Duignan

A *Plea for Playgrounds*, 2014–2016
Installation: wood, stainless steel chain, metal, vinyl, digital print of a vintage photograph and poster, leaflets, stencils
Reykjavik Art Museum, 2016

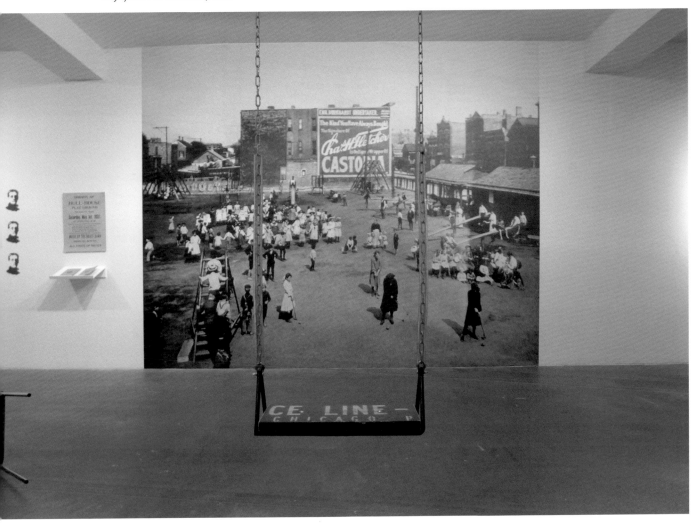

■ School supplemented my education and the parks and playgrounds fed a deep curiosity for my own physical and imaginative capacities. The play lots forged a lifelong connection towards Chicago's natural habitats and the ways in which I was able to think. The flow of play, the physical entanglement at playgrounds inside the vast landscapes, provided the simplest platform to figure most anything out. It was a site of self-education, auto-wonder, independent from the rules of engagement and the patterns adults applied for themselves. I never took advice as a kid. It compromised the shape of an experience one needs to encounter alone. My body and imagination had a literacy and a memory. It was seeded in the outdoor spaces of Chicago and has established a combined learning and artistic apparatus I have used my entire life.

The swing was a channel towards my flight. A way of hovering over the ground and knowing gravity as a medium. The children would run as fast as they could to the swings because they know of their magical properties. It was one part invention, one part barricade, one part flying machine, one part learning portal and mostly, an equal part perfect. This project is to build a public swing in cities everywhere as a call to a simple time when we could look forward to anything and it was all possible. Well, we were kids. Swinging in the air, the pressure against your chest, pushed against the fear of falling back and our hands holding on, the wind flying by, assuring the imagination to dip deeply, striking each trip back, knees bent oracles.

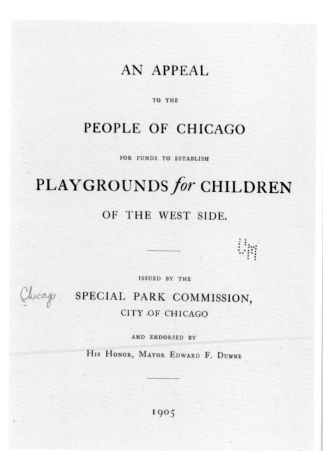

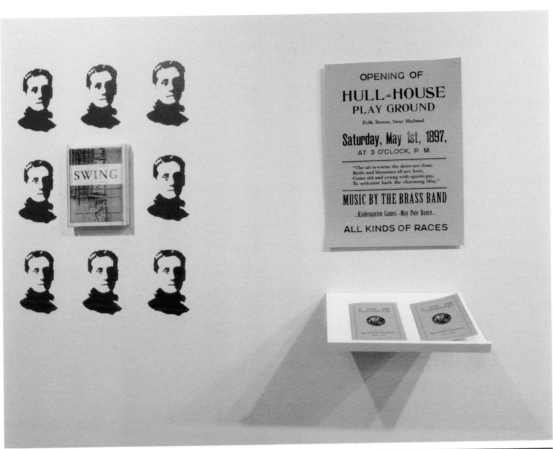

151

OPENING OF

HULL=HOUSE

PLAY GROUND

Polk Street, Near Halsted

Saturday, May 1st, 1897,

AT 3 O'CLOCK, P. M.

"The air is warm, the skies are clear,
Birds and blossoms all are here,
Come old and young with spirits gay,
To welcome back the charming May."

MUSIC BY THE BRASS BAND

...Kindergarten Games---May Pole Dance...

ALL KINDS OF RACES

PLAYGROUND

James Mollison

Al Furqan School, Birmingham, UK, May 26, 2010
Archival inkjet print, 96.6 × 127 cm
Courtesy of Flatland Gallery, Amsterdam and the artist

This school was founded in 1989 as the Muslim Study Group with just four children aged three through four. It proved popular with Muslim parents and grew rapidly. In 1998 Al Furqan was approved for government funding and obtained grant-maintained status, becoming the first state-funded Islamic school in England. It moved to its present site in 2002. In recent years, the school has come under fire for its educational practices. In November 2012 England's Office for Standards in Education, Children's Services and Skills (Ofsted) rated the achievement of pupils, quality of teaching, and leadership and management as inadequate. However, the report also noted that the pupils' spiritual, cultural and social development was good. Older female students at the school wear headscarves (and can't be photographed) as do all the female teachers; some teachers wear the niqab.

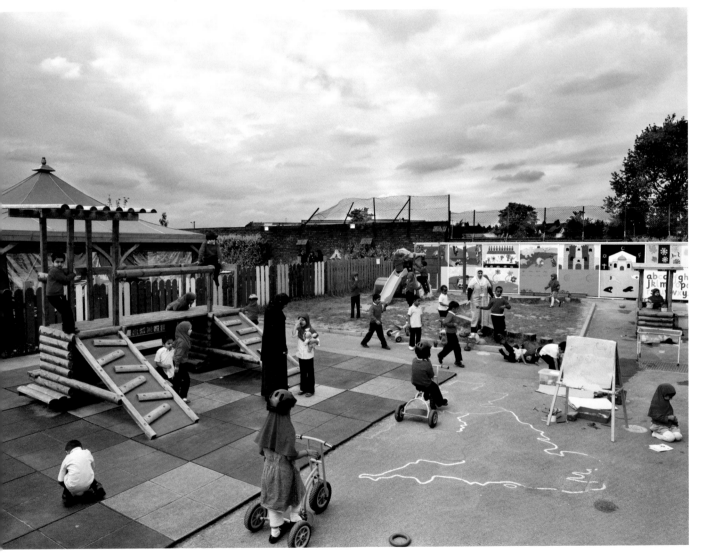

■ When I conceived this series of pictures, I was thinking about my time at school. I realized that most of my memories were from the playground. It had been a space of excitement, games, bullying, laughing, tears, teasing, fun and fear. It seemed an interesting place to go back to and explore in photographs. I started the project in the UK, revisiting my school and some of the other schools nearby. I became fascinated by the diversity of children's experiences, depending on their school. The contrasts between British schools made me curious to know what schools were like in other countries.

Most of the images from the series are composites of moments that happened during a single break time—a kind of time-lapse photography. I have often chosen to feature details that relate to my own memories of the playground. Although the schools I photographed were quite diverse, I was struck by the similarities between children's behavior and the games they played.

Hull Trinity House School, Hull, UK, November 16, 2009
Archival inkjet print, 96.6 × 127 cm
Courtesy of Flatland Gallery, Amsterdam and the artist

This school was founded in 1787 to educate boys for seafaring careers. Before sending its pupils out into the world, the brethren of Hull Trinity House would provide them with a special dinner as well as two oranges, to help protect against scurvy. Today, students no longer go from school to sea but the Dinner Day tradition survives. In 2012, the school became an academy, and as its old buildings were deemed "dilapidated and inadequate to provide a modern education," it moved to larger, updated facilities. The nearly three hundred pupils mostly come from white, working-class backgrounds; on the playground, they are tough and boisterous. The cluster of boys on the right were giving the blond boy a "wedgy": grabbing the top of the victim's underpants and jerking them upward.

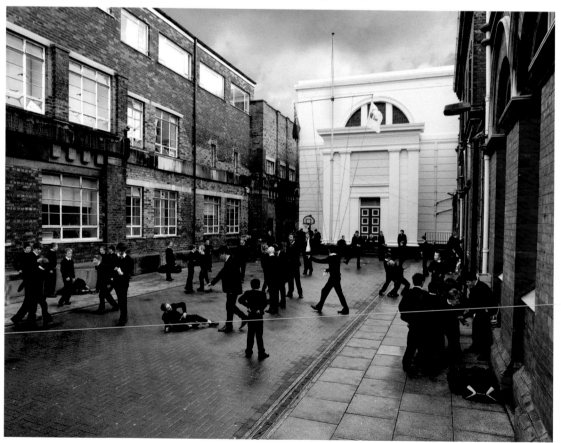

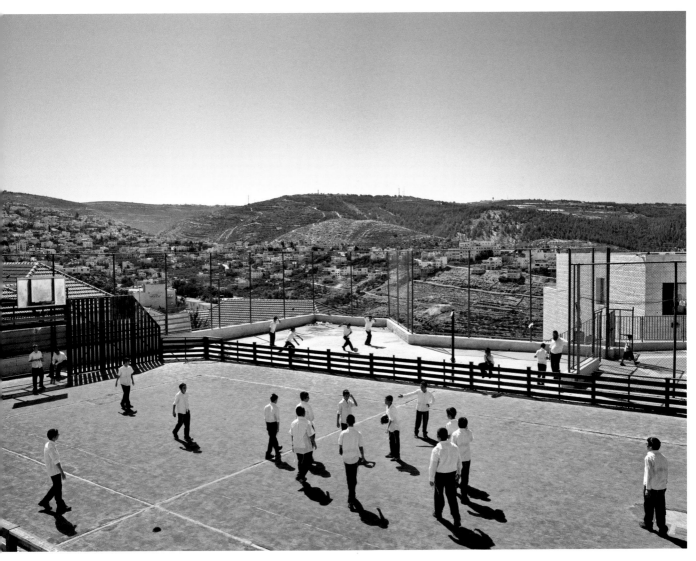

Tiferet-Menachem Chabad School, Beitar Illit, West Bank, September 10, 2013
Archival inkjet print, 96.6 × 127 cm
Courtesy of Flatland Gallery, Amsterdam and the artist

This school, serving 270 boys aged six through 13, is part of the Jewish settlement of Beitar Illit, founded in 1984. The playground looks out across the Palestinian village of Nahalin. The settlement is home to more than 45,000 Haredi Jews. It has the fastest growing population of any West Bank settlement. Nearly two-thirds of the inhabitants are under the age of 18, and 20,000 are at school. Some families have as many as five boys enrolled in the school. Sixty percent of lessons are religious. Pupils also study math, Hebrew and science. Parents who want this type of religious education also send their children to the school from Jerusalem. Although there are no physical education lessons, the boys played soccer during their break with evident enjoyment. Television is banned from the whole settlement, although computers with "kosher" internet are allowed.

Lungten Zampa, Thimphu, Bhutan, November 26, 2011
Archival inkjet print, 96.6 × 127 cm
Courtesy of Flatland Gallery, Amsterdam and the artist

This high school with 1,200 students and 51 teachers was one of the first schools to be set up in Bhutan in 1972. That year, the 17-year-old fourth Dragon King of Bhutan remarked that "Gross National Happiness is more important than Gross National Product." Subsequently this idea has become the official basis of Bhutan's government policy. GNH lessons are part of the curriculum in all Bhutanese schools. The national dress code, comprised of traditional garments, used to be compulsory for everyone and still is for all hotel and restaurant staff and taxi drivers, who have to be licensed by the government. School uniforms must also conform to the code and those of individual schools are differentiated by their color schemes. Smoke issuing from the little shrine toward the left of the frame is from incense that has been lit to bring good luck.

TO
HAVE
A VOICE

AIRINGS...
VOICES OF OUR YOUTH

Pam Kuntz and Company

Airings... voices of our youth, 2016–17
Video, 7:32, Educator's Guide brochure
Based on the eponymous dance/theater performances touring Whatcom County:
Choroegraphy/Direction—Pam Kuntz; Dancers—Evyn Bartlett, Cara Congelli, Yuki Matsukura, Ethan Riggs
Composer—Michael Wall; Sound and Video design—Angela Kiser
Lighting Design—Mark Kuntz; Video editing—Pam Kuntz; Stage Manager—Megan Dechaine
Road crew—Ian Bivins, Fish Lopez, Chris Wright; Educator's Guide—Pam Kuntz, Diana Gruman, Lucy Purgason
Courtesy of the artist

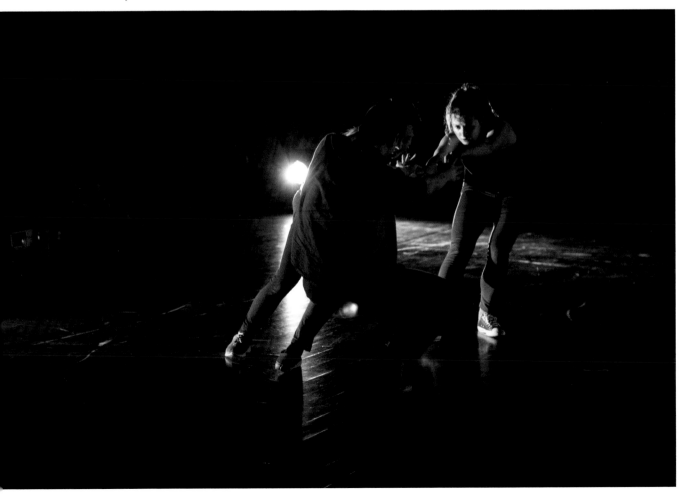

I have spent the past 14 years interviewing community members and using those interviews as source material for dance/theater performance pieces. Concerned local activists asked me to make a piece about bullying in middle and high school aged children that would include a tour to schools as way to educate, invite dialog and bring about change. I interviewed over 30 youth to create this piece, and while bullying was certainly discussed, these passionate kids had so much more on their minds, including isolation, gender identity, pressures and hope. Using these 40 hours of interviews as my guide, I brought together a wide range of artists and together we created *Airings... voices of our youth.*

To help public school educators navigate *Airings*, and to assist with facilitating dialog, we also created an educator's guide with the help of Western psychology professors Diana Gruman and Lucy Purgason. *Airings* toured Whatcom County in the Fall of 2016 and Winter 2017, reaching over 4,000 community members in community theaters and middle and high school spaces.

Statements from the kids interviewed:

"I remember the first time I was called a faggot."

"Just because something bad happens you can't give up and stay down... you have to find your balance, you have to find yourself, and you have to rise back up."

"I committed suicide twice."

(Yes—she said it that way. I stared at her. She heard what she said and then she corrected it by stating I tried to commit suicide twice. I think her original statement is quite powerful and it came from somewhere deeper than making a mis-statement.)

"You don't want to succeed when it is a system you are in that you don't like and you don't believe in."

"When you are getting bullied you don't want all the attention, you just want someone to notice that you are being bullied."

"I had to wait for two hours before anybody spoke to me."

"I was 12 when my father committed suicide."

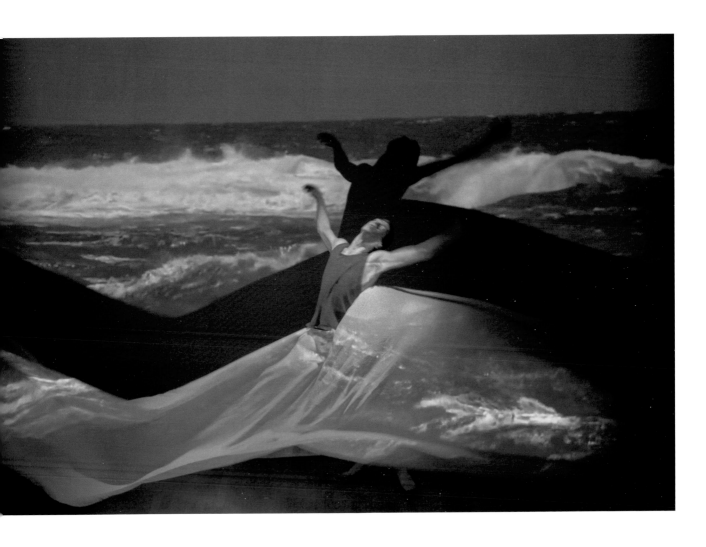

"Had I had more positive conversations and just conversations in general about women's bodies before that time then I maybe wouldn't have had to exercise my curiosity in such a harmful way... in a way that forever altered my view of what my body should look like."

"He sent me out into the hall and he said that he forgot about me. I ended up sitting in the hall for about a good hour and 15 minutes."

"The conversation wasn't directly negative... It was that there wasn't a conversation happening... It was the silence in the room."

"It's your choice to make a difference for yourself."

"It's funny how much pride and shame anorexia gives you."

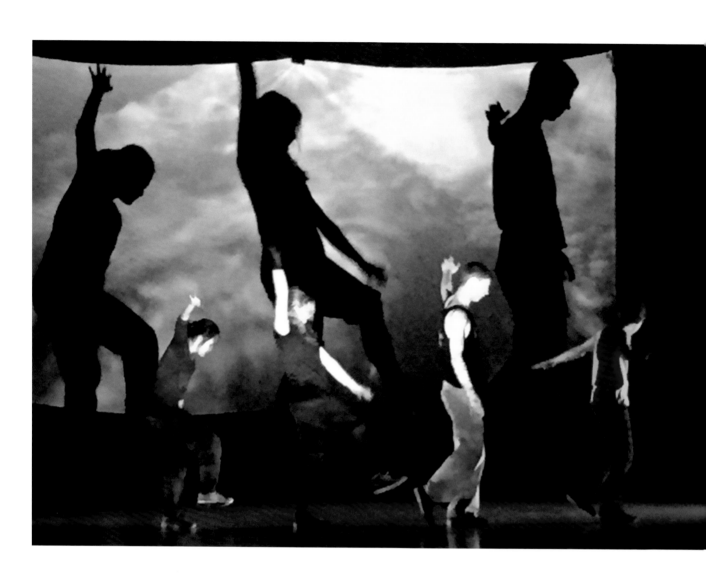

ESCOLAS [SCHOOLS]

Graziela Kunsch

Escolas [Schools], 2016
Video, 3:45, 1920 × 1080, 16:9, NTSC, color, no sound
Courtesy of the artist

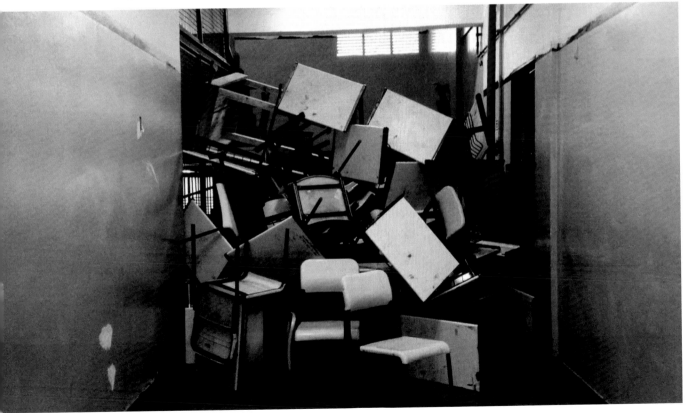

In 2015, a student uprising occupied over two hundred state schools in São Paulo to protest the state government's decision to close down several educational institutions. The video features a sequence of 26 filmed photographs of the occupations and protests, each eight seconds long, which turned state-neglected buildings into spaces of dynamic and powerful interaction. While the educational system turns people into objects, here the school chairs are humanized as subjects with determined intentions. When students appear in pictures, they are doing other things in schools, not sitting in classrooms.

The images that make up the video were made by the artist in occupied schools in São Paulo in November and December 2015 alongside photographs downloaded from the internet, published without author credits. These images were on the Facebook pages of the self-called Struggle Schools or Occupations E. E. Ana Rosa, Dica (E. E. Emiliano Cavalcanti), E. E. Fernão Dias Paes, E. E. João Kopke, Mazé (E. E. Maria José), E. E. Rachid Jabur, E. E. Salvador Allende and/or on the page of collective O Mal Educado.

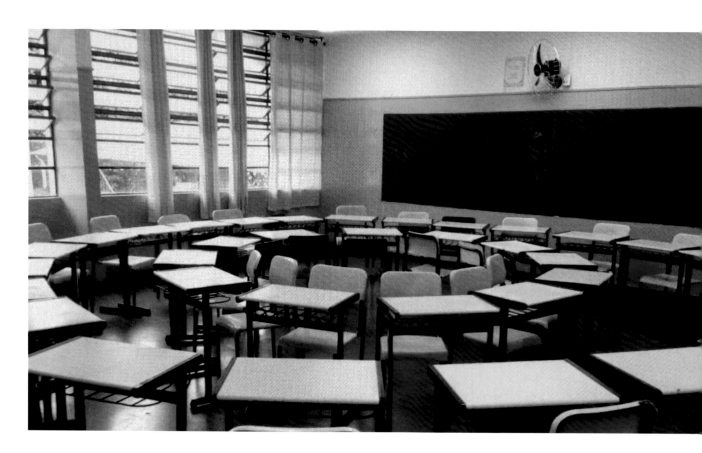

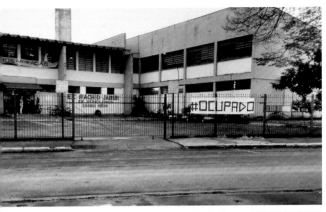 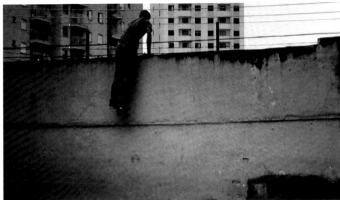

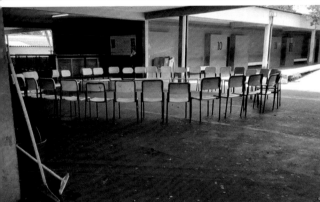 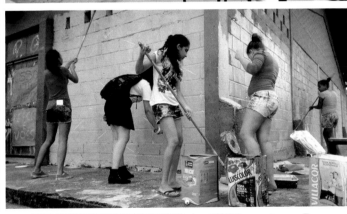

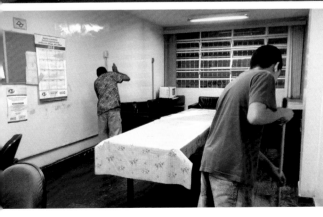 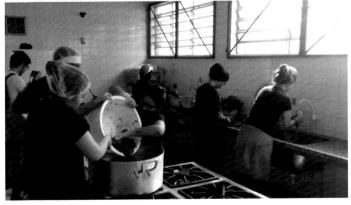

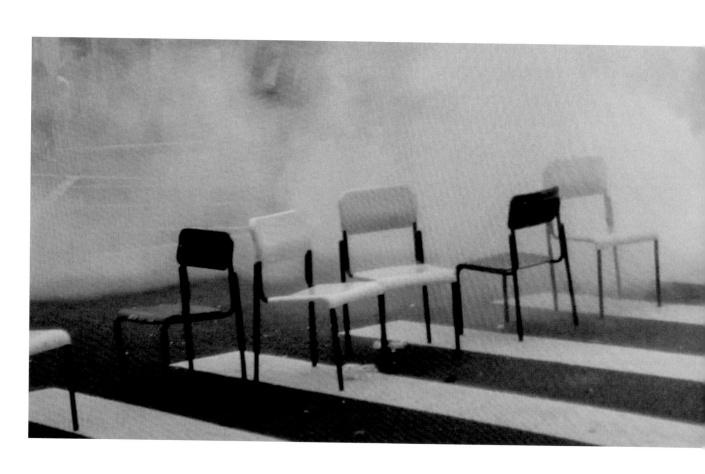

VOICING YOUR FUTURE

Eva Bakkeslett

Voicing Your Future, 2017-18
Interactive installation: software app, tablet, wood, text
Courtesy of the artist
Installation view: Western Gallery, Western Washington University, Bellingham, WA, 2018

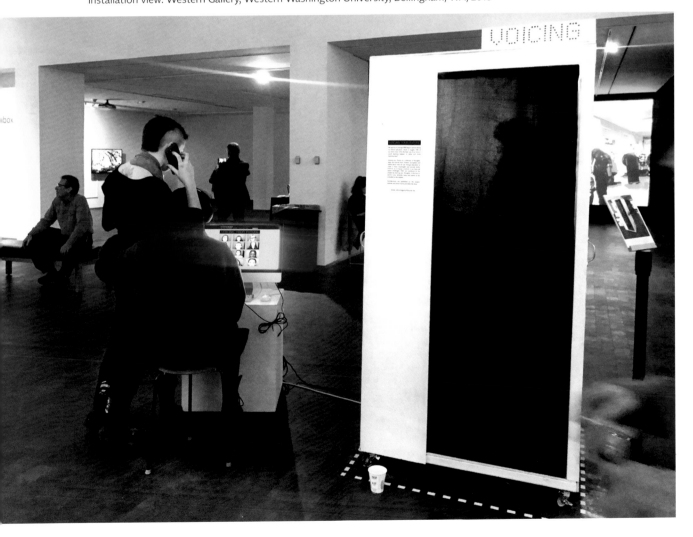

■ We spend an average of 7,700 hours in school during our primary and secondary education, which amounts to approximately 15% of our entire lives. Is this the best use of our time?

Education and creativity have been important issues for me since my own schooling. My frustration with the existing system made me question what and how we are learning and seeking better ways of doing so. Seeing my own two children growing up, I realized that schools have not gotten any better. In many ways they have gotten a lot worse. Schools are not keeping up with the changing needs of society. They are stuck in old ways instead of breeding creative minds to generate the change necessary for society to become more sustainable and thriving for all. Neither are they leading us in any new or useful directions to deal with pressing issues like climate change or extreme population growth.

Einstein argued that it isn't possible to solve problems with the same ways of thinking that created those problems. We need to get unstuck from old patterns of linear thinking and learn to think differently, in lateral and radically different ways. Schools should be places where this process can be nourished and facilitated.

In this project, it has been important for me to find ways to express this need for change in our educational system and to generate ideas for how to transform it. I have created a digital arena where people can reflect upon education, share their own experiences and voice their personal opinions about how schools and their curriculum content should change. This is an ongoing project where I am gathering voices mainly as video recordings but also as artworks, texts and poems from anyone who wants to contribute. These voices are available for the public to view on the project website www.voicingyourfuture.no. It is my hope that this collection of thoughts and ideas will inspire others to question, reflect and generate a gradual and possibly radical change in our educational system. I am also using this project as a starting point for interactions and dialogues with the public about how schools should reform.

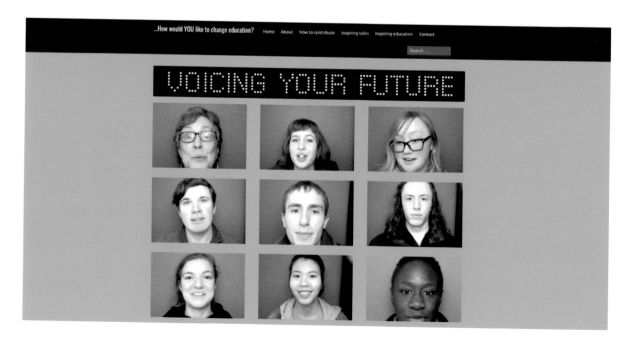

DEMOCRATIZE EDUCATION!

CROSS-BORDER COMMUNITY STATIONS

Estudio Teddy Cruz + Fonna Forman

Cross-Border Community Stations, 2017
Video installation: 2 videos, 3:56, 2:45; chart, vinyl
Courtesy of the artists
Installation view: Western Gallery, Bellingham, WA, 2018

█ In our architectural and political practice we see our primary role as researchers in horizontal terms—as mediators, curators, facilitators who translate both bottom-up and top-down knowledge. We believe that social justice today cannot be only about redistributing resources but must also redistribute knowledge across geographic, institutional and epistemic borders.

We designed the *Cross-Border Community Stations* as a network of physical research and teaching hubs in marginalized neighborhoods on both sides of the San Diego–Tijuana wall. These are public spaces that educate: "knowledge-exchange" platfoms where the specialized knowledges of the researcher and the community-based knowledges of border neighborhoods meet.

The Community Stations reject a vertical conception of charity or "applied research" —where the university is seen as the bearer of all resources and knowledge and the community a passive recipient or a mere subject of data gathering. Instead, they embody a horizontal model of *engagement* in which university and community relate as *partners*, both contributing resources and knowledge and actively participating in the coproduction of research and education.

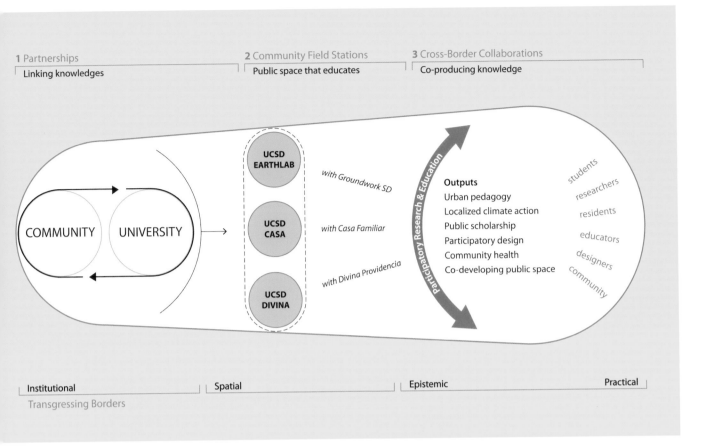

1 Partnerships
Linking knowledges

2 Community Field Stations
Public space that educates

3 Cross-Border Collaborations
Co-producing knowledge

COMMUNITY UNIVERSITY

UCSD EARTHLAB — with Groundwork SD

UCSD CASA — with Casa Familiar

UCSD DIVINA — with Divina Providencia

Participatory Research & Education

Outputs
Urban pedagogy
Localized climate action
Public scholarship
Participatory design
Community health
Co-developing public space

students
researchers
residents
educators
designers
community

Institutional

Spatial

Epistemic

Practical

Transgressing Borders

The cross-border community stations:
eight notes on redistributing knowledge beyond walls

1. Border regions are laboratories for rethinking inequality and re-imagining citizenship

The border cities of San Diego and Tijuana comprise the largest binational metropolitan region and the most trafficked checkpoint in the world. The dramatic proximity of wealth and poverty across this geography of conflict transforms this border region into a laboratory for confronting some of the most pressing global conflicts today, including the migration and displacement of peoples due to economic, climate and political strife, and deepening social and economic inequality everywhere.

We believe that the most compelling ideas about the future of cities today will emerge from peripheral communities in sites of conflict, such as the San Diego–Tijuana border region, where human resilience and adaptation manifest in the ingenious reinvention of everyday life. In these zones, survival strategies shape new social, cultural, economic and political dynamics that become models, and ideally catalysts, for alternative urban policies that enable more inclusive, sustainable patterns of urban growth.

Border zones like ours must also become laboratories for rethinking global citizenship. Public perception of the border as a barrier separating oppositions, has been shaped by politics of fragmentation and division. But identity in this part of the world is actually shaped by the hybridity and porosity of everyday life, the transgressive flows and

circulations that continually move back and forth across the wall. A key dimension of our work has been rethinking citizenship in this contested region of flows—opposing conventional jurisdictional or identitarian definitions of belonging that divide communities and nation-states with a broader and more encompassing lens that views shared practices, norms, interests and aspirations as essential criteria of community—all of which typically flow unimpeded across border walls like ours.

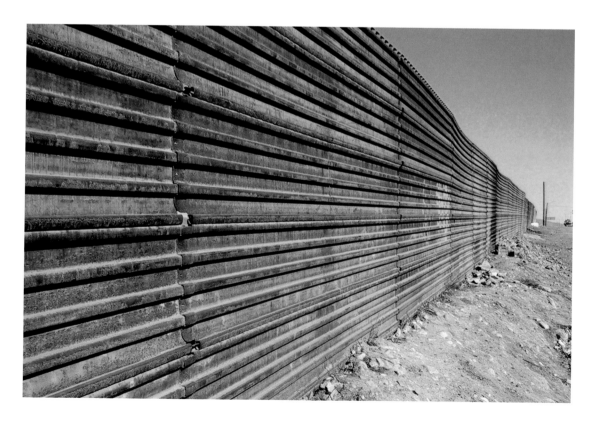

2. Localizing the global

We must move the ubiquitous discussion of "global justice" toward particular sites of need and the institutions best situated to address them. This entails that we critically engage the assumption that "global" is a spatial concept that refers to challenges "out there" as the appropriate site of action—and that we refocus instead on global challenges "right here"—*wherever right here happens to be*. If global justice demands urgent action, then we must address concrete circumstances and needs as they manifest in particular contexts, as they are understood and articulated by those experiencing them and by the institutions closest to the ground best situated to interpret and effectively respond to them. Our emphasis on the particular should not be interpreted as a claim that institutions at local or regional scales can "go it alone", without the support and knowledge, as well as resources, of institutions at broader scales. Local action needs universal norms, goals and resources to back it up. But from the perspective of global justice and the need for urgent interventions to remediate poverty, it is essential that we forge new correspondences between global and local knowledges, imperatives, resources, capacities and actions.

Exploring these correspondences is a large and important project—how the top-down and the bottom-up must converge in their knowledge and strategies to confront poverty and injustice across the globe. Here we more modestly wish to explore the role that universities in collaboration with communities across the world have played in interpreting and executing the mandates of global justice and mobilizing rapid and effective strategies to address urgent deprivations at the scale of cities and regions.

3. A crisis of knowledge transfer

We are faced today with a crisis of knowledge-transfer between institutions, fields of specialization and publics. Knowledge that remains siloed and self-referential perpetuates existing power structures and disparities. Social justice today cannot be only about redistributing resources but must also redistribute knowledge.

We believe that the meeting of top-down and bottom-up knowledges can produce new strategies of artistic and architectural intervention in the city, as well as new methods of interdisciplinary education, research and practice.

This interface between top-down and bottom-up resources and knowledge depends on a two-way dynamic: in one direction, how specific, bottom-up urban activism can have enough resolution and political agency to trickle upward to transform top-down institutional structures; and, in the other direction, how top-down resources can reach sites of marginalization, transforming normative ideas of civic infrastructure by absorbing the creative intelligence embedded in informal urban dynamics. This transferring of urban knowledge from bottom-up intelligence to formal institutions and back in the construction of urban justice requires a new understanding of the potential of *informal urbanization*. The informal pertains to a set of urban strategies and everyday practices that counter the power of imposed policies and economics of exclusion.

We see as our primary role as researchers in horizontal terms—as mediators, curators, facilitators who translate both bottom-up and top-down knowledge. There's a lot to say here. But what we've discovered again and again is that marginalized border neighborhoods have constructed ingenious participatory strategies of urban sustainability, resilience and

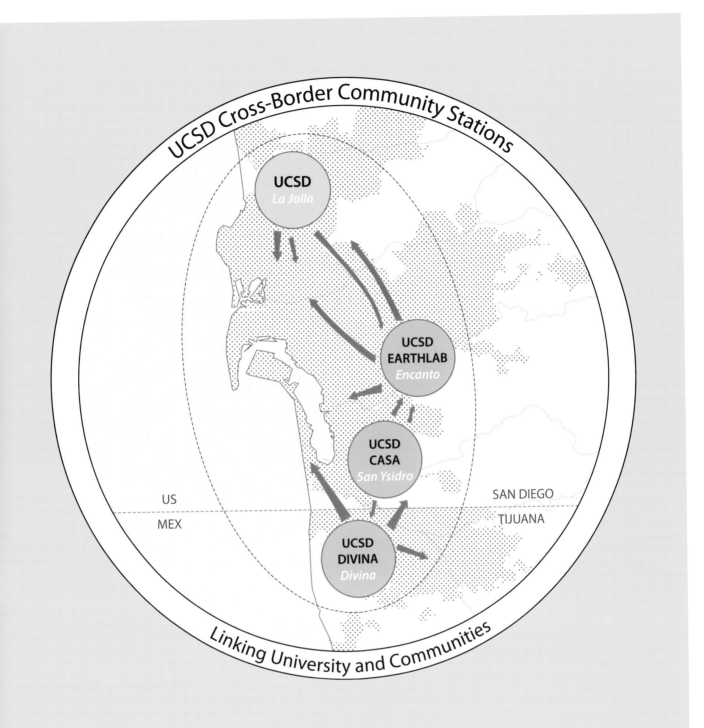

adaptation. In conditions of scarcity and precariousness, these neighborhoods are sites of amazing bottom-up democratic creativity, hardly commensurate with the racist narratives through which they are too often depicted. Surely there is crime; poverty does that to communities. But there are beautiful illustrations of participatory democratic possibility embedded in these local, bottom-up social and economic practices that need documentation and translation. Their ingenuity is typically off the radar of institutions. These illustrations need to trickle up, to inspire policy-makers to rethink their approaches to equitable urbanization. We see ourselves as translators and facilitators of this bottom-up knowledge through new strategies of partnership and scholarship.

Today's social challenges are not confined to disciplines, nor can their solutions be. We believe universities should commit to teaching our students how to become interdisciplinary thinkers and problem-solvers, with skills to analyze social disparity through multiple lenses, to communicate across disciplinary language siloes, and to collaborate with each other and with a diverse field of partners.

4. From vertical to horizontal: democratizing knowledge

Universities need humility. We reject a vertical conception of charity or "applied research"—where the university is seen as the bearer of all resources and knowledge and the community a passive recipient or a mere subject of data gathering. Instead we embrace a collaborative, or lateral, model of *engagement*, in which university and community relate as *partners* both contributing resources and knowledge, and actively participating in collaborative research, learning and problem-solving. Tipping the model from a vertical to a horizontal relationship is an ethical move.

Operating from the base of a public research university holds special opportunities and challenges. In the last century, academics have come to speak in ever smaller and more specialized circles in disciplines that often overlook the potential impact of research on the world. Many academics who care about social equity spend their careers writing and debating about justice and equality and rights and freedom and agency—and policies to address these things—without meaningful contact with the world they care about. Wouldn't it be helpful to have better ways of knowing what these challenges and aspirations mean to real people, how they structure real practices and real agendas?

The issue is even more urgent when it comes to academic claims about marginalized people. If we claim to advance ideas in defense of the marginalized, why do academics spend so little time engaging marginalized people, listening to their voices? We obviously cannot all be anthropologists but a more ethnographic sensibility would be helpful. University scholarship is infused with assumptions that we know more, that only we are "trained", that only we have the language to convey complex ideas and practices and the analytical tools to make sense of and to "fix" the chaotic tangle of real life. An engagement with the world of practice reveals, however, that these assumptions are plain wrong, that we do not know everything we think we know, and that we have possibly more to learn from the world than it does from us.

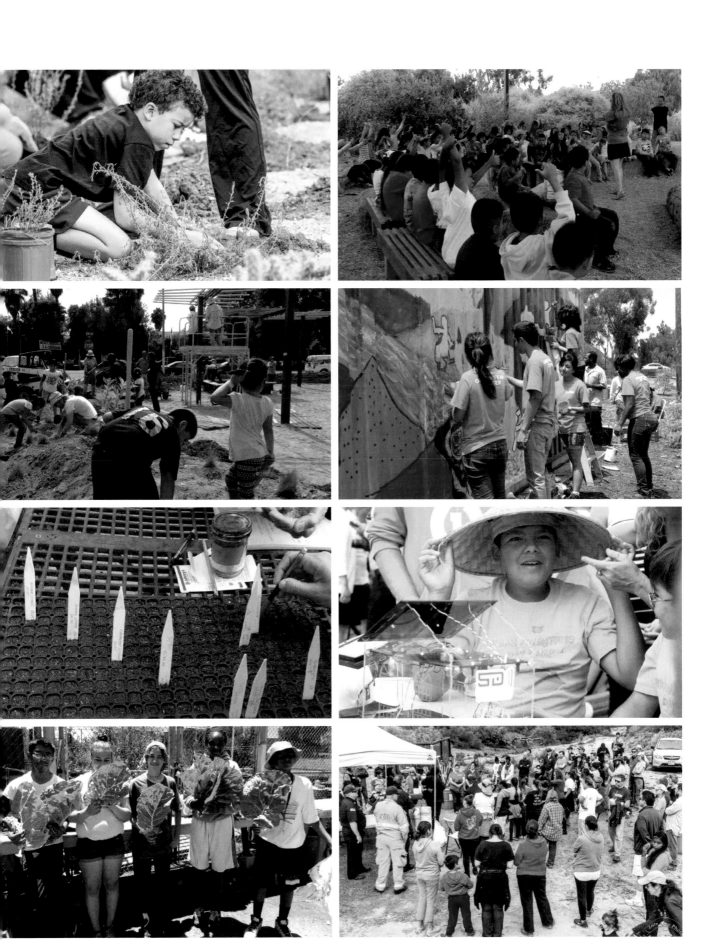

5. Bogotá redux: seeking a new citizenship culture

We have done extensive research on successful models of participatory urban transformation across the world with a special focus on Latin American cities (esp. Medellín and Bogotá, Colombia) where partnerships between research universities, progressive municipalities and community-based nonprofits were essential in democratizing knowledge in cities, activating a more participatory citizenship culture and ultimately producing dramatic improvements in quality of life for the most marginalized populations. Our work in San Diego–Tijuana is inspired by these cases.

Antanas Mockus, former mayor of Bogotá, Colombia, insisted that before transforming a city physically, we need to transform social behavior—that urban transformation is as much about changing patterns of public trust and social cooperation from the bottom-up as it is about changing urban, public health and environmental policy from the top-down. Mockus enacted a distinctive kind of egalitarian political leadership, declaring emphatically the moral norms that should regulate our relations: that human life is sacred, that radical inequality is unjust, that adequate education and health are human rights, that gender violence is intolerable, and so on. He reoriented public policy by nurturing a new *citizenship culture*, grounded in a moral claim that all human beings, regardless of formal legal citizenship, regardless of race, have dignity, deserve equal respect and a basic quality of life.

In rethinking urban justice, Mockus developed a corresponding urban pedagogy of performative cultural interventions to demonstrate precisely what he meant, inspiring generations of civic actors, urbanists and artists across Latin America and the world to think more creatively about engaging social behavior. Meeting urban violence with stricter legal penalties will not work. Law and order solutions don't interiorize new public values. What Mockus' work demonstrates is that informal social norms, which emerge from the bottom-up, can be reoriented at the urban scale through top-down municipal intervention through community process and not through police repression. These are essential lessons that can be brought to the American city today, at a time when neighborhood violence is exacerbated by a resurgence of racism, anti-immigration ideology, and police brutality, which has deepened social injustice in the city.

A more inclusive citizenship culture, based on shared values, common interests and empathy, rather than rigid identitarian categories that dehumanize the other, must be the foundation of a new public imagination.

6. Medellín redux: public space educates

What makes these Latin American cases distinctive in comtemporary urbanization is not only that they were driven by a bold position against inequality but that their investments in the public good were coupled with a commitment to renewing civic life through participatory democratic practices. No other continental region in the world has been so effective in tackling urban poverty led by municipalities in partnership with diverse sectors. The north has much to learn from the south when it comes to social justice in the city.

More recently we have witnessed the celebrated urban transformation of Medellín, Colombia, once regarded "the most dangerous city on the planet", a battleground of drug lords, paramilitaries and left-wing guerillas and a site of severe unemployment and poverty.

Public
space
educates

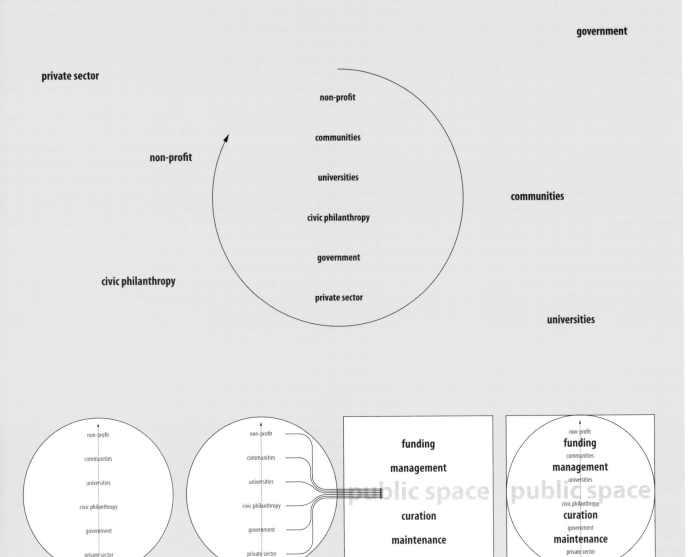

Twenty years later, Medellín is the scene of an egalitarian urban transformation so dramatic that it has captured the attention of urbanists, architects, and planners across the world.

Medellín's interventions were activated through municipal experiments in "social urbanism", an approach coined by the city's former director of urban projects, Alejandro Echeverri (2005–2008), which combined top-down collaborative municipal governance and planning, the coordination of massive cross-sector investments in public infrastructure, public education and social services in the poorest and most violent comunas in the city, and curating dignified spaces for the exercise of civic participation.

When mathematician Sergio Fajardo became mayor in 2005 the very first thing he declared: "We will not build down here (in the center, where the votes are), but up there (in the periphery, where the necessities are)." Fajardo committed to transforming Medellín into "the most educated" city in Colombia, insisting that social justice depended not only on the redistribution of resources but also on the redistribution of knowledge. Violence limits opportunities; knowledge and social inclusion open them.

Fajardo transformed his mayoral office into an urban think tank, to consolidate fragmented policies and agendas, summon the knowledges and resources of government, academia, community leadership and the private sector, all framed by a renewed commitment to civic action. This enabled a new era of swift, intelligent public investment in space and infrastructure in the city's most precarious zones.

Public infrastructure became a physical manifestation of civic commitment to infrastructure and spaces that perform egalitarian purposes. This manifested most clearly in Fajardo's famous "Library Parks" projects, which moved the discussion of public space from a neutral urban commodity animated by random encounter to the deliberate democratization of space. Fajardo committed to designing each park or public space in tandem with pedagogic support systems, injecting specific tactical programming into abstract open space to enable civic activity, education, vocational training, cultural production and small-scale economic development.

7. The cross-border community stations: a new model of "university-community partnership"

Extending our research in Bogotá and Medellín, and focusing on the premise that public space is a pedagogical space where the construction of citizenship can be mobilized through cultural action, we founded the UCSD Cross-Border Community Stations as a network of field-based research and teaching hubs located in diverse immigrant neighborhoods across the border region, where experiential learning, research and teaching is conducted collaboratively with communities, advancing a new model of community-university partnership. The Community Stations provide a unique environment to collaborate with communities on issues of equitable urbanization, environmental justice, diversity and social inclusion.

The Cross-Border Community Stations are a model of reciprocal knowledge production, linking the specialized knowledge of UC San Diego with the community-based knowledge embedded in immigrant communities on both sides of the border. They demonstrate that universities and communities can be meaningful partners in the fight against poverty, each

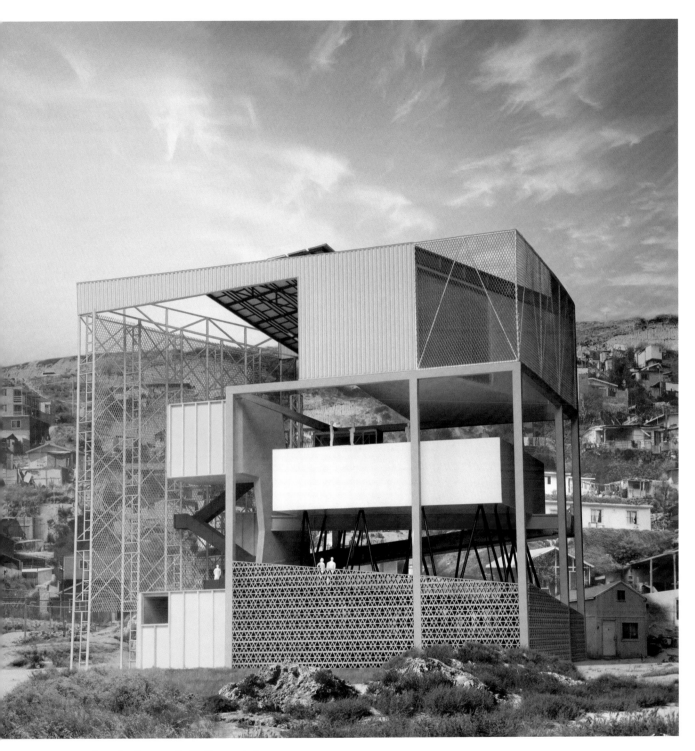

Laureles Community Station rendering

with knowledge and resources to contribute in the search for solutions to deep social, environmental and economic disparities in our society.

The Cross-Border Community Stations are in fact public spaces for reciprocal knowledge production in marginalized communities. This involves transforming vacant and neglected sites and spaces into active civic classrooms—spaces of knowledge, cultural production, participatory climate action, research and display—that are collaboratively curated between community and university, and where a new environmental literacy can stimulate climate action and political agency in marginalized neighborhoods. Essential to this effort is the coproduction of new arts and cultural programs to become instruments for civic participation, as well as engines to incentivize new neighborhood-based economies to improve the quality of life across these underserved, demographically diverse immigrant neighborhoods.

8. "Experiential learning": mobilizing empathy and coexistence

We believe that campuses should diversify themselves, not only by diversifying campus demographics but also by immersing students in diverse, underserved communities that exemplify today's most urgent social challenges. In situ, students learn the ethics of engagement, cultivating cultural sensitivity, suspending judgment and learning how to listen and collaborate. These are skills best learned in the field.

A central assumption of the UCSD Cross-Border Community Stations model is that university-community engagement is a *reciprocal* activity. While the university enters into the field (both enriching its mission and sharing its knowledge and resources), the field also enters into the campus (sharing community-based knowledge and changing the nature of pedagogy and programming on the campus). A key component of the Cross-Border Community Stations is the idea of *public scholarship*, which enables well-respected community leaders to spend time with us on campus each academic year to engage with faculty and students, coteach courses, lead workshops, and find other innovative ways of sharing their community-based experiences and knowledges.

We conclude these eight notices with an inspiring vision from the Pope as he visited Colombia recently: "All of us are necessary to create and form a society." To achieve that, we need to return to the sandbox. Informal education is a powerful tool for enabling mutual recognition, cultivating empathy and providing new pathways for coexistence.

WHAT EDUCATION DO WE NEED?

WE NEED THE IDEA OF "TRANSITIONAL LEARNING"

Peter Alheit

During the course of our lives, we create more meaning with regard to ourselves and to our social framework than we overlook from the perspective of our biographical self-thematization. We have biographical background knowledge, which in principle puts us in a position to fill out and to use the social space in which we move.

In this process, none of us has all conceivable possibilities. However, within the limited potential for change, we have better chances than we will ever realize. Our biography contains a considerable potential of "unlived life" (von Weizsäcker). The intuitive knowledge about this is part of our "practical consciousness" (Giddens). This knowledge is reflexively not easily accessible, but represents an entirely central resource for learning processes in a double sense:

- Our hidden knowledge of the life constructs that accompany us but have not yet been realised keeps the deliberately available self-reference open in principle, and thereby creates the prerequisite for us to be able to take a look at ourselves from a different perspective. The process structures of our life course suggest to us an action plan of expansion or restriction of biographical autonomy. Its deliberate "ratification" remains with us as carriers of our biographies. We are, to a certain extent, "autopoietic systems" (Maturana). We have the chance to recognise the "surplus meaning of our life experiences" and to make them usable for deliberate modifications of our self- and world reference.

- Biographical background knowledge is, however, at the same time a living potential for the modification of structures. This modification offers chances for transformation of even the institutional framework of social existence. "Structures", after all, are to a considerable extent the functioning unquestioned background certainties to which the social individuals make reference as they act on a daily basis. As soon as such prescriptions enter into and become available in one's consciousness, the structures change. "Unlived life" indeed harbors social explosiveness.

The dynamics of this "double learning resource" evokes associations to that educational option of classic psychoanalysis, "where *it* was, *I* shall become". Closer scrutiny certainly reveals that it concerns not only the sovereign, I-based handling of an otherwise unchanged basic dynamic but rather the transition into a new quality of self- and social reference—a process which leaves neither the learning nor the ambient structural context unchanged. In other words, it concerns transitional learning processes.

* **Peter Alheit** is Professor Emeritus at Universität Göttingen, former Chair in General Pedagogy.

187

SITUATED LEARNING: BEYOND THE GAP BETWEEN KNOWLEDGE AND PRACTICE

Nancy Budwig

One of the central features of 21st century education has been the increasing focus on integrative learning, especially in higher education circles. One consequence of this has been the greater attention on helping students draw practical connections between concepts learned in classrooms and what has been called "real-world" application by building better bridges between classrooms and the world.

As a developmental and learning scientist, I believe higher education would be well-served to consider alternatives to "gap" metaphors between knowledge learned in classrooms and subsequent applications. "Gap" or bridge metaphors obscure the proven fact that humans learn best from situated practice. Specific experiences in diverse learning communities supply opportunities for the learner to acquire not only the content knowledge but also the habits of mind and repertoires of practice central to being educated. On this view, education is an opportunity to not just learn *about* but learn to *participate* in communities of practice.

Much of the engaged learning movement has focused on "doing," which suggests the importance for students to practice complex problem-solving. We know from studying learning in context that the inquiry involved in *problem framing*, rarely highlighted, is an equally critical process. Such a view directly links knowledge and practice and, at the same time, breaks down the barriers between the two. As Donald Schoen has argued, practitioners "think in action"—a kind of tacit reflection or *reflection-in-practice* that takes place as one is actually engaged in practice. Triggered by habitual experience in contexts of that actual practice, reflection is not distinct from practice but very much a part of socially situated activities.

True understanding of situated learning has profound implications for thinking about issues of education in the 21st century. Recent socio-cultural theorizing about human learning lends little support for framing knowledge and practice in terms of a gap to be bridged. One implication is that the education that is needed focuses less on "learning about" and "learning to apply knowledge" and more on "learning to participate" and on acquiring the values, knowledge and practices of expert communities of which one is a part.

* **Nancy Budwig** is Professor of Psychology and former Associate Provost and Dean of Research at Clark University. She also is a Senior Scholar at the Association of American Colleges and Universities in Washington, D.C.

WHAT EDUCATION DO WE NEED?

Catherine Burke

There is a tiny settlement on the Llyn Peninsula in North Wales where volunteers, mainly young people in their first decade, after leaving school, come together from many places in the world to construct buildings, make and decorate furnishings and fittings, and grow their own food (http://www.felinuchaf.org). To do this, they draw on premodern forms of construction and art local to the area, utilizing traditional materials and tools. The work is slowly paced, penetrated by conversation destined to weave into stories and occasionally songs. In the pedagogy, there is indiscernible direction: Hierarchies are unfavored and one would have to describe the mode of living, working and playing together as an efficient form of anarchy. The volunteers will leave and move on to do many different things wherever they return to, but the fact that at this point in their lives they are drawn to these collective endeavors tells us something about the education we are currently lacking and the education we need.

First, young people, who are skilled users and developers of digital technologies, are nevertheless (and possibly as a consequence) drawn to the making of things that are honest, tangible, pleasing to the eye and lasting. They partake in activities that meet fundamental requirements for shelter, warmth, nutrition, community and culture. They envisage future generations enjoying the fruits of their labors. This suggests a longing for an education that is designed not only to address individual needs but also one that generates collective enrichment of generations yet to be born.

Second, the slow pace of making and growing reflects aesthetic delight in both the process and product. This suggests that the education we need is one that gives time for the full engagement of all the senses in nurturing educational communities and environments—be they neighborhoods, cities or schools.

Third, bringing about real and lasting changes in the landscape creates new histories through reflective collective endeavor and fulfils a human need to resonate with the environment through story-making.

This example of an existing educational project serves to suggest that the education we need is one that seriously addresses questions of authenticity and survival. At the heart of the education we need will be trust, choice, creative discipline framed by the nurturing of a critical capacity to evaluate claims of truth, detect dishonesty and resist falsehoods that ultimately threaten our humanity.

* **Catherine Burke** is Reader in History of Education and Childhood at the University of Cambridge.

WHAT EDUCATION DO WE NEED?

Tony Eaude

The world has become more diverse, fragmented and uncertain. Inequalities and injustices remain and have frequently worsened. Education must equip individual children and adults to meet new challenges, from climate change to the surveillance society, to deciding who, and what, to trust and how to use and control artificial intelligence—and to other factors we can hardly imagine.

Despite our tendencies towards narcissism, individualism and competitiveness, the importance of interdependence and working together is greater than ever. Education must help to shape the people likely to work for a more just society as well as the societies and cultures that are genuinely inclusive of those with differing aptitudes and intelligences, especially those who have traditionally been excluded—women, people of color and those who are poor.

We need an education system that challenges and changes much of what we take for granted—not only discrimination and injustice but the transmission of privilege, the acceptance that some will, necessarily, be losers in the game of life, the primacy of cognitive, academic attainment and what constitutes success. To do this, we must see education holistically as a task not only for schools but for communities. This education system must involve not only the accumulation of knowledge and skills but encourage physical, mental and spiritual well-being as well as qualities and dispositions such as courage, resilience, critical thinking and compassion, so that we learn to make connections, respect cultural and religious difference and think of others, and not only of ourselves.

Everyone, from a young age, must have a sense of agency and be engaged, so that learning becomes irresistible and infectious. Opportunities and expectations must be much broader, and involve the humanities, the arts and practical aptitudes, which schools too often ignore. We must, together, ensure that learning is both life-wide and lifelong, so that everyone, regardless of background or age or prior attainment, has access to such opportunities and to as many chances for success as they may need.

We will not achieve this overnight. However, concentrating more on relationships and feelings, encouraging active participation and care for others, and finding space for experience of the natural world and reflection would be a start.

* **Tony Eaude** is an independent research consultant and author of books on young children's education.

TEACH AND LEARN FROM THE PRESENT TIMES!

Bente Elkjaer

The education we need today is one that prepares students for meetings with difference and otherness (Elkjaer, 2009). This appears increasingly important particularly due to climate changes, which make it evident that human beings are part of a whole world that hangs together. One of the results of these changes (and of wars and poverty) is the migration of people seeking "promised lands." American pragmatism and particularly the works by John Dewey (1859–1952), which are as relevant today as they were 80 years ago, may be inspirational. Dewey says, *"We always live at the time we live and not at some other time, and only by extracting at each present time the full meaning of each present experience are we prepared for doing the same thing in the future. This is the only preparation which in the long run amounts to anything"* (Dewey, 1938 [1988]: 29–30). Thus, we cannot make use of a fixed curriculum. We need to teach and to learn from the present times and take lessons from history and experience in light of the "now." We need to do what Dewey told us to do—namely to deal with the "problems of men" in visionary ways (Dewey, 1917 [1980]: 46). We need to maintain relevance and imagination as reference points for education.

One of the pillars that pragmatism rests upon is the understanding that our actions and thinking are connected, which means that the role of education is to pave the path for acting in "intelligent", i.e. thoughtful, ways. Another pillar in pragmatism is the knowledge that as human beings, we are formed by the continuous transactions of persons, "things" and environments in experimental and playful ways. In other words, we think more in "what-if" ways rather than in "if-then" ways. "What-if" we look at ourselves as connected to the immigrants of the world rather than proposing a story of "if" we build walls around us, "then" they will be kept out. What would these experimental and probing ways of asking questions mean for the organizations of our workplaces, schools and societies? I further believe that we, as teachers, counselors and consultants, should take on an active and responsible role to support these forms of imaginative teaching and learning. This would "in the long run amount to something."

* **Bente Elkjaer** is Professor and Chair in Learning Theory at the Department of Education, Aarhus University.

References

Dewey, J. (1917 [1980]). The Need for a Recovery of Philosophy. In J. A. Boydston (Ed.), *The Middle Works of John Dewey, 1899–1924* (Vol. 10: 1916–1917, pp. 3–48). Carbondale and Edwardsville: Southern Illinois University Press.

Dewey, J. (1938 [1988]). Experience and Education. In J. A. Boydston (Ed.), *The Later Works of John Dewey, 1925–1953* (Vol. 13: 1938–1939, pp. 1–62). Carbondale and Edwardsville: Southern Illinois University Press.

Elkjaer, B. (2009). Pragmatism. A learning theory for the future. In K. Illeris (Ed.), *Contemporary theories of learning. Learning theorists… in their own words* (pp. 74–89). Abingdon, New York: Routledge.

AN IA SCHOOL MOVEMENT TO AMPLIFY INTELLIGENCE

Ann Goldberg and **Ken Goldberg**

Artificial intelligence (AI) has surpassed humans at Jeopardy and Go, and driverless cars are widely believed to be around the corner. News articles claim we're on the brink of a singularity where robots will steal 50% of our jobs. Many view AI and robots as existential threats to humanity, but what is being overlooked is the potential for these new technologies to amplify our intelligence—what Doug Engelbart called intelligence amplification (IA).

Consider that in 1910, only 10% of American students finished high school; and in that year, emerging advances in farm automation gave rise to what was called the high school movement, which focused on the goal of transforming education to prepare students for jobs other than farming. In a relatively short span of time, thousands of high schools were built and new curricula developed. The result? By 1950 80% of Americans finished high school.

Just as automation motivated us to rethink the way we taught and learned 100 years ago, can we now envision an IA school movement for this century? This time the goal is to evolve the way we learn to emphasize the uniquely human skills that AI and robots cannot replicate: creativity, curiosity, imagination, empathy, human communication, diversity and innovation. The resulting IA systems can provide universal access to sophisticated adaptive testing and provide trained teachers with new ways to discover the unique strengths of each student and to help each student amplify his or her strengths. The goal would be to support continuous learning for students of all ages and abilities.

Much of education today still emphasizes conformity, obedience and uniformity. The important question is not when machines will surpass human intelligence but how humans can work and learn with computers in new ways. Rather than discourage the students of the world with threats of an impending singularity, can we emphasize multiplicity where advances in AI and IA inspire us to think deeply about what humans are best at and how we might embrace diversity to create a myriad of new partnerships?

Assessment measures will adapt to student strengths and enable learning to be deeper and more complex. Individual differences will be accepted. Failure in school, as we know it now, will disappear and be replaced by a wide array of student accomplishments through projects in science, math, art, music and language. Accelerating student progress is the goal.

History and literature will continue to be important subjects linking our past and present and providing templates for the future. The cloud and our libraries will offer a wealth of resources for academic as well as practical learning.

Some rote memorization is vital but will be taught using movement, language, music and repetition through a variety of tools/media during both waking hours and in sleep.

To emphasize the previous premise: Multiplicity is collaborative instead of combative.

The newspapers are full of predictions about robots stealing jobs and an impending singularity when robots will surpass us. Consider instead what we might call multiplicity: diverse groups of people and machines working together to solve problems. Multiplicity is not science fiction. A combination of machine learning, the wisdom of crowds, and cloud computing already underlies tasks that Americans do every day. It is how Google search finds webpages, Amazon recommends books, Netflix suggests movies and Facebook organizes our news. A continuing stream of human interaction ensures that these systems evolve as new items are introduced and as tastes change.

Multiplicity is collaborative instead of combative. Rather than discouraging the human workers of the world, this new frontier has the potential to empower them.

* **Ann Goldberg** is Ken Goldberg's mother. She taught elementary school as a reading specialist and later worked as the Bethlehem PA School District coordinator.
Ken Goldberg is an artist, writer, inventor, and researcher in the field of robotics and automation. He is Professor and Department Chair, Industrial Engineering and Operations Research at UC Berkeley.

A CASE FOR CREATIVE CONTRADICTION

Jessica Hamlin

Public education, although conceived as a civic right, rarely acknowledges the deep contradictions embedded in the tense relationship between its function and form. In the United States the public imagination has been trained to expect increasingly efficient educational factories staffed with professionals who follow directions, demand conformity and enact methods that standardize learning for the most bodies possible. We are deeply mired in a fight between the ideals of preparing citizens equitably and the realities of corporate influence, labor market demands and the pernicious shadow of structural racism.

We need an education that can grapple with these contradictions in creative, inclusive and critically conscious ways; an education that understands that if we commit to the practice of reproducing our past, parroting the values of the status quo, and staunchly defending an invisible economic and cultural caste system that keeps privilege and power in "rightful" places, we are lost.

Much like education, the artist plays a difficult and often contradictory role in society. Artists are simultaneously elevated and maligned for the ways in which they expose what we can't or don't want to see. As artists nurture more socially engaged practices, they afford us an expanding set of creative strategies for working within and also in response to society. The education we need works like an artist, following curiosities and working in a state of constant questioning. It is playful, experimental and attentive to what is around it. It is responsive to the now while acknowledging diverse and difficult histories and contemporary points of view. It is collaborative and cogenerated, invested in understanding the difficult relationship between the individual and society. It opens up spaces and models strategies for posing and solving problems. It provides opportunities to develop new language and modes of representation to share our stories and build empathy and connection across difference. It confronts the status quo and offers the ability to look at ourselves and the world around us in new and unconventional ways with new lenses. It pushes our buttons and forces uncomfortable notions to surface and become part of a larger conversation. Ultimately, it allows us to envision and act out a more sustainable future for humankind as we struggle to understand ourselves, coexist and survive on an increasingly fractious and strained planet.

* **Jessica Hamlin** is Clinical Professor of Arts Education in the Steinhardt School for Culture, Education, and Human Development at New York University.

WHAT EDUCATION DO WE NEED?

Knud Illeris

This question can be answered in many ways and at many different levels. To me it is important to stress that education is not the same as learning.

On the one hand, education insists that the person in question is employed by a school or other similar institution and therefore is kept away from other possible activities such as work, play or social projects. For many children and young people, education connotes a kind of storage, which also involves a specific occupation, control, grading, selection and other kinds of submission.

On the other hand, education always aims at specific learning. Educators and politicians often stress that education is about learning for life, work, culture and the like, not just for schooling. But in today's educational reality with all its tests, measurements and grading, most learners experience the reverse. This has created a need to return to the concept of "transfer of learning," which was central for learning research and theory in the early years of the past century: Why doesn't relevant school learning more often turn up and influence later practice and work situations?

The dominating answer to this question at that time was about common elements. There must be considerable common elements in school and in later life and practice. School learning must not be limited to a more or less closed school universe. This answer clearly reflects the traditional understanding of learning as an acquisition of a specific content and ignores that all learning must also include emotional, social and societal dimensions.

However, the relevant answer in relation to the application of school learning as it affects later life, work, social and cultural contexts must also include another very important component: the strength and direction of the learners' engagement in the learning situation. To what extent are the learners really engaged in their learning, and to what extent is this engagement directed towards a personal acquisition and involvement in the learning content and its conditions?

* **Knud Illeris** is Professor of Lifelong Learning at the Danish University of Education.

THE EDUCATION WE NEED NOW

Manish Jain

The most important thing that we need to focus on education now is *un*learning. I have been on my own unlearning journey for the past 25 years and have been hosting many processes of deconditioning and decolonizing myself and my community. I believe that a focus on unlearning will create new spaces for rethinking everything we believe that we have been taught from an "anthropocentric" lens and for seeing and being in the world more holistically.

Unlearning includes questioning our assumptions, our frameworks, our habits, our fears, our political correctness and all of our sacred cows. At the core of unlearning is to challenge the dominant monoculture worldview of the "West is Best" that has been forced all over the planet. This has been not only devastating for most of the global south, but is also now generating unprecedented levels of suffering in the global north.

Factory schooling was designed to convert diverse human beings into "homo economicus" or economic slaves. All across the world, we are witnessing that factory schooling has either destroyed or commodified diverse languages, knowledge systems, local economies, connections with sacred lands and water bodies, sense of community and ancestors, etc., in its relentless quest to modernize, develop and globalize life.

There is no standardized pedagogy of unlearning, nor is it a one-time process. Unlearning basically involves journeying outside the pristine, well-ordered flatlands of text/digitalia into the messiness, complexities and paradoxes of life. Reconnecting to the wisdom of the hands, the heart, the unique place, together with silence, reveals the sense of wonder and vulnerability that can trigger one's unlearning journey.

Unlearning might be able to open up the way for us to listen outside of the confines of institutionalized experts and their hyper-rationality, linear, technological utopianism, and cost-benefit analytical frameworks. It is not the same as postmodern nihilism. Unlearning can bring us to a healthy regenerative place where we can start to admit, "I don't know what to do in the face of the massive crises that face us." This means that we might be open to looking in other places for "answers" or even "questions"—from the margins, the shadows, the poor, the indigenous, the profane, and to trust the wisdom of the voice that lives inside us and our own experiences. This could take us to a place beyond blame and a discourse of entitlements and reclaim a sense of sacred and wholeness and could move us from a politics of *mainstreaming* to one of *many streaming*, which brings us home to our deeper creative consciousness.

* **Manish Jain** is coordinator and cofounder of Shikshantar: The Peoples' Institute for Rethinking Education and Development in Udaipur, India and cofounder of the Swaraj University.

SHORT ANSWER? RISK

Ronald Jones

Risk is always about managing. From the side of advanced academic research, we would tell you: Rather than a default programmatic style, or applied research, what would be more productive is pure research, if you can manage the risk that comes with a nonessentialist approach towards research that we historically associate with Ludwig Wittgenstein's Theory of Games or later, Morris Weitz' Open Textured Concept. Weitz' theory of the Open Texture not only encourages disciplines to intermingle at their edges, but is nimble enough to quickly exploit unforeseen innovation arising from that amalgamation. And more to the point, our research tells us, this level of innovation would have likely remained otherwise hidden without being animated by interdisciplinary research. And then? Best advice is to quickly adapt practice to theory to opportunity. An example? Recognizing that both an emergency room staff and a commercial airline crew operate within complex cross-disciplinary environments, where life and death decisions are often made in rapidly evolving circumstances, with an often unpredictable future, doctors and pilots can, and have, shared best practices which are then adapted from one side to the other, from doctoring to piloting and back again. In such a case verbs replace nouns where methodology is concerned, and all within a very steep learning environment in which time is always of the essence.

* **Ronald Jones** is an artist, critic and educator. He is Senior Tutor in Service Design at the Royal Academy of Arts in London.

TRAINING FOR THE WORLD OF TOMORROW STARTS IN PRIMARY SCHOOL

Floris Koot

About two weeks into my first year at primary school I gave my teacher a drawing. It showed the classic house, stick people, clouds and sun. She accepted, smiling, but with one look, criticized it: "You draw clouds with a blue pencil." What!? Outside I saw bright white clouds, which I had tried to draw as such on a white piece of paper. I've forgotten what my solution was, but how could I be wrong and a blue pencil right? The teacher disavowed my perception. I decided then and there something like: "Well, lady (read: all of school), if it's between what you tell me and what I see, I'll trust what I see myself any time."

Why did she disown my own experience and research? Why did she treat her solution as the right one? What's this educational fixation on "the right answer?" Life and art do have millions of valid answers. I believe that training by returning the right answers doesn't prepare you for life at all. It prepares you to "do what's expected of you."

In time I've become a creative and educational innovator, experimenting in many fields. I rethink "how things are always done." Many modern day start-ups do the same. But they are hindered by "right answers" not only from authorities but also from within. Having made hundreds of tests, they often seem to focus on: "What is expected of me here? What (right) answer do 'they' (clients, bosses, authorities) expect me to give?"

And, I think, this damaging preparation for life now also threatens our world.

When education prepares young people for the world as a fixed reality, then it has to fail.

When educators act as all-knowing authorities of life as it is, then it has to fail.

Our world currently has very urgent questions that need creative answers and quests for change. How will we deal with the rapid decline of our ecosystems, climate change, fast growing gap in wealth, and possible unemployment for millions due to the rise of robots? We must stop training youth to just join the ranks of the system that created those problems.

The core question should be: How do we prepare our youth to discover the solutions to the problems *we* created? We need to have them sort out what *they* are willing to try as solutions. And that training can start at the age of five. That's when my inventive mind was willing to try out its own solutions to a clear problem. How to draw white clouds on white paper? Such inquiries should be supported, not cut short, because that's where the change has to begin.

* **Floris Koot** is a Dutch inventor and facilitator of innovative processes, and a cofounder of the Knowmads school.

THE ARTFULNESS OF EDUCATION

Tyson Lewis

There are perhaps three ways to think about the relationship between the arts and education.

The first would be to think about how to teach the arts. Art educators often concern themselves with this question and develop age-appropriate methods for teaching art skills, which cultivate art talents and foster ways of talking/reflecting on the meaning of art.

A second way to think about this question might be to ask what particular art forms teach us about the world (or themselves)? Follow-up questions might include: Is the artist the teacher and the work of art the lesson, or is the art itself an autonomous teacher? Do specific arts teach specific lessons, and if so, how?

The third approach would focus on education itself as an art form. Certainly, philosophers of education have often used aesthetic concepts to describe educational processes. To mix artistic metaphors here, the classroom is a "stage" or a "theater." Teaching "forms" the student as a sculptor forms clay. Classroom dialogue has a certain "rhythm." The teacher is a kind of "conductor." Thus, education appears to be an art form, or a form of art that borrows from theater, sculpture, music, and other fine arts in order to define its own activities. Some might argue that these are mere metaphors. But I would suggest that education *as* art highlights dimensions of education that would otherwise be lost—affective, embodied and perceptual dimensions.

And it is precisely this aesthetic dimension of education that is under threat. With the teacher-proof curriculum and with data-driven pedagogy, the ways in which education is artful are sacrificed in the name of efficiency, effectivity and objectivity. This is not to say that efficiency, effectivity and objectivity are not *aesthetic*. Rather, these concepts attempt to deny their aesthetic dimensions in order to appear scientific, rational, and thus unbiased/universal (rather than political, particular, and historical). To battle against certain forms of educational domination, we have to recognize that the terrain of struggle concerns the aesthetics of what can and cannot count as educational and who can and cannot be seen as educated.

As such, it becomes a deeply political issue to think of the artfulness of education.

* **Tyson E. Lewis** is Associate Professor of Art Education at University of North Texas.

THE ABILITY TO ENGAGE WITH THE UNKNOWN

Sugata Mitra

Let us define "education" as "applied learning"—the ability to apply learning to thinking.

So, in order to be educated, we need to learn things and we need to think. Schools do both of these for us. We learn things and we learn how to think using the things we learned. But schools have a problem. They were designed a long time ago and that design is now obsolete.

Schools were designed assuming that there was a list of things everyone needed to learn before they were about 17 years old. It was a fixed list and did not change much over time. The underlying and unexpressed assumption was that the world would not change all that much over time and this list of things would be sufficient for anyone to live after they had "finished" school. It was also assumed that these things could not be learned after "schooling" was over because the necessary books, teachers and learning materials would not be available anymore.

The world changes much faster now and the list of things we need to learn changes with it. Things can be learned using the internet alone without books or teachers. The list of things learned before the age of 17 can no longer be sufficient for negotiating the future. All of the assumptions on which schools are based are no longer valid.

We need an education that enables us to live with the internet. It is continuously available to us. This cloud changes and adapts to the present continuously.

We need an education where the ability to predict and adapt to the future is more important than learning about the past. For example, a good driver will not find what she learned about driving very useful in an autonomous car.

What is known is no longer as important as the ability to engage with the unknown. We need to design schools to teach that skill and to assess accurately if we have that ability.

Our education must prepare us to be "one" with the cloud.

* **Sugata Mitra** is Professor of Educational Technology at the School of Education, Communication and Language Sciences at Newcastle University, England, and Chief Scientist, Emeritus, at the for-profit training company NIIT.

EDUCATE TODAY'S CHILDREN FOR THEIR FUTURE, NOT OUR PAST

Andreas Schleicher

We need to educate today's children for *their* future, not *our* past. Our past was divided: Subjects and students were separated out by given expectations of their future career prospects. Our past was isolated—with schools designed to keep students inside and the rest of the world out. This suggested a lack of engagement with families and a reluctance to partner with other schools. The future needs to be integrated—with an equal emphasis on the integration of subjects and students. The future also needs to be connected—so that learning is closely related to real-world contexts and contemporary issues, open to the rich resources available in the community. Powerful learning environments are constantly creating synergies and finding new ways to enhance professional, social and cultural capital. These learning environments do that with families and communities, with higher education, with businesses, and especially with other schools. This is about creating innovative partnerships. Isolation in a world of complex learning systems will seriously limit potential.

Instruction in the past was subject based. Instruction in the future needs to be more project-based and build experiences that help students think across the boundaries of subject-matter disciplines. The past was hierarchical. The future is collaborative and recognizes both teachers and students as resources and cocreators.

In the past, different students were taught in similar ways. Today, school systems need to embrace diversity with a variety of learning methods. The goals of the past were standardization and compliance, with students educated according to age. Education followed the same standard curriculum with the same grading standards. The future is about building instruction from student passions and capacities and helping students to personalize their learning and progress in ways that foster engagement and talent. Most importantly, it's about encouraging students to be ingenious. We need to take to heart that learning is not a static place but a changing, moving process. While this will counter educational disadvantage, this shift in attitude will also allow educators to capitalize on the strengths of the most talented students.

In the past, schools were technological islands, where that technology was often limited in order to support already existing practices. Students frequently outpaced their schools in their own personal adoption and consumption of technology. It is time for schools to use the potential of technologies to liberate learning from past conventions and connect learners in new and powerful ways, with sources of knowledge, with innovative applications and with one another.

* **Andreas Schleicher** is Director for Education and Skills, and Special Advisor on Education Policy to the Secretary-General at the Organisation for Economic Co-operation and Development (OECD) in Paris.

FOSTERING A REFLEXIVE DISPOSITION

Mark Tennant

Education is as much about being *in* the world as it is about knowledge *of* the world. The focus on "being" is typically taken to mean the transmission and acquisition of values, beliefs and attitudes, as evident in the specification of learner attributes in curricula at all levels of education. But the focus on "being" is best seen as a disposition and capacity for critical self-examination, an examination that scrutinizes both one's self and how it relates to the circumstances and forces that surround and shape one. In the contemporary world of change and uncertainty, knowledge of and the capacity to manage one's self has arguably become more crucial. For most of us, in Western cultures at least, there are no longer the comforts of having strong anchoring points for our identity. We live in diverse societies with different cultures, identities, belief systems and moral values. This diversity means that different ways of being—different "selves"—are opened up to us. However, the pace of social, economic and technological change in the contemporary world means that a singular, unchanging "self" is unlikely to lead to a satisfying and successful life. And so a fundamental aspect of the human condition is that our selves are always in the process of becoming. We thus need to develop the capacity to adapt, be flexible and embrace personal change. It is only a small step from here to consider the whole of life as a project of one's "self"—to know oneself, manage oneself, take care of oneself and to continually recreate oneself in response to changing life circumstances.

The education we need is one that fosters agency in the process of personal formation and change. It is an education that promotes a reflexive engagement with the world, by which is meant an understanding and critical evaluation of one's self, the circumstances in which one lives and the way one is positioned in all relationships—in work, family, institutional and in community life. From a pedagogical point of view this means providing learning experiences that engage students in the uncertainties, messiness and value conflicts of "real world" challenges, whether they be local and particular or global and general. A reflexive engagement means that the lens, or self, through which these challenges are seen remains open to scrutiny, reassessment and change.

* **Mark Tennant** is Emeritus Professor and Deputy Vice-Chancellor (Research), University of Technology Sydney.

EDUCATION THAT INCORPORATES BUILDING STUDENTS' COGNITIVE FLEXIBILITY FOR CREATIVE PROBLEM-SOLVING, COLLABORATION, AND INNOVATION IN A GLOBALIZED WORLD

Judy Willis

What we see depends on what we look for. What we need in education are more opportunities for students to see beyond the obvious or "one right answer." When they are empowered to do so, they can engage more flexibly and be more receptive to new experiences, unfamiliar customs, variations of opinions and interpretations, alternative points of view, multiple approaches to problem-solving, and creative innovation.

Yet as high stakes standardized tests and curricula continue to hold to factory model educational traditions of uniformity and conformity, students miss developing the cognitive flexibility needed for success in careers and in life. In fact, what we are seeing in students with educational experiences in the factory model style is *inattentional blindness*. This occurs when attention is restricted to the designated task so that one fails to notice other things in plain sight that the brain presumes are irrelevant to the current goal or task. The consequences of this inflexibility and goal-focused attention extends to rigidity to changing facts and technology, different cultures, different opinions, alternate possibilities, with resulting heuristics, stereotypes and loss of creativity.

In today's world, the skillsets of *cognitive flexibility* are more critical and valuable than ever before. As technology evolves, if a job can be automated or done by computers, it will be. To be competitive in the job market and enjoy the expanding opportunities of technology and globalization, students need to do what computers cannot do, such as conduct original research, innovate, solve problems and successfully collaborate.

To prepare students for higher learning, global employment, and creative innovation, educators need to provide authentic opportunities throughout their curriculum and learning experiences and to widen their perspectives with cognitive flexibility. This goes beyond being simply tolerant, to being receptive and open-minded to new experiences, unfamiliar customs, variations of opinions and interpretations, alternative points of view and multiple approaches to problem-solving as well as the willingness to take the risk of mistakes as students engage in creative innovation.

"The education that we need" is the capacity to be open and receptive to considering all aspects of an experience, sources of information, a variety of interpretations or approaches to problems. With well-developed cognitive flexibility, students will have greater capacities to consider alternative points of view, predict a variety of outcomes and assess changing data or new information from multiple perspectives. Cognitive flexibility could enhance the likelihood of openness to multiple interpretations, even when asked to respond with only *one*.

H. G. Wells predicted that our future would be a race between education and catastrophe. We live in very exciting times. As educators have opportunities to unleash students'

creativity and build foundational understanding of the neuroscience of learning and neuroplasticity, pathways will open to boost the development of their cognitive flexibility and creativity. Through these fortified skillsets for cognitive flexibility for creative problem solving, global collaboration, and innovation, they will not just win the race; they will push the boundaries beyond the finish line and participate in the challenges and opportunities for creative innovations that await them in their 21st century.

* **Judy Willis** is a neurologist on the adjunct faculty of the University of California Graduate School of Education, Santa Barbara.

FIXING EDUCATION FOR THE AI AGE

Conrad Wolfram

At no time in history has new machinery threatened to take over from humans as it does now.

Previous eras of mechanization have been largely confined to replacing, then scaling up physical activities. Instead, computers continue to take over intelligence and knowledge-based activities—areas previously considered quintessentially human.

How should education react? Do we still need to learn skills that computers now perform? If not, what should we learn instead?

I believe strongly that taking advantage of new powers of automation and going further is the urgent priority, not trying to compete with them. This means learning to handle harder, more complex problems earlier (to mimic growing complexity in the real world) as well as gaining experience of managing and interfacing with AI. But it also means jettisoning most of the skills that the computer has taken over.

In mainstream school education, mathematics is starkly at the centre of this issue: Curricula everywhere have hand-calculating as their focus. Yet in the real world—where maths skills are so coveted—almost all calculating is by computer, adding much more conceptual complexity and very different approaches for which students are ill-prepared. With these criteria, the content of around 80% of school maths is wrong; however good the teaching, pedagogical approach or IT provision, it will still fail to match up.

For all education, in a rapidly changing world with increasing AI, we regularly need to be answering both what are "today's human survival skills?" and what are "top human value adds?" Ability at computational thinking (with our modern day toolset) is an important element for both our most affluent societies transition from knowledge economies (in which direct knowledge is the key driver) to what I term computational knowledge economies (in which knowledge of applying computational thinking is key).

In 2010 I launched computerbasedmath.org to build the anchor school technical subject, given that computers can now be assumed—surprisingly a unique enterprise! Our very different topics, materials and view of the outcomes required for a computational knowledge economy starkly emphasize the outmoded subject-matter in today's curricula and the urgent need for fundamental change by countries and communities worldwide.

* **Conrad Wolfram** is the CEO of Wolfram Research Europe Ltd., and the founder founder of Computerbasedmath.org Ltd.

TO INSPIRE AND ENCOURAGE EVERYDAY HEROISM

Philip Zimbardo

After years of investigating the conditions that lead good people to turn evil, the effort to inspire and train ordinary people to become "everyday heroes" has become my new paramount mission. Our San Francisco nonprofit association, the Heroic Imagination Program (HIP), develops and implements research, education, and corporate and public initiatives to inspire and encourage everyday heroism (https://www.HeroicImagination.org/). HIP summarizes decades of psychological research and offers an engaging and impactful series of lessons that give the opportunity to make heroic action a daily choice that is within our reach. We have had great success with our American program and also globally in a dozen countries.

An overview of our lessons offers a sense of the scope of our new educational adventure. The program relies on a rich fund of evidence-based literature: primarily social psychology perspectives reliant on my lifework as well as many other lines of research. Topics include heroic empathic listening, learning about fixed/static mind sets versus dynamic growth mindsets with the goal of cultivating a growth mindset and situational awareness—recognizing our environment and how situational forces can overpower us, social conformity, and ways to avoid submission to unjust authority, learning how to avoid being a bystander, and understanding bias, its impact and how to address it in order to reverse it.

Anyone can be a hero any time an opportunity arises to stand up for what is right and just, and to speak out against injustice, corruption and other evils. We are all heroes, no matter age, sex, political affiliation, religion or ability. We are mostly ordinary, everyday people whose acts of heroism qualify as extraordinary. Focusing on *we* rather than *me*, we form essential links amongst all of us; we forge the bonds of our human connection.

* **Philip George Zimbardo** is Emeritus Professor at Stanford University and the founder and president of the "Heroic Imagination Project". He is renown worldwide for his Stanford prison experiment.

EPILOGUE

HOW TO BECOME A NON-ARTIST

Ane Hjort Guttu

How To Become a Non-Artist, 2007
Slide show/HD video of about 20 stills and a voiceover
12 min
Courtesy of the artist

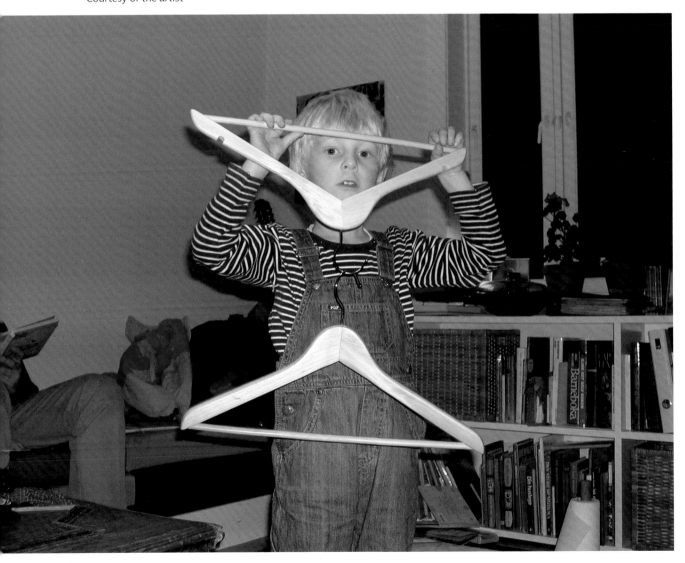

In the winter of 2006, I started observing my son Einar's experiments with form. Einar was creating small arrangements around the house, combining objects or moving them to new places. I documented the arrangements, wondering if a four-year-old related more freely to objects and meaning, or if he had any concept of composition. The age of four is a very particular age; a transition between two different modes of coping with the world; understanding the world and mastering it. We can witness this transition in his process, which is simultaneously a movement from small sculptures, to readymades, to functional objects, that is; from art to non-art.

We, as grownups, pass by; we notice one of these objects and define them as play. But because I had thoroughly tried to understand what was happening, why my son did these things, I didn't see it as merely play anymore. For children, play is of course deadly serious. There is a lot of interesting research done on play and its highly complex and important function in human life. But in our daily speech, play has almost come to mean entertainment. Our reductive understanding of the activity of play makes the use of the word patronizing and even colonialist, in the sense that it is too often used to characterize and inferiorize other people and their activites: activities that we don't fully understand. … Play is only play for those who don't play. For kids, play merges with life, research, exploration, processing of experiences and all these categories do not exist.

And this, I think, could be compared to art's role in the life of the artist. Art is only art for those who don't do it themselves. We have learned to separate art and life, since all things in this society have to be categorized and put in its proper place. But, at least for me, at work, there is no such clear distinction; you do what you do because you have seen something, or thought about something, or felt something, and you would like to understand it and express it, and you do it in a way that can accommodate what you would like to say, which you think would best protect, or preserve, the poetry, or the anger, or the confusion that was such a precious part of your experience. And, sadly, this is called art.

So I think there are many similarities between the activity of play and the artistic practice. But not the superficial parallels that are often promoted: the creative use of strange forms and lively colors or the weirdness of the actions. The similarity rather consists in the concentrated and deeply earnest search for the means to understanding and interpreting the world—so to say, the means of survival.

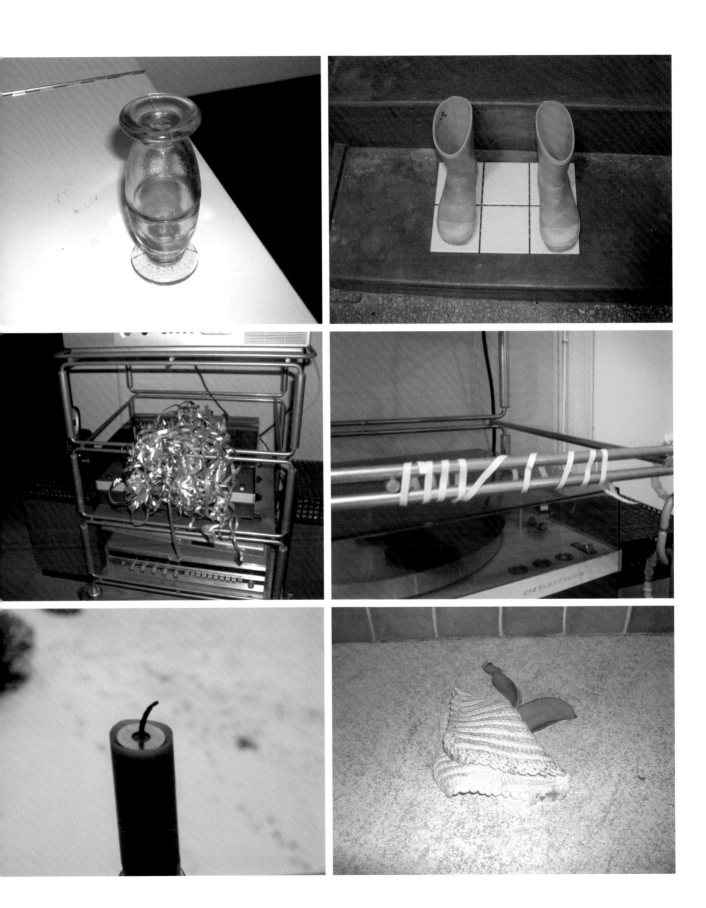

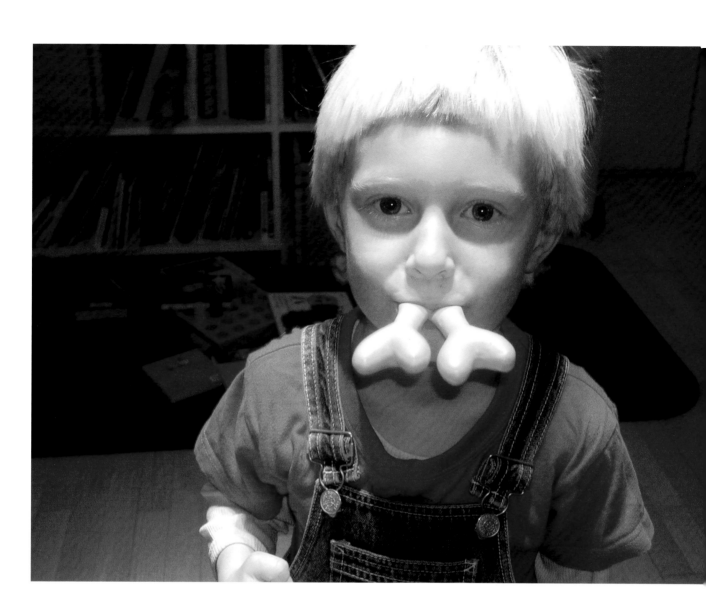

THE MUSEUM IS A SCHOOL

Luis Camnitzer

The Museum is a School. The artist learns to communicate.
The public learns to make connections, 2010-ongoing
Statement, dimensions variable
Reykjavík Art Museum, Reykjavík, Iceland, 2016

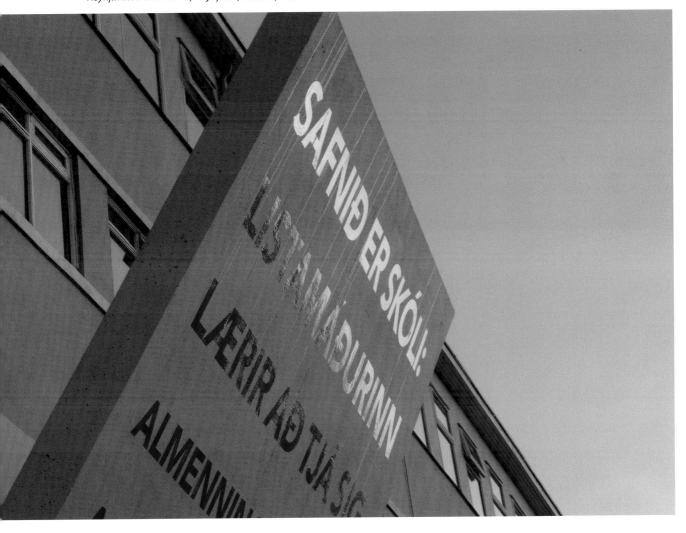

The point of this piece is to establish a contract between the museum and the public in which the museum commits itself to handle the institution's policy following the message of the text. This will allow the public to demand accountability from the institution if they perceive that the museum is derelict in this regard. That is why it's important that I don't appear as author of a work of art but as an enabler for the contract.

Installation views: Western Gallery, Western Washington University, Bellingham, WA, 2018
Kunsthall Stavanger, Stavanger, Norway, 2017

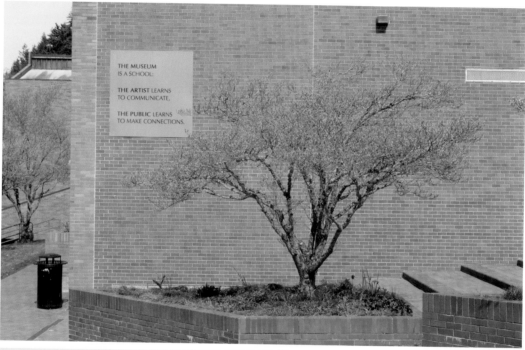

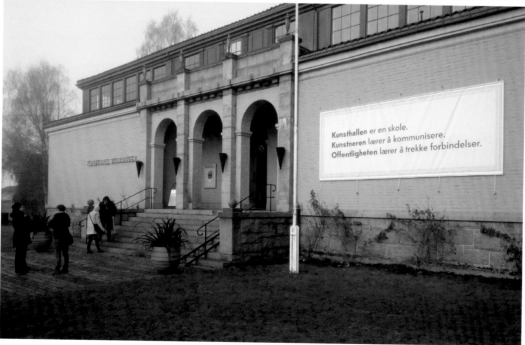

BIOGRAPHIES

Eva Bakkeslett
Born 1966 in Ramsund, Norway, lives and works in Engeløya, Norway.

Selected solo exhibitions
2017 *Biological Diversity*, Bodø Art Society, Norway.
2015 *Everything is connected to everything*, Østfold Artcentre, Fredrikstad, Norway.
 In Between, North Norwegian Art Centre, Svolvær, Norway.
2014 *All is Connected*, Galleri Nord-Norge, Harstad, Norway.

Selected group exhibitions
2017 *Child as a Teacher—Art and Radical Pedagogy*, Stavanger Kunsthall, Norway.
2016 *Høstutstillingen* (The autumn salon), Kunstnernes hus, Oslo, Norway.
 The New Eden—Article biennale, Stavanger Kulturhus, Norway.
 Greenpoint Film Festival, Brooklyn, New York, USA.
 Pusterom (Breathing spaces), Dancefestival Barents, Hammerfest, Norway.
2015 *Rømmekolle Revival*, Barents Spektakel, Kirkenes, Norway.
 Landart Biennale, Kjerringøy, Norway.
 RISK, RE-culture III, 3rd International Visual Art Festival Patras, Greece.
2014 *Bread as Social Sculpture*, Breadhouses Network, Bulgaria.
 Exploring the Microcosmos—new paradigms of the microbial communities. Schumacher College, Devon, UK.
 Gut Feelings, Cardiff M.A.D.E, Wales, UK.
2013 *Cartographies of Hope: Change Narratives*, DOX Centre for Contemporary Art, Prague, Czech Republic.
2012 *Nurturing Nature—artist engage environment*, Center for the Arts, Albright College, Pennsylvania, U.S.

Dare to Share, Barents spektakel, Pikene på Broen, Kirkenes, Norway.
2011 *Nurturing Nature—artists engage environment*, Osilas Gallery, Bronxville, New York, U.S.
 Halikon Lahti Green Art Trilogy, Salo, Finland.

Selected publications
The New Eden, Article Biennale 2016, (cat.).
Lucy Neil, *Playing for Time: Making art as if the world mattered*, London, 2015.
Eva Bakkespett, "Konsten att utvidga perspektiven," in: *Hållbar Konst—en kreativ utmaning!*, Gnesta, Sweden, 2013.
Jaroslav Andel (ed.), *Cartographies of Hope—Change Narratives*, Prague, 2012.
Kvinneliv i Nord, Ingjerd Telle and Wenche Pedersen, Horisont Forlag, 2012.
Eva Bakkespett et al, *Klimatilpasninger—hva betyr det for meg?* Oslo, 2012.
Hållbar konst—en kreativ utmaning, Stockholm, 2011.
Rolf Erik Solheim and, Vidar Rune Synnevåg (eds.), *Framtidsfrø— spirer til en bedre verden*. Anthology, Tingvoll, 2011.
Rob Hopkins and Tamzin Pinkerton, *Local Food: How to Make it Happen in Your Community*, Totnes, UK, 2009.

**Společnost za veselejší současnost
[Society for a Merrier Present]
(Petr Payne, Luboš Rychvalský, Bára Štěpánová)**
Group of dissidents who organized happenings as public events that ridiculed the Communist regime and its repressive policies in 1989. It was active from the spring of 1989 till the end of that year.

Exhibitions

2017 *Child as Teacher: Art and Radical Pedagogy*, Kunsthall Stavanger, Norway.

2016 *Back to the Sandbox: Art and Radical Pedagogy*, Reykjavík Art Museum, Iceland.

Selected literature

Petr Blažek, "Happeningem proti totalitě. Společnost za veselejší současnost v roce 1989," *Paměť a dějiny*, no. 3, 2014, pp. 12–23. http://old.ustrcr.cz/data/pdf/pamet-dejiny/pad1403/012-023.pdf.

Pavlínová Formánková and Petr Koura, "'Olgo, mohl by jít Václav s námi na písek?' Rozhovor s Bárou Štěpánovou o Společnosti za veselejší současnost, bězích třídou Politických vězňů, disidentech na pískovišti a humoru na sklonku komunistické totality," *Dějiny a současnost*, vol. 30, č. 10, 2008, pp. 37–40.

Informace o Chartě 77, samizdat, vol. 12, 1989, no. 10, pp. 13–14, no. 11, p. 17, no. 12, pp. 17, 18, no. 16, p. 18–19, no. 17, pp. 14–15. https://www.vons.cz/data/pdf/infoch/1980/.

Luis Camnitzer

Born 1937 in Luebeck, Germany. Emigrated to Uruguay at the age of one, where he grew up, studied and taught. Lives in NY since 1964 when he cofounded the New York Graphic Workshop.

Selected solo exhibitions

2017 *Transhumance*, Centre National des Arts Plastiques, Paris.
Alexander Gray Associates, NY.

2016 Parra & Romero, Madrid.
SITE, Santa Fe, U.S.

2010 *Luis Camnitzer*, Museum Daros, Zurich.

1988 Uruguayan Pavilion, Venice Biennial, Venice.

Selected group exhibitions

2016 *Bienal de Montevideo*, Montevideo, Uruguay.

2015 *Transmissions*, Museum of Modern Art, New York City.
Under the Same Sun: Art from Latin America Today, Guggenheim Museum, New York City.

2009 *Bienal de la Habana*, Guest of Honor, Havana, Cuba.

2002 *Documenta 11*, Kassel, Germany.

2000 *Whitney Biennial*, New York City.

Selected literature

Kristin G. Congdon and Kara Kelley Hallmark, *Artists from Latin American Cultures: A Biographical Dictionary*, Santa Barbara, CA 2002, pp. 238–240.

Estudio Teddy Cruz + Fonna Forman

Teddy Cruz

Architect and urbanist, born 1962 in Guatemala City, lives in San Diego, and is a professor of visual arts and director of Urban Research at the Center on Global Justice, University of California, San Diego.

Fonna Forman

Political theorist, born 1968 in Milwaukee, lives in San Diego, and is a professor of political science and Director of the Center on Global Justice, University of California, San Diego.

Selected recent exhibitions

2018 *Venice Architecture Biennale*, Venice.

2017 *The Mecalux Retrofit*, California-Pacific Triennial of Art, Orange County Museum of Art.
Visualizing Citizenship: Seeking a New Public Imagination, Yerba Buena Center for the Arts, San Francisco.

2016 *Radicalizing the Local: 60 Miles of Trans-Border Urban Conflict*, Museum of Modern Art, New York.
Cross-Border Community Station, Cooper Hewitt, Smithsonian Design Museum.
Manufactured Sites, Constellation.s, Arc en rêve, Bordeaux.

2015 *The Medellín Diagram*, with Matthias Görlich and Alejandro Echeverri, Bi-City Biennale of Urbanism/Architecture, Shenzhen, China.
Retrofit Gecekondu Wohnungsfrage, Haus der Kulturen der Welt, Berlin.
Political Equator 2015, M+ Hong Kong.

Recent projects

Urban Rooms, San Jose, 2017.
Meeting House at the Old Manse, Concord, Massachusetts, 2016.
EPIC: The Chollas Eco-Village, 2015.
The Mecalux Retrofit Social Housing Project 2015.
The Medellín Diagram, 2013–17.
The Cross-Border Citizen, San Diego and Tijuana, 2013–17.
The UCSD Community Stations, 2010–ongoing.
- *The Cross-Border Community Station at Casa Familiar: Living Rooms at the Border.*
- *The Cross-Border Community Station in Tijuana at Divina Providencia.*
- *Earthlab Community Station Masterplan.*

Recent publications

Top-Down / Bottom-Up: The Political and Architectural Practice of Estudio Teddy Cruz + Fonna Forman. Berlin: Hatje Cantz, under contract.

The Political Equator: Unwalling Citizenship, London: Verso, under contract.

"Global Justice at the Municipal Scale: the Case of Medellín, Colombia," in *Institutional Cosmopolitanism*, Luis Cabrera (ed.), Oxford University Press.

"Climate Change, Mass Migration And Sustainability: A Probabilistic Case for Urgent Action," *Humanitarianism and Mass Migration*, Marcelo Suárez-Orozco (ed.), University of California Press (Forman and Veerabhadran Ramanathan).

"Social Norms and the Cross-Border Citizen," in *Cultural Agents Reloaded: The Legacy of Antanas Mockus*, ed. Carlo Tognato (ed.), Cambridge, MA 2017.

"The Cross-Border Public," in *Public Space? Lost and Found*, Gediminas Urbonas, Ann Lui and Lucas Freeman (eds.), Cambridge MA. 2017.

"Un-walling Citizenship", *Avery Review*, Winter 2017.

"Latin America and a New Political Leadership," in *Public Servants: Art and the Crisis of the Common Good*, eds. Johanna Burton, Shannon Jackson and Dominic Wilsdon (eds.), Cambridge MA 2017.

Bending the Curve: Ten Scalable Solutions for Carbon Neutrality and Climate Stability. University of California Press. (Forman, Vice-Chair), 2016.

The Universal Declaration of Human Rights in the 21st Century: Report of the Global Citizenship Commission Open Book Publishers (Forman, Commissioner and Coauthor), 2016.

"The Wall: The San Diego-Tijuana Border," *ArtForum*, Summer 2016.

Informal Markets Worlds—Reader: The Architecture of Economic Pressure, (coeditors with Helge Mooshammer and Peter Mortenböck), Rotterdam 2015.

Fonna Forman and Teddy Cruz, "Public Imagination, Citizenship and an Urgent Call for Justice," *The Just City Essays: 26 Vision for Urban Equity, Inclusion and Opportunity, Next City*, Vol. 1, Toni Griffin (ed.), New York 2015.

Priscila Fernandes

Born 1981 in Coimbra, Portugal, lives and works in Rotterdam, The Netherlands.

Selected solo exhibitions

2015 *Those bastards in caps come to have fun and relax by the seaside instead of continuing to work in the factory*, TENT, Rotterdam, The Netherlands.

2014 *¿Y EL ARTE?—The Book of Aesthetic Education of The Modern Schoo*, Espai13, Fundació Joan Miró, Barcelona, Spain.
Against the Enamel, Temple Bar Gallery, Dublin, Ireland.

Selected group exhibitions

2017 *Terra, Solar*, Vila do Conde, Portugal.
Free Play, Västerås Museum, Sweden.
It's very new school, Rua Red Contemporary Art Centre, Dublin, Ireland.
What I Am, MAAT, Lisbon, Portugal.

2016 *32nd São Paulo Bienal*, São Paulo, Brazil.
Millennials, Museum Arnhem, The Netherlands.
Games people play, NEST, Den Haag, The Netherlands.
Festival Chantiers d'Europe, Palais de Toyko, Paris, France.
Back to the Sandbox: Art and Radical Pedagogy, Rekjavík Art Museum, Iceland.
PIGS, Artium Basque Museum of Contemporary Art, Victoria, Spain.
S'Wonderful, La Casa Encendida, Madrid, Spain.
Priscila Fernandes, Jessica Stockholder and David Hanvald, Galerie Stadtpark, Krems, Austria.
Social Choreography—an Ecology of Collective Experience, Tenderpixel, London, UK.

2014 *Playtime*, Les Ateliers de Rennes, Bienniale d'art contemporain, Rennes, France.
The Value of Nothing, TENT, Rotterdam, The Netherlands.
This is the Time. And this is the Record of the Time, SMBA, Amsterdam, The Netherlands.
Playgrounds, Museo Nacional Centro de Arte Reina Sofía, Madrid, Spain.
12 Contemporâneos—Estados Presentes. Serralves Museum, Porto, Portugal.

Selected literature

Learning—Volume 45, quarterly publication of architecture, art and design, The Netherlands, 2015.

On Boycott, Censorship and Educational Practices, De Appel Arts Center, Amsterdam, 2015.

Priscila Fernandes (ed.), *The Book of Aesthetic Education of the Modern School*, 2014.

Lars Bang Larsen, *History's Intimate Others: The Child and Its Play in Contemporary Art*, in The Phantom of Liberty, Berlin 2014.

Juan Canela and Ane Agirre, *Lesson 0*, Fundació Joan Miró, Barcelona 2014.

Michael Joaquin Grey

Artist, inventor, and designer. Born 1961 in Los Angeles, California, lives and works in New York City.

Selected solo exhibitions

2015 *My Lagerstätte*, Chronus Art Center, Shanghai. Curator: Zhang Ga.

2013 *Orange between orange and Orange*, Carroll/Fletcher Gallery, London.

2011 *Botticelli | Grey*, Gemäldegalerie, National Museum, Berlin. Curator: Stefan Weppelmann (cat.).

2010 *Horizon Over Time*, Galerie Sherin Najjar, Berlin.
Works of Michael Joaquin Grey, Sundance Film Festival 2010, Park City, Utah.

2009 MoMA / P.S. 1 Contemporary Art Center, New York, Curator: Klaus Biesenbach.

2006 *Reentry: From Primordial to Precocial*, bitforms gallery, New York.

2005 Weather Reports and the Matter of Media: Please Follow the Yellow Line, bitforms gallery, Seoul.

2003 bitforms Gallery, New York.

1995 Kunsthalle Loppem, Belgium.

1993 Brooke Alexander Editions, New York

1992 Lisson Gallery, London.
Barbara Gladstone Gallery, New York.
Stuart Regen Gallery, Los Angeles.

1990 Petersburg Gallery, New York.

Selected group exhibitions

2017 *The Child As Teacher: Art and Radical Pedagogy*, Kunsthall Stavanger, Norway.

2016 *Botticelli Reimagined*, Victoria and Albert Museum, London (cat.).
Still/Moving, Norton Museum of Art, West Palm Beach, Florida.
Back to the Sandbox: Art and Radical Pedagogy, Reykjavik Art Museum, Iceland.

2015 *The Botticelli Renaissance*, Gemäldegalerie, Berlin National Museum, Germany (cat.).

2014 *thingworld*, International Triennial, New Media Art, National Museum of China (cat.).

2013 *Transposition: Motion is Action*, National Art Museum of China, Beijing.
NYC 1993: Experimental Jet Set, Trash and No Star, New Museum, NY (cat.).

2012 *Cartographies of Hope*, DOX Center, Prague, Curator: Jaroslav Andel (cat.).
Century of the Child, MoMA, New York, Curator: Juliet Kinchin (cat.).

2011 *Midnight Party*, Walker Art Center, Minneapolis. Curator: Joan Ruthfuss.
2010 *Remote Viewing*, Arts Santa Monica, Pacific Design Center, Los Angeles.
2007 *RIP. MIX. BURN. BAM*. PFA, Berkeley Art Museum and Pacific Film Archive, Berkeley.
2006 *CUT/FILM Film as Found Object in Contemporary Video*, touring museum exhibition, Philbrook Museum of Art, Tulsa; MOCA, North Miami; Milwaukee Art Museum (cat.).
2001 *Public Offerings*, Los Angeles Museum of Contemporary Art, Los Angeles (cat.).
2000 *Circus Circus*, Norrtalje Konsthall and Konsthall Barbacka, Sweden (cat.).
1994 *Breakdown: Jorge Pardo, Rita McBride, Michael Joaquin Grey*, Museum of Contemporary Art, San Diego (cat.).
1993 *The Final Frontier*, The New Museum of Contemporary Art, New York.
Biennial Exhibition, Whitney Museum of American Art, New York (cat.).
1992 Barbara Gladstone Gallery, New York.
1991 Stuart Regen Gallery, Los Angeles.
1990 Petersburg Gallery, New York.

Selected Literature
Klaus Biesenbach, "Erdkunde mit Klaus Biesenbach," *Monopol Magazin*, June 2009.
Edward A. Shanken, *Art and Electronic Media (Themes & Movements)*, New York, USA / London, UK, 2009.
Saul Ostrow, "Michael Joaquin Grey," *Art in America*, November 2009.
Jerry Saltz, "Deal or No Deal," *New York Magazine*, June 4, 2007.
Roberta Smith, "A Medium in the Making: Slicing Familiar Film Into Something New," *The New York Times*, July 29, 2005.
Edward A. Shanken, *From Drips to ZOOBs: The Cosmology of Artist/Inventor Michael Grey*, Artbyte, August–September 1998.
Herbert Kohl, "ZOOBs: A Challenge for the Hand and Mind," *Rethinking Schools*, vol. 12, no. 3, Spring 1998.

Ane Hjort Guttu
Born 1971 in Oslo, Norway, lives and works in Oslo.

Selected solo exhibitions
2018 *Films*, Tromsø Kunstforening.
2017 *Furniture Isn't Just Furniture*, Fotogalleriet, Oslo, Norway.
2016 *The Rich Should be Richer*, Speicher Düsseldorf, Germany.
2015 *Time Passes*, South London Gallery, London.
Festspillutstillingen: eating or opening a window or just walking dully along, Bergen Kunsthall, Bergen, Norway.
2014 *Urbanisme Unitaire, Le Quartier*, Centre d'Art Contemporain de Quimper, France.
Det här är alla ställen, Tensta Konsthall, Stockholm, Sweden.
2012 *De rike bør bli enda rikere*, Kunsthall Oslo, Oslo, Norway.
2007 *Nye arbeider*, Unge Kunstneres Samfund, Oslo, Norway.
2004 *Nye arbeider*, Kunstnerforbundet, Oslo, Norway.

Selected group exhibitions
2018 *Workflow*, CC Sint Niklaas, Belgium.

Kampen om Grønland, Interkulturelt Museum, Oslo, Norway.
More for Less, A4 Arts Foundation, South Africa.
Back to the Sandbox: Art and Radical Pedagogy, Western Gallery, Bellingham, WA, USA.
2017 *Exhausted Academies*, Nottingham Contemporary, Nottingham.
The Child as Teacher: Art and Radical Pedagogy, Kunsthall Stavanger, Norway.
Byen, Kunstmuseet KUBE, Ålesund, Norway.
2016 *Back to the Sandbox: Art and Radical Pedagogy*, Reykjavik Art Museum, Iceland.
Playing by the Rules, Royal Standard, Liverpool, UK.
11th Gwangju Biennale, South Korea.
Identity, National Art Museum of Ukraine (NAMU), Kiev, Ukraine.
Kunstverein, München, Germany.
2015 *The Mothernists*, Upominki, Rotterdam, The Netherlands.
Lorck Schive kunstpris, Trondheim Kunstmuseum.
Future Light, Wienbiennalen, Austria.
Europe—The Future of History, Kunsthaus Zürich, Switzerland.
Krigens skygge. Politisk kunst i Norge 1914–2014, Kunstnernes hus, Oslo, Norway.
Reiser alene, Tromsø Kunstforening, Tromsø, Norway.
2014 *[self.]*, Trøndelag senter for samtidskunst,
Play Time, Les Ateliers de Rennes, France.
Where Angels Fear to Tread, 19th Biennale of Sydney, Australia.
1814 Revisited, Akershus kunstnersenter/Eidsvoll, Norway.
In These Great Times, Kunstnernes hus, Oslo, Norway.
2013 *Bergen Assembly*, Bergen, Norway.
Does Europe Matter?, The Pavillion—Vitamin Creative Space, Beijing, China.
JENS, Hordaland Kunstsenter, Norway.
Constellation Europa, Donostia-San Sebastián, Spain.
Cultural Freedom in Europe, Sint Lukas Gallery/Goethe Institute Brussels, Belgium.
Society Without Qualities, Tensta Konsthall, Stockholm, Sweden.
2012 *West to the East*, Gallery Y, Minsk, Belarus.
Multiple Choices, KARST Projects, Plymouth, England.
Lære for livet, Henie-Onstad kunstsenter, Oslo, Norway.
Eliza's Eating Elephants and Hates to Draw Trees. sic! Raum für Kunst, Luzern, Switzerland.
Scenarien über Europa, Galerie für Zeitgenössische Kunst Leipzig, Germany.
2011 *Genius Without Talent*, de Appel Art Centre, The Netherlands.
Ane Hjort Guttu/Aase Texmon Rygh, Porsgrunn Kunstforening, Porsgrunn, Norway.
Making is Thinking, Witte de With Centre for Contemporary Art, The Netherlands. 2010
Akademi, KHIO, Oslo.

Markus Kayser
Inventor, designer, and artist, focusing on novel design and digital fabrication processes at the intersection of design, technology, and biology. Born 1883 near Hanover, Germany, and lives in Burgwedel, Germany.

Environments

2016 *Synthetic Apiary. A Perpetual Spring Environment for Bees and Humans.* The Mediated Matter Group MIT Media Lab (with Prof. Neri Oxman et al.).

2014 *GLASS I. (G3DP). Water-based Digital Fabrication Platform.* The Mediated Matter Group With Profe. Oxman et al. in collaboration with MIT's Department of Mechnical Engineering and MIT's Glass Lab. Additional researchers include Shreya Dave (MIT MechE) and James Weaver (WYSS Institute, Harvard).

2013 *Silk Pavilion.* Research and Design by the Mediated Matter Research Group MIT Media Lab in collaboration with Prof. Fiorenzo Omenetto (TUFTS University) and Dr. James Weaver (WYSS Institute, Harvard University).

Patents

Title: Methods and Apparatus for Additive Manufacturing of Glass
U.S. Patent No: US14697564
Filed: April 27, 2015
Inventors: John Klein, Giorgia Franchin, Michael Stern, Markus Kayser, Chikara Inamura, Shreya Dave, Peter Houk and Neri Oxman

Selected Publications

With Neri Oxman et al. "Silk Pavilion: A Case Study in Fiber-based Digital Fabrication," in: Fabio Gramazio, Matthias Kohler and Silke Langenberg eds. *Fabricate: Negotiating Design & Making*, London 2017.

With Michael Stern et al Additive Manufacturing of Optically Transparent Glass in: *3D Priniting and Additive Manufacturing*, Volume 2, Number 3, 2015.

With Laia Mogas-Soldevila et al., "Designing the Ocean Pavilion," *Proceedings of IASS Annual Symposia*, IASS 2015 Amsterdam Symposium: Future Visions—Digital Architecture and Design, pp. 1–13 (13).

With J. D. Royo et al, "Modeling Behavior for Distributed Additive Manufacturing," in: Thomsen M., Tamke M., Gengnagel C., Faircloth B., Scheurer F. (eds) *Modelling Behaviour*. Springer, Cham 2015.

With Neri Oxman et al, "Biological Computation for Digital Design & Fabrication," in: Stouffs, Rudi and Sariyildiz, Sevil (eds.), *Computation and Performance*—Proceedings of the 31st eCAADe Conference—vol. 1, Delft 2013, pp. 585–594.

With Neri Oxman et al, "Robotically Controlled Fiber-based Manufacturing," in: *Green Design, Materials and Manufacturing Processes*, London 2013.

With Neri Oxman et al, "Freeform 3D Printing: toward a Sustainable Approach to Additive Manufacturing," in: *Green Design, Materials and Manufacturing Processes*, London 2013.

Eva Koťátková

Born 1982 in Prague, Czech Republic, lives and works in Prague.

Selected solo exhibitions

2015 *Out of Sight*, MIT List Visual Arts Center, Hayden Gallery, Cambridge, MA, USA.
Training in Ambexderity, Joan Miró Foundation, Barcelona, Spain.
Dvouhlavý životopisec a muzeum představ [Two-headed Biographer and the Museum of Notions], Prádelna Bohnice, Bohnice Psychiatric Hospital, Prague, Czech Republic.

2014 *Experiment for 7 Body Parts*, Staatliche Kunsthalle Baden-Baden, Germany.
Eva Koťátková: Anatomical Orchestra, Schinkel Pavillion, Berlin, Germany.
Scrap Metal Gallery, Toronto, Canada.

2013 *A Story Teller's Inadequacy*, MAO—Modern Art Oxford, Oxford, UK.
Stages of Sleep, Wroclow Museum of Contemporary Art, Wroclow, Poland.
Theatre of Speaking Objects, Kunstverein Braunschweig, Germany.
Unlearning Instinct, RURART centre d'art contemporain, Rouilles, France.

2012 *Internal Machine*, Tongewolbe T25, Sammlung Wittman, Inglostadt, Germany.

2011 *Unsigned: Eva Koťátková and Gugging*, Austrian Cultural Center, Prague, Czech Republic.
Educational Model, Kunstvereniging Diepenheim, The Netherlands.

2010 *City of Old*, Meyer Riegger, Karlsruhe, Germany.
Reading Room, Space for One Work, Moravian Gallery, Brno, Czech Republic.
House Arrest, Conduits Gallery, Milano, Italy.

2009 *Eva Koťátková—Dictation*, ARGE Kunst Galerie Museum, Bolzano, Italy.

2008 *Eva Koťátková—I do it because they taught me to*, Meyer Riegger, Berlin.
Social Game, DUMB—Dům umění města Brna, galerie G99, Brno, Czech Republic.
Walk to School, Václav Špála Gallery, Prague, Czech Republic.

2006 *Speak Slower, Please*, Preproduction Gallery, Berlin.

Selected group exhibitions

2015 *The Silver Lining: 25 Years of the Jinřich Chalupecky Award*, Prague National Gallery at the Veletžní Palace, Prague, Czech Republic.
Avatar und Atavism. Outside the Avantgarde, Kunsthalle Duesseldorf, Germany.

2015 *Triennial: Surround Audience*, New Museum, N.Y., New York, U.S.
All Back in the Skull Together, Maccarone, N.Y., New York, U.S.

2014 *Punctum, Bemerkungen zur Photographie*, Salzburger Kunstverein, Austria.
Silence, A Holocaust Exhibition, Ludwig Museum Budapest, Hungary.
Report on the Construction of a Spaceship Module, curated by Tranzit-CZ, New Museum, New York, U.S.
Dorothea von Stetten Kunstpreis 2014—Czech Republic, Kunstmuseum Bonn, Germany.
Frieze Projects, New York, N.Y., U.S.

2013 *5 Moscow Biennale of Contemporary Art*, Manege Exhibition Hall, Moscow, Russia.
7 Ways to Overcome the Closed Circuit, Bremen, Bremen, DE & the Museum of Contemporary Art Belgrade, Serbia.
Salon der Angst, Kunsthalle Wien, Vienna, Austria.
Of Natural Materials | z nietrwałych materiałów, Gdansk City Gallery, Gdansk, Poland.

The Encyclopedic Palace, curated by Massimiliano Gioni, 55th Venice Biennale, Venice.

2012 *Diagrammatic Representations*, Bielefelder Kunstverein, Germany.
Qui Vive?, III. Moscow International Biennale for Young Art, Moscow, Russia.
18th Biennale of Sydney: All Our Relations, Sydney, Australia.
Between the First and Second Modernity, 1985–2012, National Gallery in Prague at the Veletržní Palace, Prague, Czech Republic.
Air de Lyon, Fundacion PROA, Buenos Aires, Argentina.

2011 *Uchronie*, curated by Le Bureau (FR), FRAC Franche-Comte, Besancon, Galerie Klatovy / Klenova, Klatovy, Galerie 35—Institute France, Prague, Czech Republic.
Prison: A Place for Art, DOX Center for Contemporary Art, Prague, Czech Republic.
Zeichnung?, Kunstverein Nuernberg, Germany.
Young Visual Artist Awards Exhibition, Slovak National Galerie, Bratislava, Slovakia.
Expanded Territory, KAI10, Arthena Foundation, Duesseldorf, Germany.
A Terrible Beauty is Born, 11th Biennale de Lyon, France.
Lost Stories, curated by Barnabas Benscik, Sokol Gallery for Contemporary Art, Nowy Sacz, Poland.
10X10: Koťátková, Mančuška, Prinz Gholam, curated by Karel Císař, European Cultural Congress, Wroclaw, Poland.
Les amis de mes amis sont mes amis, Hommage a Ján Mančuška, Galerie Jocelyn Wolff, Paris, France.
Sense and Sensibility, Salzburger Kunsterverein, Salzburg, Austria.
Sculpture in the Street II, curated by Karel Císař, DUMB: Brno House of Arts, public spaces in Brno. Czech Republic.
Art in General: To Perceive in the Darkness of the Present, PRAGUEBIENNALE 5, Prague, Czech Republic.
Farewell to Longing, Kunstraum Niederosterreich, Vienna, Austria.
Instituceum, Modern Institutions and Contemporary Art, Bohunice Psychiatric Hospital, Bohnice-Prague.
Starke Emergenz, Kunstraum Innsbruck, Innsbruck, Austria.

2010 *School days*, Lewis Glucksman Gallery, Cork, Ireland.
20 Years of Jindřich Chalupecký Award Winners, DOX, Prague, Czech Republic.
Liverpool Biennial, International 10: Touched, Tate Liverpool, UK.
Where Do We Go From Here?, Secession, Vienna, Austria.

2009 *New Millenium*, Minor Sensations, Museum of Art, Seoul National University, South Korea.
Performa 09, Conduits Gallery, Milan, Italy.
Je est un autre, Meyer Riegger Berlin, Germany.

2008 *The Mechanics of the Canvas*, Ernst Museum Budapest, Budapest & Mucsarnok Kunsthalle, Budapest, Hungary.

2007 *Prague Biennale 3, Glocal Outsiders*, Karlín Hall, Prague, Czech Republic.
(In)visible things, Trafo House for Contemporary Art, Budapest, Hungary.
Gross Domestic Product / Hrubý domácí produkt, Prague City Gallery, Prague, Czech Republic.

Essl Award 2007, Moderní galerie at the Academy of Fine Arts, Prague, CZ & Essl Museum, Kunsthaus Klosternburg, Austria.

2006 *Funciones del Cuerpo (Body Functions)*, 9th Havana Biennial, Cuba.

2005 *Hill 88 Project*, Marin Headlands, San Francisco, CA, USA.
5th Biennale of Young Artists, GHMP: Prague City Gallery, House of the Stone Bell, Prague, Czech Republic.

Graziela Kunsch

Born 1979 in São Paulo, Brazil, lives and works in São Paulo.

Selected solo exhibitions
2007 *Nothing to be looked at*. Sesc, São Paulo.
2001 *Graziela Kunsch doesn't exist*. FAAP, São Paulo.

Selected group exhibitions
2017 *Avenida Paulista*, MASP, São Paulo, Brazil.
Os,. Instituto Tomie Ohtake, São Paulo, Brazil.
20th Contemporary Art Festival Sesc_ Videobrasil, Sesc, São Paulo, Brazil.

2015 *31st Sao Paulo Biennial: Selected Works*, Museu de Serralves, Porto, Portugal.
1st Frestas Art Triennial, Sesc, Sorocaba, Brazil.

2014 *31st Sao Paulo Biennial: How (…) things that don't exist*, Fundação Bienal, São Paulo, Brazil.
Há escolas que são gaiolas e há escolas que são asas, MAR, Rio de Janeiro, Brazil.

2013 *X Bienal de Arquitetura*—with Movimento Passe Livre, Centro Cultural São Paulo, Brazil.
33 Panorama de Arte Brasileira—with USINA collective, MAM, São Paulo, Brazil.

2011 *All thats fits: the aesthetics of journalism*, QUAD, Derby, UK.

2010 *29th Sao Paulo Biennial: There's always a cup of sea to sail in*, Fundação Bienal, São Paulo, Brazil.

Selected literature
Pedro Fiori Arantes, "Refazendo escolas, in: Coletivo Contrafilé (eds.), *A batalha do vivo*. São Paulo: MASP, 2016.
Nuria Enguita Mayo; Erick Beltrán (eds.), *Catalogue 31st Bienal de Sao Paulo—How (…) things that don't exist*, São Paulo: Fundação Bienal de São Paulo, 2014.
Binna Choi (ed.), *The Grand Domestic Revolution Handbook*, Utrecht: Casco Office for Art Design and Theory, 2014.
Irene Small. "Live Streaming: on Documentary Strategies in Brazilian Art and Activism," in: *Artforum*, May/2014.
Graziela Kunsch (ed.), *Urbania*, no. 5: Education. São Paulo: Editora Pressa, 2014. PDF version at: https://naocaber.org/revista-urbania-5/.
Glória Ferreira (ed.), *Contemporary Brazilian Art: Documents and Critical Texts*. Santiago de Compostela: Dardo, 2009.

Pam Kuntz

Dancer, choreographer and educator. Born 1970 in Helena, MT, lives and works in Bellingham, WA. She is the founder and Artistic Director of Kuntz and Company (kuntzandco.org) where she works with professional artists and community

members to share the stories of this community through the arts. She is teaching at Western Washington University.

Selected live performances

2016 *Airings... voices of our youth.*
2014 *Hide and Seek.*
 Positive.
2013 *Hello, My name is You.*
2012 *The Family Project.*
2011 *Leave my shoes by the door.*
 Prison Pieces.
2010 *In the Context of Life.*
 Stories from Jim and Jo.
2009 *Wrinkles... grace in time.*
2008 *Conversations.*
 That One Curve.
2007 *The Parent Project.*
2005 *The Mom Project.*

Selected screendances

Ellis won't be dancing today, 2016.
Parkinson's dreams about me, 2012.
Welcoming Clyde, 2011.

James Mollison

Born in 1973 in Nairobi, Kenya, schooled in the UK, lives in Venice, Italy.

Selected solo exhibitions

2017 *Where Children Sleep*, The Leonardo, Salt Lake City, U.S.
 Playground, Miasto-Ogrodow, Katowice, Poland.
2016 *Where Children Sleep*, David J. Sencer CDC Museum, Atlanta, U.S.
2015 *Playground*, Aperture Foundation, NYC; Flatland Gallery, Amsterdam, The Netherlands.
2014 *Where Children Sleep*, Fullerton Museum Center, California, U.S.
2013 *Where Children Sleep*, The Citadelle Art Foundation, Texas; Where Children Sleep, James A. Michener Art Museum, Pennsylvania, U.S.
 The Disciples, The Aldrich Contemporary Art Museum, Connecticut, U.S.
2012 *Where Children Sleep*, Atrium in The Hague City Hall, The Hague, The Netherlands.
2011 *Where Children Sleep*, Museum Dr. Guislain, Gent; Flatland Gallery, Utrecht; DSM Art Collection, Kerkrade, The Netherlands.
2010 *Where Children Sleep*, Auditorium Parco della Musica, Rome Italy.
 Face to Face, The Herbert Art Gallery and Museum, Coventry, UK.
2009 *The Disciples and James & Other Apes*, Flatland Gallery, Utrecht; Colette Gallery, Paris.
2008 *The Disciples and James & Other Apes*, Hasted Hunt Gallery, New York; Oceanographic Museum, Monaco, France.
2007 *Face to Face*, Australian Museum, Sydney, Australia; Museon den Haag, Den Haag, The Netherlands.
2006 *Face to Face*, Swedish Museum of Natural History, Stockholm, Sweden.
 Face to Face, World Museum, Liverpool, UK.
2005 *James & Other Apes*, Brancolini Grimaldi Arte

Contemporanea, Florence, Italy;
Natural History Museum, London.

Selected group exhibitions

2017 *The Child as Teacher: Art and Radical Pedagogy*, Kunsthall Stavanger, Norway.
2016 *Childhood*, Side Gallery, Newcastle, UK.
 Fotoistanbul, Istanbul, Turkey.
 Back to the Sandbox: Art and Radical Pedagogy, Reykjavík Art Museum, Iceland.
2015 *We Want More*, The Photographers' Gallery, London.
2014 *Photaumnales*, Galerie Nationale de la Tapisserie de Beauvais, France.
 Festival Du Film Et Forum International Sur Les Droits Humains, Geneve, Switzerland.
2013 *Nuit des Images*, Lausanne, Switzerland.
 Le 106, Scène de Musiques Actuelles de la CREA, Rouen, France.
2012 *Bursa Foto Fest*, Istanbul, Turkey.
 Happiness and Other Survival Techniques, Design Museum, London; Bergen Art Gallery, Norway.
 Movies That Matter Festival, The Hague, The Netherlands.
 Look3 Festival of Photograph, Charlottesville, VA, USA.
 Nordic Light, International Centre of Photography, Kristiansund, Norway.
2011 *Out of Mind*, Lodz Fotofestiwal, Lodz, Poland.
 Arnhem Fashion Biennale, Arnhem, The Netherlands.
 Child in Danger, Child as Danger, Museum Dr. Guislain, Gent, Belgium.
2010 *Getxo Photo*, Getxo, Spain.
2009 *Who Shot Rock and Roll*, Brooklyn Museum, NY, U.S.
 Animalism, National Media Museum, Bradford, UK.
2007 *Les Yeux Ouverts*, Shanghai Art Museum, Shanghai, China.
 Chocolate, 21_21 Design Sight, Tokyo, Japan.
2006 *Les Yeux Ouverts*, The Centre Pompidou, Paris, France.
 Bêtes de Style, Mudac, Lausanne, Switzerland.
2005 *Contact Photography Festival*, Toronto, Canada.
2004 *Rencontres d'Arles festival*, Arles, France.

Monographs

Playground by James Mollison. Published by Aperture Foundation, New York 2015.
Where Children Sleep by James Mollison. Published by Chris Boot Ltd, New York 2010.
The Disciples by James Mollison / Introduction by Desmond Morris. Published by Chris Boot Ltd, New York 2008.
The Memory of Pablo Escobar by James Mollison. Published by Chris Boot Ltd, New York 2007.
James & Other Apes by James Mollison / Introduction by Jane Goodall. Published by Chris Boot Ltd, New York 2004.

Petr Nikl

Multimedia artist, works in visual and performing arts. Born in 1960, Zlín, Czech Republic, lives in Prague.

Selected solo exhibitions

2018 *Opice*, Galerie Václava Chada, Zlín, Czech Republic.
 Samovolnosti, 8 Gallery, Prague, Czech Republic.
2017 *Čarodějka příroda*, Muzejní a galerijní centrum, Valašské Meziříčí, Czech Republic.

Petr Nikl, Magické Vikýře, PLAY, Galerie Malostranská beseda, Prague, Czech Republic.

2016 *Pijavice*, Václav Špála Gallery, Prague, Czech Republic.
Brown Pictures, 8 Gallery, Prague, Czech Republic.

2015 *Časosběry*, Galerie města Plzně, Czech Republic.

2014 *The Faces from New York*, Fait Gallery, Brno, Czech Republic.
Cockroaching: Beetle Works, Pellé Gallery, Prague, Czech Republic.

2013 *Dialogue With My Mother*, Czech Center, Milano, Italy.
The Game of Time, Galerie hl. m. Prahy, Prague, Czech Republic.

2012 *The Faces from New York*, Wortnerův dům, Alšova jihočeská galerie, České Budějovice, Czech Republic.
I Am Your Hare, Wanieck Gallery, Brno, Czech Republic.

2011 *Dialogue with My Mother*, Czech Center, Paris, France.

2010 *Drawings from the New World*, Galerie Havelka, Prague; Regional Gallery in Zlín, Star Summer Palace, Prague, Czech Republic.

2009 *Faces*, Galerie Via Art, Prague, Czech Republic.
Fools, Galerie Mona Lisa, Olomouc, Czech Republic.

2008 *The Labyrinthes*, Gallery Moderna, Prague, Czech Republic.

2007 *The Pleasure*, Gallery of Czech Insurance Company, Prague, Czech Republic.

2006 *Soul-Étude*, The Abbatoir, London, England

2005 *Curtains*, Gambit Gallery, Prague, Czech Republic.
Black Paintings, Gallery of Visual Arts, Opava, Czech Republic.

2004 *Freaks?*, Rue Montgrand Gallery, Marseille, France.

2003 *Garden*, Gallery 36, Kiev, Ukraine.

2002 *Broken Fairy Tale*, Mustasaari Gallery, Oulu, Finland.

2001 *Paintings, Drawings*, Neue Rathaus, Weiden, Germany.

1999 *Parrot Heading Out to the Cosmic Space*, Václav Špála Gallery, Prague, Czech Republic.

1998 *Broken Tale*, Gallery at the White Unicorn, Klatovy, Czech Republic.
As a Butterfly, National Gallery in Prague—Veletržní Palác, Czech Republic.

1996 *My Saints*, Czech Cultural Center, Berlin, Germany.
Jindřich Chalupecký Prize, Václav Špála Gallery, Prague, Czech Republic.

1995 *Little Rooms*, Aspekt Gallery, Brno, Czech Republic.

1994 *Sacred Mask*, Window Gallery, British Council, Prague, Czech Republic.

1993 *Died Toys*, MXM Gallery, Prague, Czech Republic.

1992 *Paintings, Objects*, Sechzig Gallery, Feldkirch, Austria.

1991 *Time*, La Coupole Gallery, Neu-Isenburg, Germany.

Selected group exhibitions

2015 *The Heart of Europe*, Power Station of Art, Shanghai, China.

2014 *Lone Rangers*, Galerie 1. patro, Prague, Czech Republic.

2013 *Lone Rangers*, Frameless Gallery, London, UK.

2011 *Fundamenty sedimenty*, GHMP, Prague, Czech Republic.
1984–1995, Wanieck Gallery, Brno, Czech Republic.

2010 *Czech Art*, Galerie Dabubiána, Bratislava, Slovakia.

2009 *14 S, My Europe*, DOX Center for Contemporary Art, Prague, Czech Republic.

2008 *The Stubborn after 20 Years*, Středočeské Muzeum Visual Arts Praha, Czech Republic.

2005 *And What Are You Thinking About?*, Prague City Gallery, Czech Republic.

2004 *The Light*, Museum of Applied Arts, Brno, Czech Republic.

2002 *Art dans la ville*, St Etienne, France.
Prague, d'un printemps a l'autre, l'Ecole d'art de Belfort, France.

2001 *New Connections*, Contemporary Art from the Czech Republic and Slovakia, World Financial Center, New York, U.S.

1997 *The Dawn of Magicians*, National Gallery in Prague—Veletržní Palác, Czech Republic.
Biennial of Young Art, Cetinja, Montenegro.

1994 *Distant Voices: Contemporary Art from the Czech Republic*, South London Gallery, London, UK.

1993 *New Painting of Eastern Europe*, Galerie de Arte Detursa, Madrid, Spain.

1992 *The Stubborn*, City Library, Prague, Czech Republic.

1991 *Seven Artists from Prague*, Akademie, Brussels, Belgium.
The Stubborn, Arhus Kunstbygning, Arhus, Denmark; Theatre National de Bretagne, Rennes, France.

1987 *The Stubborn*, Lidový dům, Prague, Czech Republic.

Renzo Piano

Architect and engineer, born in 1937 in Genoa, Italy, works and lives in Paris, France.

Selected architectural projects

Stavros Niarchos Foundation Cultural Center, Athens, Greece (2016)

Centro de Arte Botín, Santander, Spain (2012–2017)

Valletta City Gate and Parliament House (2011–2015)

The Harvard Art Museums, Cambridge, Massachusetts (2008–2014)

Whitney Museum of American Art, New York City (2007–2015)

Kimbell Art Museum extension, Fort Worth, Texas (2007–2013)

Astrup Fearnley Museum of Modern Art, Oslo, Norway (2006–2012)

Los Angeles County Museum of Art (BCAM and Resnick Pavilion), Los Angeles (2003–2010)

Central Saint Giles, London (2002–2010)

The Shard, London (2000–2010)

Modern wing of the Art Institute of Chicago (2000–2009)

California Academy of Sciences renovation and extension, San Francisco (2000–2008)

New York Times Building (2000–2007)

Morgan Library Renovation and Extension (2000–2006)

High Museum of Art Extension (1999–2005)

Zentrum Paul Klee (1999–2005)

Nasher Sculpture Center (1999–2003)

Auditorium of the Parco della Musica (1994–2002)

Maison Hermès (1998–2001)

Auditorium Niccolo Paganini (1997–2001)

Aurora Place, Sydney, Australia (1996–2000)

Potsdamer Platz, Berlin (1992–2000)

Fondation Beyeler (1991–1997)

Jean-Marie Tjibaou Cultural Centre, Noumea, New Caledonia (1991–1998)

Kansai International Airport (1991–1994)

Old Port of Genoa (1985–2001) and Lingotto Factory in Turin (1983–2003)

Menil Collection (1981–1987)
Centre Pompidou (1971–1977)

Selected exhibtions

2018 *I still believe in miracles—Works from Selvaag Art
 Collection*, Astrup Fearnley Museet, Oslo, Norway.
 Renzo Piano: Progetti d'acqua, Fondazione Vedova,
 Venezia, Italy.

2017 *Renzo Piano & Richard Rogers*, Centre Pompidou, Paris,
 France.
 Renzo Piano Building Workshop, Piece by Piece, Stavros
 Niarchos Foundation Cultural Center, Athens, Greece.

2016 *Renzo Piano Building Workshop*, La Biennale di Venezia,
 Venezia, Italy.

2015 *Renzo Piano Building Workshop, La Méthode Piano*,
 Cité de l'architecture & du patrimoine, Paris, France.
 Renzo Piano Building Workshop, Piece by Piece, Power
 Station of Art, Shanghai, China.
 Renzo Piano Building Workshop, Water Projects, Naval
 Museum of Pegli, Genoa, Italy.
 The Making of Valletta, City Gate Valletta, Malta.

2014 *Renzo Piano Building Workshop, Piece by Piece*, Palazzo
 della Ragione, Padova, Italy.

2013 *Renzo Piano Building Workshop, Fragments*, Gagosian
 West 21, New York, U.S.

2007 *Renzo Piano Building Workshop*, Le Città Invisibili
 Triennale di Milano, Italy.

2005 *On Tour with Renzo Piano & Building Workshop: Selected
 Projects*, LACMA, Los Angeles, U.S.
 *Celebrate Architecture! Renzo Piano & Building
 Workshop*, High Museum of Arts, Atlanta, U.S.

2004 *Renzo Piano & Building Workshop*, Progetti in Mostra
 Porta Siberia, Porto Antico, Genoa, Italy.

2000 *Renzo Piano: Architekturen des Lebens*, Neue National
 Galerie, Berlin, Germany.
 Renzo Piano: un regard construit, Centre Georges
 Pompidou, Paris, France.

Selected literature

Favier Olivier, Renzo Piano and Renzo Cassigoli,
 La Désobéissance de l'Architect, Paris 2016.
NPR Staff, "Blueprints Before High Tide: An Architect
 Explains the Perfect Sandcastle," August 1, 2015.
 https://www.npr.org/2015/08/01/428088284/blueprints-
 before-high-tide-an-architect-explains-the-perfect-
 sandcastle.
Renzo Piano, "How To Build the Perfect Sand Castle,"
 The Guardian, July 14, 2015.
Philip Jodidio, *Renzo Piano Building Workshop*, Köln 2014.

Calvin Seibert
Born 1958 in Denver, CO, U.S. Lives and works in New York City.

Selected solo exhibitions

2000 Derek Eller Gallery, New York City.
1999 Derek Eller Gallery, New York City.
1996 White Room, White Columns, New York City.

Selected group exhibitions

2017 *Earth Day*, Ramiken Gallery, New York City.
2017 *Child as Teacher: Art and Radical Pedagogy*, Kunsthall
 Stavanger, Norway.

2016 *Back to the Sandbox: Art and Radical Pedagogy*,
 Reykjavik Art Museum, Iceland.

2014 *Another, Once Again, Many Times More*, Martos Gallery,
 East Marion.

2013 *Rock Art & the X-ray Style*, Brighton Beach, Brooklyn,
 NY.

2000 *Greater New York*, P.S.1 Contemporary Art Center, New
 York City.

1999 *Some When*, Mass Art, Boston.

1996 *Space, Mind, Place*, Andrea Rosen Gallery, New York
 City.

Selected literature

Greg Herbowy, "The Sandcastle Sculptures Of SVA Alumnus
 Calvin Seibert," Visual Arts Journal, Spring, 2018.
 http://www.sva.edu/features/the-sandcastle-sculptures-
 of-sva-alumnus-calvin-seibert.
Calvin Seibert and Joel Lewin, "I Build Modernist Sandcastles,"
 Financial Times, September 18, 2015.
Jesica Braune, "Interview with Calvin Seibert: Ganz so wie
 Kinder," Die Zeit. no. 32/2015, August 6, 2015,
 https://www.zeit.de/2015/32/sandburgen-calvin-seibert.
Corey Kilgannon, "King of Sand Castles," *The New York Times*,
 August 14, 2015.
Elizabeth Stinson, "7 Modernist Sand Castles From a Master's
 Hand," Wired, May 6, 2014, https://www.wired.com/2014/
 05/7-modernist-sand-castles-from-a-masters-hand/.
Lukas Feireiss and Robert Klanten (eds.), *Imagine Architecture*,
 Berlin 2014.

BIBLIOGRAPHY

1631 Comenius, John Amos. *Janua linguarum reserata sive seminarium linguarum et scientiarum omnium* [The Door of Languages Unlocked, or the Seedbed of All the Languages and Sciences], Leszno, 1631 (1629–31)

1640 Comenius, John Amos. *Porta linguarum trilinguis reserata*, London: George Miller (anonymous "pirate" edition by Johannes Anchoranus), 1631; London: Edward Griffin, 1640

1642 Comenius, John Amos. *Januae linguarum reseratae aureae Vestibulum*, Amsterdam: Jansson
Comenius, John Amos. *A Reformation of Schooles*, London: Michael Sparke

1657 Comenius, John Amos. *Opera didactica omnia, ab anno 1627 ad 1657 continuata* (1633–1638–1657), Amsterdami

1658 Comenius, John Amos. *Orbis Sensualium Pictus.* Noribergae [Nuremberg]: Typis & Sumptibus Michaelis Endteri

1659 Comenius, John Amos. *Orbis Sensualium Pictus—Visible World*, trans. Charles Hoole, London: J. Kirton

1668 Comenius, John Amos. *Via Lucis.* Amsterdami: Ad Christophorum Conradum Typographum, (1641–42)

1680 Comenii, Joh. Amos [Comenius, John Amos]. *Spicilegium didacticum.* Amsterdam: Nigrinus

1690 Locke, John. *An Essay Concerning Human Education.* London: Thomas Bassett

1693 Locke, John. *Some Thoughts Concerning Education.* London: A. and J. Churchill at the Black Swan in Paternoster-row
Comenii, Joh. Amos. *De rerum humanarum emendatione consultatio catholica ad genus humanum, ante alias vero ad eruditos, religiosos, potentes Europae* [General Consultation on an Improvement of All Things Human], (1645–70); Halle, 1702

1762 Rousseau, Jean-Jacques. *Émile ou De L'Éducation.* Paris: La Haye, J. Néaulme

1780 Pestalozzi, Johann Heinrich. *Die Abendstunde eines Einsiedlers* [The Evening Hour of a Hermit]

1787 Pestalozzi, Johann Heinrich. *Lienhard und Gertrud* [Leonard and Gertrude] (1781–87). Zürich: Gessner

1801 Pestalozzi, Johann Heinrich. *Wie Gertrud ihre Kinder lehrt* [How Gertrude Teaches Her Children]. Bern, Zürich: Gessner

1806 Herbart, Johann Friedrich. *Allgemeine Pädagogik: Aus dem Zweck der Erziehung Abgeleitet.* Göttingen: J. F. Röwer

1822 Fröbel, Friedrich. *Ueber Deutsche Erziehung überhaupt, und über das allgemeine Deutsche der Erziehungsanstalt in Keilhau insbesondere.* Rudolstadt: Privilegierte Hofbuchhandlung

1823 Jacotot, Jean-Joseph. *Enseignement Universel. Langue maternelle.* Louvain/Dijon: Chez Victor Lagier

1835 Herbart, Johann Friedrich. *Umriss Pädagogischer Vorlesungen.* Berlin: Dieterich

1839 Jacotot, Jean-Joseph. *Musique, Dessin et Peinture.* Paris: Mansut fils

1844 Fröbel, Friedrich. *Mutter- und Koselieder.* Blankenburg: Anstalt zur Pflege des Beschäftigungstriebes der Kindheit und Jugend

1883 Parker, Francis W. *Notes on Talks of Teaching.* New York: E. L. Kellogg & co

1886 Parker, Francis W. *The Practical Teacher.* New York: E. L. Kellogg & co

1894 Parker, Francis W. *Talks on Pedagogics: an Outline of the Theory of Concentration.* New York: E. L. Kellogg & co
Steiner, Rudolf. *Die Philosophie der Freiheit.* Berlin: Emil Felder

1897 Parker, Francis W. *Course of Study in Pedagogics.* Chicago: Chicago Normal School Press

1898 Herbart, Johann Friedrich. *Letters and Lectures on Education.* Syracuse: C. W. Bardeen

1900 Key, Ellen. *Barnets århundrade: studie. 1.* Stockholm: Bonnier
Key, Ellen. *Barnets århundrade: studie. 2.* Stockholm: Bonnier

1902 Dewey, John. *The Child and the Curriculum*. Chicago: The University of Chicago Press

1907 Gulick, L. "Play and Democracy." *Charities and the Commons* 18 (3): 481–486
Steiner, Rudolf. *Die Erziehung des Kindes vom Gesichtspunkte der Geisteswissenschaft*. Berlin: Besant-Zweig

1909 Addams, Jane. *The Spirit of Youth and the City Streets*. New York, The Macmillan company
Dewey, John. *Moral Principles in Education*. Boston, New York: Houghton Mifflin Company

1910 Addams, Jane. *Twenty Years at Hull-House: With Autobiographical Notes*. New York, The Macmillan company
Dewey, John. *How We Think*. Amherst: Prometheus Books
Key, Ellen. *Tal till Sveriges ungdom*. Stockholm: Fram
Montessori, Maria. *Antropologia Pedagogica*. Milano: Doctor Francesco Vallardi Pu. Good. N. D.. Casa Editrice

1913 Ferrer i Guàrdia, Francesc. *The Origins and Ideals of the Modern School*. New York: Knickerbocker Press
Montessori, Maria. *Il Metodo della Pedagogia Scientifica Applicato all'Educazione Infantile nelle Case dei Bambini*. Roma: Loescher

1916 Dewey, John. *Democracy and Education: An Introduction to he Philosophy of Education*. New York: Free Press

1917 Montessori, Maria. *L'Autoeducazione nelle Scuole Elementari: Continuazione del Volume II Metodo della… Scientifica Applicato all'Educazione Infantile nelle Case dei Bambini*. Roma: Loescher-Maglione e Strini

1919 Korczak, Janusz. *Momenty Wychowawcze*. Warsaw: Biblioteka Zrzeszenia Nauczycielstwa Polskich Szkół Początkowych

1922 Parkhurst, Helen. *Education On The Dalton Plan*. New York: E. P. Dutton & Company

1923 Montessori, Maria. *Das Kind in der Familie und andere Vorträge*. Wien: Montessori-Schule

1926 Vygotsky, Lev. *Pedagogicheskaya Psikhologiya: Kratkij Kurs*. Moscow: Izdateľstvo Rabotnik Prosveshcheniya

1929 Korczak, Janusz. *Prawo Dziecka do Szacunku*. Warsaw, Krakow: Wydawnictwo J. Mortkowicza
Whitehead, Alfred North. *The Aims of Education and Other Essays*. New York: Macmillan Company

1930 Isaacs, Susan S. *The Intellectual Growth of Young Children*, London: Routledge and Kegan Paul
Pestalozzi, Johann Heinrich. *Wie Gertrud ihre Kinder Lehrt*. Berlin: Deutsche Bibliothek
Vygotsky, Lev. *Pedologiya Podrostka*. Moscow: MGU
Vygotsky, Lev. *Voobrazhenie i Tvorchestvo v Shkoľnom Vozraste*. Moscow and Leningrad: GIZ

1931 Anderson, Lewis. *Pestalozzi*. New York: McGraw-Hill Book Co

1932 Piaget, Jean. *Le Jugement Moral chez L'enfant*. Paris: Bibliothèque philosophie contemporaine

1933 Whitehead, Alfred North. *Adventures of Ideas*. New York: Macmillan Company

1935 Vygotsky, Lev. *Umstvennoe Razvitie Detej v Protsesse Obucheniya*. Moscow-Leningrad: Uchpedgiz

1936 Piaget, Jean. *La Naissance de l'Intelligence chez l'Enfant*. Paris: Delachaux et Niestlé

1938 Dewey, John. *Experience and Education*. New York: Macmillan

1939 Korczak, Janusz. *Pedagogika żartobliwa*. Warsaw: Wydawnictwo J. Mortkowicza

Neil, Alexander Sutherland. *The Problem Teacher*. ?: Herbert Jenkins

1940 Rugg, Harold. *Man and His Changing Society* 9 volumes. Boston: Ginn & Co

1943 Read, Herbert. *Education through Art*. London: Faber and Faber

1946 Freinet, Célestin. *L'École Moderne Française*, Paris: Ophrys

1947 Piaget, Jean. *La Psychologie de l'Intelligence*, Paris: Armand Colin

1948 Piaget, Jean. *Le Droit à l'Education dans le Monde Actuel*. Paris: Librairie du Recueil Civil
Read, Herbert. *Culture and Education in World Order*. New York: MOMA

1949 Freinet, Célestin. *L'Éducation du Travail*. Paris: Ophrys
Montessori, Maria. *Educazione e Pace*. Milano: Garzanti

1950 Montessori, Maria. *La Scoperta del Bambino*. Milano: Garzanti

1953 Hilgard, Ernest R.; Whipple, J. Rote memorization, understanding, and transfer: an extension of Katona's card-trick experiments, *Journal of Experimental Psychology* 46 (4), pp. 288–292
Neil, Alexander Sutherland. *The Free Child*. London: Herbert Jenkins

1955 Cronbach, Lee J., & Meehl, Paul E. Construct validity in psychological tests, *Psychological Bulletin* 52, pp. 281–302

1956 Bloom, Benjamin S. *Taxonomy of Educational Objectives*. Boston: Allyn and Bacon
Freinet, Célestin. *Les Méthodes Naturelles dans la Pédagogie Moderne*. Paris: Bourrelier

1957 Dreikurs, Rudolf. *Psychology in the Classroom: A Manual for Teachers*. New York: Harper & Row

1958 Dewey, John. *Experience and Nature*. New York: Dover

1960 Neil, Alexander Sutherland. *Summerhill: A Radical Approach to Child Rearing*. New York: Hart Publishing Company
Scheffler, Israel. *The Language of Education*. Springfield: Charles C. Thomas

1961 Broudy, Harry S. *Building a Philosophy of Education*. Englewood Cliffs: Prentice-Hall

1962 Gagnè, Robert. *Psychological Principles in System Development*. New York: Holt, Rinehart, and Winston
Glaser, Robert (ed.) *Training Research and Education*. New York: Columbia University Press

1963 Kerr, Clark. *The Uses of University*. Cambridge: Harvard University Press

1966 Bruner, Jerome. *Towards a Theory of Instruction*. New York: W. W. Norton & Company

1967 Piaget, Jean. *Biologie et Connaissance. Essai sur les Relations entre les Régulations Organiques et les Processus Cognitifs*. Paris: Gallimard
Tough, A. *Learning without a Teacher: A Study of Tasks and Assistance During Adult Self-teaching*. Toronto: Ontario Institute for Studies in Education

1968 Freire, Paulo. *Pedagogia do Oprimido*. São Paulo: Paz e Terra
Habermas, Jürgen. *Erkenntnis und Interesse*. Frankfurt am Main: Suhrkamp
Jackson, Philip W. *Life in Classrooms*. New York: Holt, Rinehart and Winston
Neil, Alexander Sutherland. *Summerhill: A Radical Approach to Child Education*. London: Penguin Books

1969 Freinet, Célestin. *Pour l'École du Peuple*. Paris: Maspero

Holt, John. *The Underachieving School.* New York: Pitman

Mager, Robert F. *Preparing Behavioral Objectives.* Atlanta: Center for Effective Instruction

Piaget, Jean. *Psychologie et Pédagogie.* Paris: Denoël

Postman, Neil; Weingartner, Charles. *Teaching as a Subversive Activity.* New York: Dell

Rogers, Carl. *Freedom to Learn: A View of What Education Might Become.* Columbus: Charles Merill

Skidelski, Robert. *English Progressive Schools.* Harmondsworth: Penguin

1970　Bourdieu, Pierre. *La Reproduction. Éléments pour une théorie du Système d'Enseignement.* Paris: Les Éditions de Minuit

Hart, Harold. *Summerhill: For and Against.* New York: Hart

Hirst, Paul; Peters, Richard. *The Logic of Education.* London: Routledge and Kegan Paul

Piaget, Jean. *L'Evolution Intellectuelle entre l'Adolescence et l'Age Adulte.* Milan: Foneme

1971　Bruner, Jerome. *The Relevance of Education.* New York: Norton

Illich, Ivan. *Deschooling Society.* New York: Harper & Row

Malaguzzi, Loris. *Esperienze per una Nuova Scuola dell'Infanzia: Atti del Seminario di Studio Tenuto a Reggio Emilia il 18–19–20 marzo 1971.* Roma: Editori riuniti

Sarason, Seymour. *The Culture of the School and the Problem of Change.* Boston: Allyn and Bacon

1972　Hemmings, Ray. *Fifty Years of Freedom: A Study of the Development of the Ideas of A.S. Neil.* London: Allen and Unwin

1973　Scribner, Sylvia; Cole, Michael. Cognitive Consequences of Formal and Informal Education, *Science* 182, pp. 553–559

1974　Gagnè, Robert. Educational Technology and the Learning Process, *Educational Researcher* 3 (1), pp. 3–8

1975　Foucault, Michel. *Surveiller et Punir: Naissance de la Prison.* Paris: Gallimard

Knowles, Malcolm. *Self-Directed Learning.* Chicago: Follet

Oakeshott, Michael. *On Human Conduct.* Oxford: Oxford University Press

Piaget, Jean. *L'Equilibration des Structures Cognitives.* Paris: Presses Universitaires de France

1976　Bowles, Samuel; Gintis, Herbert. *Schooling in Capitalist America: Educational Reform and the Contradictions of Economic Life.* New York: Basic Books

Holt, John. *Instead of Education: Ways to Help People Do Things Better.* New York: Dutton

1977　Willis, Paul. *Learning to Labour: How Working Class Kids Get Working Class Jobs.* Farnborough: Saxon House

1978　Barrow, Robin. *Radical Education: A Critique of Freeschooling and Deschooling.* London: Martin Robertson

Donaldson, Margaret. *Children's Minds,* London: Fontana/Croom Helm

Vygotsky, Lev. *Mind in Society.* Cambridge: Harvard University Press

1979　Apple, Michael W. *Ideology and Curriculum.* London: Routledge

Campbell, Donald T. Assessing the impact of planned social change, *Evaluation and Program Planning* 2 (1), pp. 67–90

Fuller, R. Buckminster; Kahn, Robert; Wagschal, Peter. *R. Buckminster Fuller on Education.* Amherst: University of Massachusetts Press

Lyotard, Jean-François. *La Condition Postmoderne: Rapport sur le Savoir.* Paris: Minuit

Swidler, Ann. *Organization without Authority: Dilemmas of Social Control in Free Schools.* Cambridge: Harvard University Press

1980　Bloom, Benjamin S. *All Our Children Learning.* New York: McGraw-Hill

Cremin, Lawrence Arthur. *American Education: The National Experience, 1783–1876.* New York: Harper & Row Publishers

Husén, Torsten. *Skolan i Prestationssamhället: Ett Forsök att Kritiskt Granska Skol an Som Institution.* Ljudbok: Natur och kultur

Papert, Seymour. *Mindstorms: Children, Computers, and Powerful Ideas.* Hassocks: Harvester Press

1981　Mitchell, Richard. *The Graves of Academe.* Boston: Little Brown

Peters, Richard. *Moral Development and Moral Education.* London: George Allen & Unwin

1982　Apple, Michael W. *Education and Power.* London: Routledge

1983　Arons, Stephen. *Compelling Belief: The Culture of American Schooling,* McGraw-Hill, New York

Gardner, Howard. *Frames of Mind: The Theory of Multiple Intellegencies.* New York: Basic Books

Schwab, Joseph. The Practical 4: Something for Curriculum Professors to Do, *Curriculum Inquiry* 13 (3), pp. 239–265

1984　Goodlad, John. *A Place Called School.* New York: McGraw-Hill

Knowles, Malcolm. *Andragogy in Action.* San Francisco: Jossey-Bass

Noddings, Nel. *Caring: A Feminine Approach to Ethics and Moral Education.* Berkeley: University of California Press

Sizer, Theodor. *Horace's Compromise: The Dilemma of the American High School.* New York: Houghton-Mifflin

1985　Bloom, Benjamin S. (ed). *Developing Talent in Young People.* New York: Ballantine Books

Blumenfeld, Samuel. *Is Public Education Necessary?* Boise: Paradigm Company

1986　Aronowitz, Stanley; Giroux, Henry. *Education under Siege: the Conservative, Liberal and Radical Debate over De-schooling.* London: Routledge & Kegan Paul

Dechter, Rina. Learning while searching in constraint-satisfaction-problems, *Proceedings of the Fifth National Conference on Artificial Intelligence* (AAAI-86), pp. 178–183

Hargreaves, A. *Two Cultures of Schooling: The Case of Middle Schools.* London: Falmer Press

Osherson, D.; Weinstein, S. *Systems that Learn.* Cambridge: MIT Press

1987　Eisner, Elliot W. *The Role of Discipline-Based Art Education in America's Schools.* Los Angeles: The Getty Center for Education in the Arts

Kohlberg, Lawrence. *Child Psychology and Childhood Education: A Cognitive Developmental View.* Boston: Addison-Wesley

Flew, Anthony. *Power to the Parents: Reversing Educational Decline.* London: Sherwood Press

1988 Glenn, Charles. *The Myth of the Common School*. Amherst: University of Massachusetts Press

1989 Aleynikov, Andrey. O Kreativnoy Pedagogike, *Vestnik Vysshej Skoly* 12, pp. 29–34

Banks, James; McGee Banks, Cherry. *Multicultural Education: Issues and Perspectives*. Boston: Allyn and Bacon

Holt, John. *Learning All the Time: How Small Children Begin to Read, Write, Count and Investigate the World, Without Being Taught*. New York: Addison-Wesley

McLaren, Peter. *Life in Schools: An Introduction to Critical Pedagogy in the Foundations of Education*. New York and London: Longmans

1990 Freire, Paulo. *Paulo Freire Conversando con Educadores*. Montevideo: Roca Viva

Cremin, Lawrence. *Popular Education and its Discontents*. New York: Harper & Row

1991 Boaz, David (ed). *Liberating Schools: Education in the Inner City*. Washington: Cato Institute

Lather, Patti. *Getting Smart: Feminist Research and Pedagogy With/in the Postmodern*. London: Routledge

Lave, Jean; Wenger, Etienne. *Situated Learning: Legitimate Peripheral Participation*. Cambridge: Cambridge University Press

Liebschner, Joachim. *Foundations of Progressive Education: The History of the National Froebel Society*. Cambridge: Lutterworth Press

1992 Asghar, Iran-Nejad; Chissom, Brad. Contributions of Active and Dynamic Self-Regulation to Learning, *Innovative Higher Education* 17 (2), pp. 125–136

Greenberg, Daniel. Sudbury Valley's secret weapon: Allowing people of different ages to mix freely at school, *The Sudbury Valley Experience* 3, pp. 121–136

Martin, Jane Roland. *The Schoolhome: Rethinking Schools for Changing Families*. Cambridge: Harvard University Press

Noddings, Nel. *The Challenge to Care in Schools: An Alternative Approach to Education*. New York: Teachers College Press

Reigeluth, Charlie. Elaborating the elaboration theory, *Educational Technology Research & Development* 40 (3), pp. 80–86

Shor, Ira. *Empowering Education: Critical Teaching for Social Change*. Chicago: University of Chicago Press

1993 Apple, Michael W. *Official Knowledge: Democratic Education in a Conservative Age*. London: Routledge

Lieberman, Myron. *Public Education: An Autopsy*. Cambridge: Harvard University Press

Papert, Seymour. *The Children's Machine: Rethinking School in the Age of Computer*. New York: Basic Books

1994 bell hooks. *Teaching to Transgress: Education as the Practice of Freedom*. London, New York: Routledge

Chase, Penelle; Doan, Jane (eds). *Full Circle: A New Look at Multi-Age Education*. Portsmouth: Heineman Publishers

Darling, John. *Child-Centered Education and its Critics*. London: Paul Chapman Publishing

Scardamalia, M., & Bereiter, C. Computer support for knowledge-building communities. *The Journal of the Learning Sciences*, 3 (3), pp. 265–283.

1995 Apple, Michael W.; Bean, James A. (eds). *Democratic Schools*. Alexandria: Association for Supervision and Curriculum Development

Glenn, Charles. *Educational Freedom in Eastern Europe*. Washington: Cato Institute

Malaguzzi, Loris. *In Viaggio con i Diritti delle Bambine e dei Bambini*. Reggio Emilia: Edizioni Reggio Children

Röhrs, Hermann; Volker, Lenhart (eds). *Progressive Education Across the Continents. A Handbook*. New York: Lang

1996 Bernstein, Basil. *Pedagogy, Symbolic Control, and Identity: Theory, Research, Critique*. London: Taylor and Francis

Bruner, Jerome. *The Culture of Education*. Cambridge: Harvard University Press

Tooley, James. *Education Without the State*. London: Education and Training Unit, Institute of Economic Affairs

Wilkinson, Roy. *The Spiritual Basis of Steiner Education*. London: Sophia Books

1997 Brehony, Kevin J. An 'undeniable' and 'disastrous' influence? John Dewey and English Education (1895–1939), *Oxford Review of Education* 23, pp. 427–445

Brosterman, Norman. *Inventing Kindergarten*. New York: Harry N. Abrams

1998 Kohn, Alfie. *What to Look for in a Classroom… And Other Essays*. San Francisco: Jossey-Bass

Pinar, William. *Queer Theory in Education*. London: Routledge

1999 Cappel, Constance. *Utopian Colleges*. New York: Peter Lang.

Gutierrez, Francisco; Prado, Cruz. *Ecopedagogia e Cidadania Planetaria*. São Paulo: Cortez

Kohn, Alfie. *The Schools our Children Deserve: Moving beyond Traditional Classrooms and "Tougher Standards"*. New York: Houghton Mifflin

2000 Ausubel, David P. *The Acquisition and Retention of Knowledge: a Cognitive View*. Boston: Kluwer Academic Publishers

Carey, Lou; Carey, James; Dick, Walter. *The Systematic Design of Instruction*. Boston: Allyn & Bacon

Field, John. *Lifelong Learning and the New Educational Order*. Stoke on Trent: Trentham Books

Gatto, John Taylor. *Underground History of American Education*. New York: Oxford Village Press

Lascarides, V. C.; Hinitz, Blythe F. *History of Early Childhood Education*. New York: Falmer Press

Meier, Deborah. *Will Standards Save Public Education?* Boston: Beacon Press.

Wolfe, Jennifer. *Learning from the Past*. Mayerthorpe, Alta: Piney Branch Press

Wollons, Roberta (ed). *Kindergartens and Cultures: The Global Diffusion of an Idea*. New Haven: Yale University Press

2001 Brehony, Kevin J. From the particular to the general, the continuous to the discontinuous: progressive education revisited, *History of Education* 30, pp. 413–432

Brehony, Kevin J. *The Origins of Nursery Education: Friedrich Froebel and the English System*. London: Routledge

Cooper, Graham; Tindall-Ford, Sharon; Chandler, Paul; Sweller, John. Learning by imagining, *Journal of Experimental Psychology: Applied* 7, pp. 68–82

Fielding, M. Students as radical agents of change, *Journal of Educational Change* 2 (2), pp. 123–141

Mayer, Richard. *Multimedia Learning*. New York: Cambridge University Press

227

Marsick, V.; Watkins, K. Informal and incidental learning, *New Directions for Adult and Continuing Education* 89, pp. 25–34

Reese, William J. The origins of progressive education, *History of Education Quarterly* 41, pp. 1–24

Robinson, Ken. *Out of Our Minds: Learning to Be Creative.* Mankato: Capstone

2002 Bereiter, Carl. *Education and Mind in the Knowledge Age.* Mahwah: Lawrence Erlbaum Associates

Darder, Antonia. *Reinventing Paolo Freire: A Pedagogy of Love.* Boulder: Westview Press

Goldring, Ellen; Smrekar, Clare. Magnet Schools: Reform and race in urban education, *Taylor and Francis Publishing* 76, pp. 13–15

Kruglov, Yuri (ed.). *Kreativnaya Pedagogika: Metodologiya, Teoriya, Praktika.* Moscow: Alfa

Novak, Joseph. Meaningful learning: The essential factor for conceptual change in limited or inappropriate propositional hierarchies leading to empowerment of learners, *Sci Ed* 86, pp. 548–571

2003 Berger, Ron. *An Ethic of Excellence: Building a Culture of Craftsmanship with Students.* Portsmouth: Heinemann

Brusilovsky, Peter. Adaptive and intelligent web-based educational systems, *International Journal of Artificial Intelligence in Education* 13 (2–4), pp. 159–172

Green, Maxine. Feminism, philosophy, and education: Imagining public spaces. In: *The Blackwell Guide to the Philosophy of Education.* Blake, Nigel (ed.) Blackwell, pp. 73–92

Hodkinson, Phil; Colley, Hellen; Janice Malcolm. The interrelationships between informal and formal learning, *Journal of Workplace Learning* 15, pp. 313–318

Weiner, Bernard. The classroom as a courtroom, *Social Psychology of Education* 6, pp. 3–15

2004 Chitty, C. *Education Policy in Britain.* Basingstoke: Palgrave Macmillan

Gee, James Paul. *Situated Language and Learning: A critique of traditional schooling.* New York: Routledge

Kincheloe, Joe L. *Critical Pedagogy Primer.* New York: Peter Lang

Shulman, Lee. *The Wisdom of Practice: Essays on Teaching, Learning and Learning to Teach.* San Francisco: Jossey-Bass

2005 Gee, James Paul. «Learning by Design: good video games as learning machines». *E-Learning*, Volume 2 (1), pp. 5–16

Siemens, George. Connectivism: A learning theory for the digital age, *International Journal for Instructional Technology and Distance Learning* 2 (1), pp. 3–10

Squire, Kurt. Recessitating educational technology research: design based research as a new research paradigm. *Educational Technology* 45 (1), 8–14

2006 Berdan, Kristina; Boulton, Ian; Eidman-Aadahl, Elise; Fleming, Jennie; Gardner, Launie; Rogers, Iana; Solomon, Asali. *Writing for a Change: Boosting Literacy and Learning Through Social Action.* Jossey-Bass: San Francisco

Bonk, Curtis; Graham, Charles. *The Handbook of Blended Learning: Global Perspectives, Local Designs.* New York: John Wiley & Sons

Darling-Hammond, Linda. *Powerful Teacher Education: Lessons from Exemplary Programs.* Jossey-Bass: San Francisco

Johnson, G. M. Synchronous and asynchronous text-based CMC in educational contexts: A review of recent research, *TechTrends* 50 (4), pp. 46–53

Rule, A. The components of authentic learning, *Journal of Authentic Learning* 3 (1), pp. 1–10

2007 Chitty, C. *Eugenics, Race and Intelligence in Education.* London: Continuum

Dalke, Anne et al. Emergent pedagogy: Learning to enjoy the uncontrollable—and make it productive, *Journal of Educational Change* 8 (2), pp. 111–130

Giroux, Henry. *The University in Chains: Confronting the Military–Industrial–Academic.* Boulder: Paradigm

Kincheloe, Joe; McLaren, Peter. *Critical Pedagogy: Where are we Now.* New York: Peter Lang Publishing

Nye, David. *Technology Matters: Questions to Live with.* Cambridge: MIT Press

Salen, Katie (ed.). *The Ecology of Games: Connecting Youth, Games, and Learning.* Cambridge: MIT Press

2008 Crook, D. The middle school cometh'… and goeth: Alec Clegg and the rise and fall of the English middle school, *Education 3–13* 36 (2), pp. 117–125

Ecclestone, Kathryn; Hayes, Dennis. *The Dangerous Rise of Therapeutic Education.* London: Routledge

Garoian, Charles R.; Gaudelius. Y. *Spectacle pedagogy: art, politics, and visual culture.* Albany: New York State University of New York Press

Monchinski, Tony. *Critical pedagogy and the everyday classroom.* Dordrecht: Springer

Palmer, S.; Holt, D.; Bray, S. Does the discussion help? The impact of a formally assessed online discussion on final student results, *British Journal of Educational Technology* 39 (5), pp. 847–858

Peters, Michael; Britton, A.; Blee, H. *Global citizenship education: philosophy, theory and pedagogy.* Rotterdam Senses Publishers

2009 Alexander, R. J. *Children, their World, their Education.* Final Report and Recommendations of the Cambridge Primary Review. London: Routledge

Apple, Michael W. *The Routledge International Handbook of Critical Education.* New York: Routledge

Drago-Severson, Eleanor. *Leading Adult Learning: Supporting Adult Development in Our Schools.* Thousand Oaks, CA: Corwin, 2009

Ito, Mizuko. *Engineering Play: A Cultural History of Children's Software.* Cambridge: MIT Press

Karacapilidis, Nikos. *Solutions and Innovations in Web-Based Technologies for Augmented Learning: Improved Platforms, Tools, and Applications.* Hershey: Information Science Reference

Paradise, Ruth; Rogoff, Barbara. Side by side: Learning by observing and pitching in, *Journal of the Society for Psychological Anthropology*, pp. 102–138

Zhang, J., Scardamalia, M., Reeve, R., & Messina, R. Designs for collective cognitive responsibility in knowledge-building communities. *Journal of the Learning Sciences*, 18 (1), pp. 7–44

2010 Ainsworth, Heather; Eaton, Sarah Elaine. *Formal, Non-Formal and Informal Learning in the Sciences.* Calgary: Eaton International Consulting Inc.

DeVoss, Danielle Nicole; Eidman-Aadahl, Elyse; Hicks, Troy. *Because Digital Writing Matters: Improving Student Writing in Online and Multimedia Environments.* Jossey-Bass: San Francisco

Harasim, Linda. *Learning Theory and Online Technologies*. Routledge: New York

Kahn, Richard. *Critical Pedagogy, Ecoliteracy, and Planetary Crises: The Ecopedagogy Movement*. New York: Peter Lang

Kaplan, Andreas M.; Haenlein, Michael. Users of the world, unite! The challenges and opportunities of social media, *Business Horizons* 53 (1), pp. 59–68

Rufo-Tepper, Rebecca; Salen, Katie; Shapiro, Arana; Torres, Robert. *Quest to Learn: Growing a School for Digital Kids*. Cambridge: MIT Press

Steele, Claude M. *Whistling Vivaldi: How Stereotypes Affect Us and What We Can Do*. New York: W. W. Norton & Company

Wilkinson, Richard; Pickett, Kate (eds). *The Spirit Level—Why Equity is Better for Everyone*. London: Penguin Books

2011 Brown, John Seely; Thomas, Douglas. *A New Culture of Learning: Cultivating the Imagination for a World of Constant Change*. CreateSpace Independent Publishing Platform

Cagliari, Paola; Gardner, Howard; Rinaldi, Carla; Vecchi, Vea. *Making learning visible*. Reggio Emilia: Reggio Children

Gee, James Paul; Hayes, Elisabeth. *Language and Learning in the Digital Age*. London & New York: Routledge

Giroux, Henry. *Education and the Crisis of Public Values: Challenging the Assault on Teachers, Students, & Public Education*. New York: Peter Lang

Herr-Stephenson, Becky; Perkel, Dan; Rhoten, Diana; Sims, Christo. *Digital Media And Technology In Afterschool Programs, Libraries, And Museums*. Cambridge: MIT Press

Kohn, Alfie. *Feel Bad Education: And Other Contrarian Essays on Children and Schooling*. Boston: Beacon Press

Markham, T. Project Based Learning, *Teacher Librarian* 39 (2), pp. 38–42

Paull, John. Rudolf Steiner and the Oxford Conference: The birth of Waldorf education in Britain, *European Journal of Educational Studies* 3 (1), pp. 53–66

Selwyn, Neil. *Education and Technology: Key Issues and Debates*. London: Continuum International Publishing Group

2012 Allensworth, Elaine. Want to Improve Teaching? Create Collaborative, Supportive Schools. *American Educator*, 36.3

Burns, M. Immersive learning for teacher professional development. *ELearn*, 4, 1

Jay, Joelle K. Capturing complexity: a typology of reflective practice for teacher education. *Teaching and Teacher Education*. 18.1. (2012), pp. 73–85

Ryu, S., & Sandoval, W. A. Improvements to elementary children's epistemic understanding from sustained argumentation. *Science Education*, 96 (3), pp. 488–526

Savitz-Romer, Mandy and Suzanne M. Bouffard. *Ready, Willing and Able: A Developmental Approach to College Access and Success*. Cambridge: Harvard Education Press

2013 Apple, Michael W. *Can Education Change Society*. New York: Routledge

Berry, Barnett; Byrd, Ann; Wieder, Alan. *Teacherpreneurs: Innovative Teachers Who Lead but Don't Leave*. San Francisco: Jossey-Bass

Crompton, H. A historical overview of mobile learning: Toward learner-centered education. In: *Handbook of Mobile Learning*, Berge, Z.; Muilenburg, L. (eds), Florence: Routledge, pp. 3–14

Finzer, W. The data science education dilemma. Technology Innovations in *Statistics Education*, 7 (2)

Goleman, Daniel. *Focus: The Hidden Driver of Excellence*. New York: Harper & Row

Hernández-Leo, D.; Chacón, J.; Prieto, J. P.; Asensio-Pérez, J. I.; Derntl, M. Towards an integrated learning design environment, *Proceedings of 8th European Conference on Technology Enhanced Learning*, pp. 448–453

Hye-Jung, Lee; Cheolil, Lim. Peer evaluation in blended team project-based learning: What do students find important?, *Journal of Educational Technology & Society* 15 (4), pp. 214–224

Howlett, John. *Progressive Education: A Critical Introduction*. London: Bloomsbury Academic

Ito, Mizuko (ed.) et al. *Hanging Out, Messing Around, Geeking Out: Kids Living and Learning with New Media*. Cambridge: MIT Press

Kelley, P., & Whatson, T. Making long-term memories in minutes: a spaced learning pattern from memory research in education. *Frontiers in Human Neuroscience*, 7, p. 589

Siegel, Daniel, J. *Brainstorm: The Power and Purpose of the Teenage Brain*. New York: Penguin Group, 2013

2014 Barron, Brigid; Gomez, Kimberley; Martin, Caitlin K.; Pinkard, Nichole. *The Digital Youth Network: Cultivating Digital MediaCitizenship in Urban Communities*. Cambridge: The MIT Press

Mager, Robert F. *Making Schools Work*. Carefree: Mager Assosiates

Dilani S. P. Gedera. Students' experiences of learning in a virtual classroom, *International Journal of Education and Development Using Information and Communication Technology* 10 (4), pp. 93–10

Fullan, Michael. *Change Leader: Learning to Do What Matters Most*. San Francisco: Jossey-Bass

Rogoff, B.; Najafi, B.; Mejía-Arauz, R. Constellations of cultural practices across generations: Indigenous American heritage and learning by observing and pitching, *Human Development* 57 (2–3), pp. 82–95

Schwartz, S.; Rhodes, J.; Liang, B.; Sanchez, B. Spencer; Kremer, S.; Kanchewa, S. Mentoring in the digital age: Social Media use in adult-youth relationships, *Children and Youth Services Review* 47 (3), pp. 205–213

Thornburg, David. *From the Campfire to the Holodeck: Creating Engaging and Powerful 21st Century*. San Francisco: Jossey-Bass

2015 Aronica, Lou; Robinson, Ken. *Creative Schools: The Grassroots Revolution That's Transforming Education*. New York: Viking Press

Gros, Begoña; Kinshuk, Maina, Marcelo (eds). *The Future of Ubiquitous Learning: Learning Designs for Emerging Pedagogies*. Berlin: Springer

Jenkins, Henry; Ito, Mizuko; boyd, danah. *Participatory Culture in a Networked Era: A Conversation on Youth, Learning, Commerce, and Politics*, Cambridge: Polity Press

Kohn, Alfie. *Schooling Beyond Measure... And Other Unorthodox Essays About Education*. Portsmouth: Heinemann

Pogorskiy, Eduard. Using personalisation to improve the effectiveness of global educational projects, *E-Learning and Digital Media* 12 (1), pp. 57–67

2016 Berger, Ron; Vilen, Anne; Woodfin, Libby. *Learning That Lasts*. San Francisco: Jossey-Bass

Greene, J. A., Sandoval, W. A., & Bråten, I. *Handbook of Epistemic Cognition*. London: Routledge

Godwin-Jones, R. Augmented reality and language learning: from annotated vocabulary to place-based mobile games. *Language Learning & Technology*, 20 (3), 9–19.

Kaplan, Andreas M.; Haenlein, Michael. Higher education and the digital revolution: About MOOCs, SPOCs, social media, and the Cookie Monster, *Business Horizons* 59 (4), pp. 441–50

Kiili, C., Coiro, J., & Hämäläinen, J. An online inquiry tool to support the exploration of controversial issues on the internet. *Journal of Literacy and Technology*, 17, 3 pp. 1–52.

Shapira, N., Kupermintz, H., & Kali, Y. Design principles for promoting intergroup empathy in online environments. *Interdisciplinary Journal of e-Skills and Lifelong Learning*, 12, pp. 225–246

Tannenbaum, C. (2016). *STEM 2026: A Vision for Innovation in STEM Education*. US Department of Education: Office of Innovation and Improvement, Washington, DC

2017 Ballard, H. L., Dixon, C. G., & Harris, E. M. (2017). Youth-focused citizen science: examining the role of environmental science learning and agency for conservation. *Biological Conservation*, 208, 65–75.

Tatiana Chemi; et al,. *Innovative Pedagogy: A Recognition of Emotions and Creativity in Education*. Rotterdam: Senses Publishers

DeRosa, R., & Robison, S. From OER to open pedagogy: harnessing the power of open. In R. S. Jhangiani & R. Biswas-Diener (Eds.), *Open: The Philosophy and Practices that are Revolutionizing Education and Science*, pp. 115–124. London, UK: Ubiquity Press.

De Veaux, R. D., Agarwal, M., Averett, M., Baumer, B. S., Bray, A., Bressoud, T. C., Bryant, L., Cheng, L. Z., Francis, A. Gould, R. et al. (2017). Curriculum guidelines for undergraduate programs in data science. *Annual Review of Statistics and Its Application*, 4, pp. 15–30

Ferguson, R., Barzilai, S., Ben-Zvi, D., Chinn, C. A., Herodotou, C., Hod, Y., Kali, Y., Kukulska-Hulme, A., Kupermintz, H., McAndrew, P., Rienties, B., Sagy, O., Scanlon, E., Sharples, M., Weller, M., & Whitelock, D. (2017). *Innovating Pedagogy 2017*: Open University Innovation Report 6. Milton Keynes: The Open University, UK

Knox, J. Playing with student data: the Learning Analytics Report Card (LARC). Practitioner Track Proceedings of the 7th International Learning Analytics & Knowledge Conference (LAK17)

O'Neil, Cathy. *Weapons of Math Destruction: How Big Data Increases Inequality and Threatens Democracy*. New York, NY: Crown Publishing Group

Pocock, M. J., Tweddle, J. C., Savage, J., Robinson, L. D., & Roy, H. E. (2017). The diversity and evolution of ecological and environmental citizen science. *PloS One*, 12 (4).

Tempelaar, D. T., Rienties, B., & Nguyen, Q. Towards actionable learning analytics using dispositions. *IEEE Transactions on Learning Technologies*, 1 (Jan–March), pp. 6–16

Wild, C. J. Statistical literacy as the earth moves. *Statistics Education Research Journal*, 16 (1), pp. 31–37

2018 Ahmet, Atay, Ahmet; Toyosaki. S. *Critical intercultural communication pedagogy*. Lanham, Maryland: Lexington Books

Atkinson, Dennis. *Art, Disobedience, and Ethics: The Adventure of Pedagogy*. Cham: Palgrave Macmillan

Herodotou, C., Sharples, M., & Scanlon, E. *Citizen Inquiry: Synthesising Science and Inquiry Learning*. New York: Routledge

Paniagua, Alejandro; Istance, D. *Teachers as Designers of Learning Environments: The Importance of Innovative Pedagogies*. Paris: OECD

Scott, Julie-Ann. *Embodied performance as applied research, art and pedagogy*. Cham, Switzerland: Palgrave Macmillan

Snow, Steven G. *Bourgeois Ideology and Education: Subversion Through Pedagogy*. New York: Routledge

Uhr, John. *Performing Political Theory: Pedagogy in Modern Political Theory*. Singapore: Palgrave Macmillan

Compiled by Anastasia Shanaah

PHOTOGRAPH CREDITS

Images from the book's front and back matter are listed by page number and placement on the page

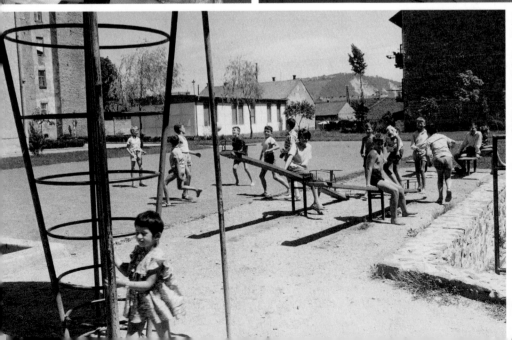

thoughts &
Prayers
Policy & Chan